FIR

ASTRO-
PHOTOGRAPHY

AN INTRODUCTION TO FILM AND DIGITAL IMAGING

H. J. P. ARNOLD

FIREFLY BOOKS

A FIREFLY BOOK

Published by Firefly Books Ltd. 2003

First printing

National Library of Canada Cataloguing in Publication Data

Arnold, H. J. P. (Harry John Philip), 1932–
 Astrophotography : an introduction to film and digital imaging /
by H.J.P. Arnold.

Includes bibliographical references and index.
ISBN 1-55297-801-X

 1. Astronomical photography. I. Title. II. Title: Astrophotography guide.

QB121.A76 2003 522'.63 C2002-905552-0

Publisher in Cataloguing-in-Publication Data (U.S.)
(Library of Congress Standards)

Arnold, H. J. P. (Harry John Philip), 1932–
 Astrophotography : an introduction to film and digital imaging /
H. J. P. Arnold.— 1st ed.
[240] p. : col. ill. , photos. , maps ; cm.
Includes bibliographical references and index.
Summary: How to photograph planets, stars, satellites, meteorites and other phenomena in the night sky. Includes equipment advice for digital and conventional photography, star charts and how to shoot photographs with telescopes.
ISBN 1-55297-801-X (pbk.) 2786 8644 903
1. Astronomical photography. I. Title. 522/.63 21 QB121.A75 2003

Published in Great Britain in 2002 by Philip's,
a division of Octopus Publishing Group Ltd,
2–4 Heron Quays, London E14 4JP

Published in Canada in 2003 by
Firefly Books Ltd.
3680 Victoria Park Avenue
Toronto, Ontario, M2H 3K1

Published in the United States in 2003 by
Firefly Books (U.S.) Inc.
P.O. Box 1338, Ellicott Station
Buffalo, New York 14205

Printed in China

Contents

Foreword

A strophotography attracts an interesting variety of people. Many of them are experienced camera users, looking for new and unusual image-making opportunities. It is the joy of making a satisfying picture that drives most of them, though many may not have considered photography of the moonlight and stars as rewarding, or even possible.

Other potential recruits are already fascinated by the night sky, astronomy and space. They know something about solar eclipses and the phases of the Moon and are alert to the passing parade of the planets. However, they are unsure about how they might capture useful pictures of them, and many will think that fancy cameras and expensive telescopes are essential or that special film or processing is needed.

Of course, there is a big overlap between these two groups, and it is true that both face interesting technical challenges if they are to make satisfying photographs of astronomical and other phenomena. But these challenges are not insurmountable, and many people will be surprised to find how easy and rewarding such photography can be. It helps to have some technical knowledge of photography if you are an astronomer, and it is useful to have some astronomy knowledge to plan a long-exposure shot if you are a photographer, but if you don't have this information you will find it in this book. This same information will help you to photograph a flash of lightning, which is over in a thousandth of a second, or the solar analemma, which takes a year to complete. In between are such unusual subjects as solar and lunar eclipses, aurorae, fleeting meteors and passing comets.

Douglas Arnold has many years experience as a professional photographer and as a writer on space and astronomical photography. From his impressive technical background he has distilled the essential ingredients necessary to get started on this most absorbing branch of photography. The writing is at a level that a beginner will appreciate, but the technical issues are not avoided, rather they are presented in a way that encourages experimentation, and in my experience, extensive and methodical experimentation (and the record-keeping that goes with it) is all-important.

The early editions of this book worked because they began by separating the astronomical ideas from the photographic ones, only to re-unite them later when the underlying principles were clear. This new edition repeats that useful pattern, but with an updated text. However, astrophotography is often affected by changes in camera design or film formulation that seem mostly cosmetic to less demanding users, and these changes are covered from the astrophotographer's point of view in the new edition. The biggest change of all since the early editions

has been the widespread acceptance of digital cameras and ready availability of electronic detectors. Digital devices now have a chapter to themselves.

These recent technical developments introduce new possibilities for picture-making and a new kind of astrophotographer, one who is skilled with a computer, digital camera and image editing software. Though the technology might be relatively new, the basic challenges of low light levels, long exposures and the Earth spinning beneath the eternal stars remain. All this and more marks astronomical photography out as an unusual pursuit, requiring special knowledge and skills. The knowledge is between these pages. Acquiring the skills will take you on a rewarding and enjoyable voyage of discovery that might last a lifetime. Don't travel without this guide!

Professor David Malin, Anglo-Australian Observatory, Royal Melbourne Institute of Technology

Preface

The pages of astronomy magazines often contain beautiful and awe-inspiring pictures, many of which are the work not of professional astronomers but of amateurs. With rare exceptions, those who took the pictures owe nothing to luck and everything to application and hard work. But they all had to start somewhere, and this book is intended to help the newcomer to astrophotography along the first part of the road that may lead to publication in the astronomy magazines and elsewhere. Even if it does not, there is still the enormous satisfaction and enjoyment to be derived from one of the most fascinating hobbies.

Telescopes do not figure prominently in this book. Although they are the astronomer's chief tool, they require knowledge and skill to operate competently. I believe there is a valuable apprenticeship to be served by the budding astrophotographer using basic photographic equipment before attempting to use the telescope. The apprenticeship will not be dull, for many astronomical objects can be captured with just the photographic essentials – a fixed camera and interchangeable lenses – without recourse to any astronomical equipment. However, binoculars are a valuable accessory: not only do they enhance our eyesight, and have a wide field of view, but they can also be used for other, non-astronomical purposes.

This is the third edition of a treatment which first saw print in 1988 so the approach must have been well received by a considerable number of readers. Once again I envisage two major readerships. The first are amateur astronomers, or those who at least know something about astronomy already, who are contemplating a move into astrophotography. The second are amateur photographers who possibly know little or nothing about astronomy, but who have admired astronomical images and are wondering what is involved. Writing for two readerships inevitably means that for one or the other a few parts of the book will contain little that is new. For example, Chapter 1 ("The sky above") can be skipped by the astronomers, while the photographers may wish to pass over Chapter 13 ("Processing"). Even for the photographers, though, Chapter 2 ("Another world") is a reminder that in many ways astrophotography is very different from everyday photography.

The major change in this edition is a greatly enlarged section on CCD and digital imaging techniques as well as a thorough updating of discussion on other items of more advanced equipment, such as "GO TO" telescopes. All of these are gathered together in the two-part Chapter 15 "The way ahead." It may be that some time hence, when CCDs increase in size, digital manipulation becomes far more widespread and those newly taking up the hobby come increasingly from computer-literate age groups, film will be but rarely used. But that time is not yet and at the very least it still has a valuable role to play in the hands of some of the masters as well as

those who are negotiating the learning curve. The avalanche of advanced equipment that continues to be introduced in the astronomical market place constitutes a great temptation and to beginners probably the soundest advice one can give is – go easy, take your time, research and discuss before making purchases and, in the early stages at least, do not forget what can be done with the "mark one" eyeball, a pair of binoculars and maybe a simple camera.

In preparing this new edition, requests for information and assistance in the US were speedily answered by Dennis di Cicco (*Sky & Telescope*), Julie Sherwin (*Astronomy*), Mike Parkes (Starry Night Software) and Sandra McGee. In the UK, staff at Agfa, Fuji, Ilford, Kodak and Konica responded helpfully to my requests for information about new films and where appropriate sent samples for testing. On the processing front, Tetenal and Fotospeed (Jay House Ltd) did likewise. Neil Bone and Ron J. Livesey, directors of the British Astronomical Association Meteor and Aurora sections respectively, provided information quickly, and I am also grateful to Keith Perryman and Caroline Lawrence for their assistance. Distributors have a valuable role to play in making sure that expenditure on sometimes costly items of equipment by amateurs is appropriate and well directed and I am grateful for information about the latest trends to Ninian Boyle of Venturescope Limited and Tony Shapps of The Widescreen Centre. (Both also allowed me to borrow samples of equipment for photographing as well as testing on one or two occasions!)

I not infrequently marvel at the work of other exponents of astronomical photography and imaging and am delighted that three leading talents – Damian Peach in the UK and Dr Robert Gendler as well as Sally and Bill Fletcher in the US – agreed to contribute fine examples of their work to this new edition, the appeal of which can only be enhanced thereby. The same applies to three excellent images retained from the Second Edition and contributed by Akira Fujii, Lanny Ream and Willem Hollenbach. Reference to high quality astronomical imaging inevitably leads me to David Malin. David's name and reputation for creating superlative images and deriving hitherto hidden information from them must be known to those with only the sketchiest knowledge of astronomy and its techniques. That being the case, I consider myself both fortunate and honored that he has seen fit to contribute a foreword.

Finally I extend thanks to Robin Gorman who, perhaps in a moment of weakness, kindly agreed to read the text so that not too many errors large and small survived into print. However, in the time honored way, I must of course confirm that any deficiencies that do remain are to be laid at my door and nobody else's.

H.J.P. Arnold, Havant, Hampshire.

The sky above

This chapter is intended to outline some of the salient features of the night sky and of the celestial objects that can be recorded on film. It is aimed principally at those with more photographic than astronomical knowledge, and the emphasis is on practical rather than theoretical considerations. By the chapter's end, I hope that the newcomer to astronomy will have a basic understanding of what is happening in the sky.

How big and how bright?

If a coin is held just in front of one of our eyes, it appears very large and blanks out a large area of the field of view. If the same coin is held at arm's length it appears much smaller, and if it is placed 100 meters (330 feet) away it might just be seen by those with excellent vision. However, the size of the coin has not altered in any way. We face this problem in describing the size of celestial objects. Some are very close in astronomical terms – a few hundred thousand kilometers. Others are so distant that special units of measurement, such as the *light year* (9.46 million million km/5.88 million million miles) and the *parsec* (30.9 million million km/19.2 million million miles), have been introduced for ease of reference. As luck would have it, there is an excellent example of the effect of distance in the Solar System. As seen from the Earth, the Sun and the Moon are about the same size, but the Moon's diameter is a mere 3476 km (2160 miles) compared with the Sun's almost 1.4 million km (865,000 miles).

It is obvious, therefore, that in describing the size of objects in the sky, and in relating their positions one to another, linear measurements cannot be used. We turn for help to the concept of the *celestial sphere*, shown in Figure 1.1. From ancient times it was imagined that the stars, grouped into constellations, and the planets were set in a sphere with the Earth at the center. This is not true, of course, but the celestial sphere does present a method of sizing any object as seen from the Earth. As Figure 1.1 shows, we can imagine a circle with the same radius as the sphere running around its equator for 360°, and another passing through the celestial pole and through the point directly overhead, the *zenith*. The angle from horizon to horizon passing through the zenith is 180°, and from the horizon to the zenith, 90°. This provides an angular system of measurement in which the apparent size of a celestial object is given in terms of its angular extent on the celestial sphere. The vertex of the measured angle is located at the observer's eye ("vertex" being a geometrical term for the point at which lines meet to make an angle.)

There are some helpful, rough-and-ready methods of estimating angular sizes that the newcomer can adopt. When the arm is fully

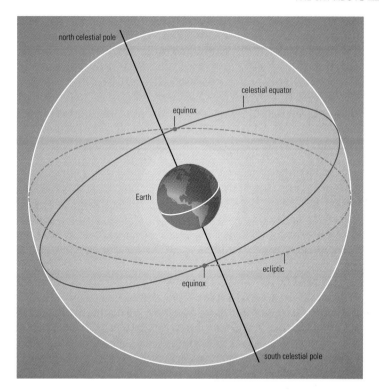

north celestial pole

celestial equator

equinox

Earth

ecliptic

equinox

south celestial pole

Figure 1.1 *The celestial sphere. When we look up at the night sky, it seems as if we are on the inside of a huge sphere that carries the stars and planets with it as it turns, once every 24 hours. The Earth's axis extended meets the sphere at the north and south celestial poles, and the plane of the Earth's equator similarly extended marks the celestial equator. The ecliptic (see page 13), the path followed by the Sun and the planets, is angled to the celestial equator, and the two points where these two circles cross are the equinoxes. The celestial sphere makes it possible to consider the sizes of celestial objects and the distances between them as angles.*

extended, a clenched fist covers an area of sky about 10° across (nine fists to zenith!), and the little finger about 1° across. Since the angular diameter of the full Moon is around $\frac{1}{2}$°, it is easily established that the lunar disk is hidden (or "occulted") by the little finger positioned at arm's length. Of course, the system is capable of much more accuracy than this. One degree is composed of 60 minutes (usually referred to as *arc minutes* to distinguish them from units of time), for which the symbol is ', and each minute is composed of 60 *arc seconds*, for which the symbol is ". Thus the angular size of both the Sun and the Moon is

slightly more than 30 arc minutes. The planets are small enough as seen from the Earth to be measured in arc seconds and the stars are so distant that effectively they are points of light with no discernible size.

In discussing the size of objects above, the term *magnitude* was avoided quite deliberately because, rather perversely, astronomers use it to describe the brightness of celestial objects. The scale used is still basically that devised by the Greek astronomer and mathematician Hipparchus in the 2nd century BC. He described the brightest stars that could be seen with the naked eye (Hipparchus lived almost two millennia before the invention of the telescope) as being of the first magnitude, and the faintest as of the sixth magnitude. The magnitude scale is now on a more precise footing, each successive magnitude change corresponding to a brightness difference of just over 2.5 times. A first-magnitude star is thus 100 times (i.e. 2.5 to the power 5) brighter than a sixth-magnitude star. Hence, the brighter the star, the lower the magnitude.

Not surprisingly, the system has been considerably refined since the time of Hipparchus. Magnitudes have been measured to decimal values (using instruments called photometers). Negative values are accorded to the four brightest stars: Sirius, the brightest star in the sky, in the constellation Canis Major; Canopus, in the southern constellation Carina; Alpha Centauri, in another southern constellation, Centaurus; and Arcturus, in the northern constellation Boötes. Sirius is surpassed by Jupiter and Mars some of the time, depending on the planets' positions relative to the Sun and Earth, and by Venus, the full Moon, and the Sun all of the time. Sirius has a magnitude of -1.5, Venus at its brightest -4.7, the full Moon -12.7, and the Sun -26.7.

As with size, a note of caution has to be sounded on the matter of brightness. Stars differ enormously in luminosity and distance from Earth, so the magnitudes indicated above are what are referred to as *apparent* or *visual magnitudes*. Values have also been calculated for the magnitudes that stars would possess if they were viewed from a standard distance of 10 parsecs, and these are known as *absolute magnitudes*. The calculation for Sirius and Polaris is enlightening. To our eyes Polaris is a very ordinary star with an apparent magnitude of $+2.0$, compared with the -1.5 of Sirius. However, the absolute magnitude of Sirius is only $+1.4$, whereas that of Polaris is -4.6, which is almost as bright as the maximum apparent magnitude of Venus. Hence Polaris is in fact far more luminous than Sirius, but its far greater distance from Earth makes it appear much dimmer. More chastening still is the calculation for our star, the Sun. Viewed from 10 parsecs it would be magnitude $+4.8$, making it a dim, albeit naked-eye object.

Nonetheless, it is apparent magnitudes that are of the greatest concern to the budding astrophotographer. Cameras and films enable us

to record stars far dimmer than those discernible to the human eye. Since our Galaxy is estimated to contain about 100,000 million stars it is extremely interesting to look at some of the numbers. There are 22 stars of first magnitude and brighter, 68 of second magnitude, 197 of third magnitude, 599 of fourth magnitude, 1976 of fifth magnitude, and 5830 of sixth magnitude – a total of 8692 stars that are, in theory, visible to the naked eye under ideal conditions. Now, we can see only about half of the celestial sphere at any particular time, and it is only near the zenith that the faintest of the sixth-magnitude stars will be visible. Away from the zenith, stars have to be viewed through more of the Earth's atmosphere, and a few degrees above the horizon only first-magnitude stars can be seen. The net result is that, from the UK or US, even under ideal conditions, no more than about 2600 stars are visible to us without the aid of binoculars or a telescope. From magnitude 6, the numbers grow rapidly: there are approximately 16,000 stars of seventh magnitude, 51,000 of eighth magnitude, and over 160,000 of ninth magnitude. It has been calculated that there are possibly 5 million stars of twelfth magnitude. Although we cannot see these faint stars individually with the naked eye, in total they contribute to the general luminosity of the night sky. This is nowhere more so than in the Milky Way, a band in the sky created by a line-of-sight effect as we look inward toward the center of the Galaxy from our position near the edge of one of the spiral arms.

The way we see

Before setting out to study the movement (real or apparent) of the stars and planets, and the part that the Earth itself plays, it will be helpful to describe briefly for the newcomer an important attribute of the human eye. The retina is the light-sensitive membrane at the back of the eye which receives the image formed by the lens. This quality is conferred by millions of sensitive elements of two different types – rods and cones, named after their characteristic shapes. The cones distinguish color and operate best in bright light conditions. The rods cannot discriminate color, and are most sensitive in low light conditions. Time is needed for the rods to accommodate to dark conditions, and this is referred to as *dark adaptation*.

The cones are concentrated in the central area of the retina and are the only elements in the fovea, a small area of the retina where the eye possesses its highest resolving power. Away from the fovea the rods rapidly begin to predominate. This explains one of the most important facts about looking at the night sky, and in particular searching for dim objects. If the observer looks directly at the area of interest, the object may not be resolved because of the cones' poor performance in low

light conditions. However, if the eye is directed slightly to one side of the object's suspected position, the superior low light performance of the rods around the fovea is far more likely to result in the object being discriminated. This observing technique is known as *averted vision*, and is one of the most valuable techniques we can learn as we set out on our journey around the skies.

The map of the sky

I magine that we are on a planet just like Earth, but that there is no Sun, so the planet's rotation brings no interruption of the permanent night. Just like Earth, this planet rotates from west to east (anticlockwise as seen from a vantage point over the north pole, clockwise from over the south pole). As the hours pass, a panorama of stars travels across the sky from east to west, until the time comes for the pattern to start being repeated. Relative to each other as seen from the Earth, the positions of the stars change very little over the centuries. It is not too difficult to project the positions of the stars on the imaginary celestial sphere on to flat, two-dimensional maps, as we do with maps of the Earth's surface.

The Earth's equator projected on to the celestial sphere forms the *celestial equator*, and the geographical poles projected form the *celestial poles* (see Figure 1.1). A coordinate system like latitude and longitude is needed. On star maps latitude becomes *declination*, abbreviated as dec, which is expressed in degrees, arc minutes and arc seconds, prefixed by + or − to indicate position north or south of the celestial equator, up to a maximum of 90° at the celestial poles. The east–west equivalent of longitude is *right ascension*, abbreviated as RA, and is expressed in hours, minutes and seconds, with a maximum of 24 hours, corresponding to the Earth's rotation period. Since one complete revolution equals 360°, 1 hour of right ascension represents 360°/24 = 15°. As with the Greenwich meridian marking the zero line in the longitude system on Earth, in mapping the stars the point or line selected for the commencement of the 24-hour clock is arbitrary. The choice actually has to do with the Sun, but since, for the moment, we are not permitting the Sun to exist, the explanation will follow later.

Over the course of a full rotation of our dayless planet, an observer at the north (or south) pole will see the pole star at the zenith, and the celestial equator will be on the horizon. The same half of the sky will always be visible (either the northern or the southern hemisphere only), and all the stars will revolve around the celestial pole with none rising or setting – that is, they will all be *circumpolar*. At the equator, an observer will see the entire celestial sphere over the course of the 24 hours in which the planet rotates. Every star will rise and set, and each will do so at a right angle to the eastern or western horizon. In

between these two extreme locations, some stars will be circumpolar, like, for example, the stars of Ursa Major as seen from the UK, while others will rise and set at a slant angle to the horizon of 90° less the latitude. For example, at 40°N the slant angle will be 50° toward the south. (The slant angle for stars rising and setting as seen from the southern hemisphere is to the north.)

For a northern-hemisphere observer at 51°N, any star with a declination of +51° will be directly overhead when it is on the *meridian*, the imaginary line through the north and south celestial poles and the zenith. From such a location, it follows that the farther south the declination of a constellation, the lower its position in the sky. For example, Leo is never as high as Ursa Major, and Orion (which straddles the celestial equator) is never as high as Leo. Capricornus, at around −15° declination, is lower still, and we eventually reach the stage where constellations are so far south in declination that they never rise for northern observers at higher latitudes. Thus Crux, the Southern Cross, can never be seen from the UK or much of continental US. The reverse is true, of course, for southern observers viewing northern-hemisphere constellations. It is appropriate to point out here that the constellations are line-of-sight effects as viewed from Earth, and are not groupings of stars that are genuinely associated.

The Sun

N ow, having explained in outline about the apparent movement of the stars and their positions in the sky, neither of which change in essence from century to century, let us introduce the Sun into the scheme of things. Here there are two effects to consider: what happens as the Earth orbits the Sun in a period of a little over 365 days, and what happens as a result of the Earth's daily rotation on its axis. For the time being we shall ignore the other planets.

As the Earth orbits the Sun during the year, the latter appears to pursue a path against the background of the stars – although it is of course too bright to permit us to see them – and this path is called the *ecliptic*. Unfortunately, the ecliptic does not run neatly along the celestial equator, because the Earth's axis is tilted at an angle of 23.5° to the perpendicular to the plane in which it orbits the Sun. This tilt causes the Sun's apparent path to appear as in Figure 1.2. (This inclination of the Earth's axis is the cause of the seasons, which have nothing to do with the Earth moving any closer to or farther from the Sun. But we limit ourselves here to the more astronomical aspects.) The Sun reaches its farthest point north (declination +23.5°) on about June 21, when it is overhead on the Tropic of Cancer (latitude 23.5°N), and its farthest point south around December 22, when it is similarly located over the Tropic of Capricorn

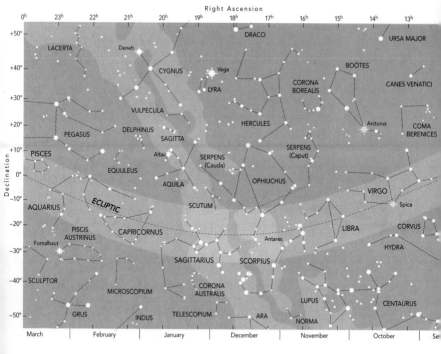

Figure 1.2 The ecliptic, the path that the Sun appears to follow against the background of the stars over the course of the year. In fact, it is the movement of the Earth about the Sun that creates this effect. Because the Earth's axis is tilted at an angle of $23\frac{1}{2}°$, the ecliptic traces the dashed sinusoidal curve shown on this star chart. On either side are the boundaries beyond which the major planets, whose orbits are all slightly inclined to the ecliptic, do not stray as seen from the Earth. (The exception is the small and distant Pluto, whose orbit is more steeply inclined.) The diagram shows why constellations are best seen in certain months of the year. For example, in January, when the Sun is in Sagittarius (RA 19h), the constellation Gemini, 12 RA hours away on the opposite side of the celestial sphere, is high in the sky at midnight in northern latitudes. (The months below the chart indicate when the Sun is in that part of the sky.)

(latitude 23.5°S). The Sun appears to remain at about the same altitude for a few days, hence the name given to these events – *solstices*, meaning "standing still of the Sun." The June date represents midsummer in the northern hemisphere and midwinter in the southern. The December date represents northern midwinter and southern midsummer.

It is quite straightforward to work out the noontime altitude or elevation of the Sun above the horizon from any position on Earth if we

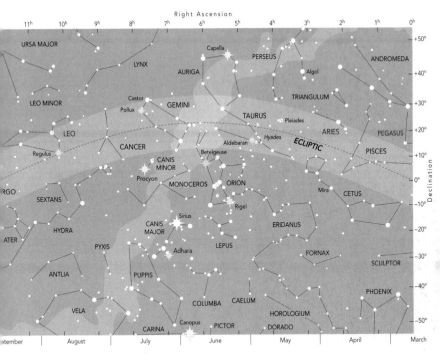

Right Ascension

know the declination of the location. Let us take June 21 as an example. The Sun's declination is then +23.5°. At latitude 51°N (the south coast of England, to be parochial) the altitude of the celestial equator is 90° − 51° = 39° to the south. Add 23.5 to 39, and we establish that the highest the Sun will ever be along the south coast of England is 62.5°. The altitude of the Sun for the same location at midwinter is just 15.5°.

June 21 and December 22 represent midsummer in the two respective hemispheres. The dates on which the Sun crosses the celestial equator on its apparent annual journey (March 21 and September 23) are called the *vernal* or *spring equinox* and the *autumnal equinox*, respectively. On these dates day and night are the same length – the word "equinox" meaning "equal night." We can refer back now to the apparently arbitrary position at which right ascension commences to be measured: it is at the spring equinox, when the Sun is in the constellation Pisces, as can be verified from Figure 1.2.

In the last section, we imagined the movement of the stars across the sky for 24 hours without the Sun. Now that we have reintroduced the Sun, Figure 1.2 enables us to see, without the need to consult any other document (or even to check the sky), which constellations will be visible at night and which will be lost in the glare of the Sun at any time of the

year. On January 5, for example, the Sun is in Sagittarius (RA 19h), so that constellation cannot be seen. But a constellation twelve RA hours away (at RA 7h), for example Gemini, is well seen in winter skies at midnight. Chapter 14 shows how a record of the Sun's apparent movement in the sky over the course of an entire year, which forms a figure of eight and is called an *analemma*, can be made on photographic film.

Now we can consider the matter of the Earth's rotation. Relative to the stars, the Earth completes its daily revolution in a little over 23 hours 56 minutes. That is known as the *sidereal day*. However, the Earth moves about 1° a day in its orbit around the Sun (although, of course, as seen from the Earth it is the Sun that appears to move by that amount). Therefore the Earth has to rotate not 360° but 361° in order to complete a *solar day*; the extra degree represents 4 minutes in time, which gives the solar day of 24 hours.

The difference between the solar and sidereal days means that the stars rise (and set) 4 minutes earlier every day. Thus, for an observer at a particular location, stars which are just rising at 22.00 local time on September 1 will be rising at 20.00 on October 1 (30 × 4 minutes = 2 hours). Moreover, this will occur year in, year out. Winter constellations remain winter constellations! This 4-minute daily gain by the stars is one way of explaining why they gradually "move" into daytime, and then back again into nighttime. Also, it is simple to project the rising or setting times backward or forward several months. Thus, to continue the example above, the stars rising at 22.00 on September 1 were rising at around midnight on August 1 and 02.00 on July 1. Moving the other way, they will be rising at 18.00 on November 1 and, say, about 14.00 on January 1. By the way, astronomers usually express all 24-hour clock times in terms of Universal Time (UT), which equates to Greenwich Mean Time (GMT). Universal Time is commonly written with a colon, as in 12:00.

One point about the RA/dec system may confuse newcomers, at least briefly. A location identified by latitude and longitude coordinates on the Earth does not move (unless viewed by an observer in space). However, in considering RA and dec coordinates we have to remember the effects of the Earth's rotation, which causes any location on the celestial sphere to appear to move. Thus the star Spica (RA 13h 25m, dec −11° 10′) in the constellation Virgo rises, passes through the meridian, and sets. A major value of the RA/dec system is that it permanently establishes the positions of the stars and other deep-sky objects relative to one another.

Many individual stars in the constellations have names, mostly Arabic in origin. They are also identified by Greek letters, a system introduced in the 17th century by the German astronomer Johann Bayer. A hundred or so of the most prominent nebulae, star clusters

and galaxies are known by their Messier numbers (for example, M31 is the Andromeda Galaxy), so called because the French astronomer Charles Messier listed them in the 18th century. To add a little confusion, these Messier objects are also known by their NGC numbers, from the *New General Catalogue of Clusters and Nebulae* published in the late 19th century, which listed several thousand more.

The planets

Table 1.1 gives some useful information about all nine planets of the Solar System. The planets orbit the Sun in broadly the same plane, but all have slightly different *inclinations* – the amounts by which their orbits are inclined to the plane of the ecliptic. Pluto has an inclination of more than 17°, but the others do not stray far from the ecliptic as seen from Earth, the second biggest inclination being that of Mercury at 7°. This fact gives additional meaning to Figure 1.2, which shows a belt 7 or 8° on either side of the ecliptic. This belt is known as the *zodiac*. It stretches all around the sky, and is the region where the Sun, the Moon and all the planets, again with the exception of Pluto, are always found. (The belt runs through the twelve zodiacal constellations, and through parts of several others which are not granted the honor of that name.) Thus, a planet will never be found in Ursa Major or Hercules in the northern sky, nor in Centaurus or Grus in the southern sky.

Mercury and Venus are known as *inferior planets*, as their orbits lie inside that of the Earth. Because of this, they show dramatically varying phases as they orbit the Sun. With angular distances from the Sun of never more than 28° for Mercury and 47° for Venus, they are essentially evening or dawn objects for naked-eye viewing. It follows that they can never be seen all through the night. The planets with orbits beyond that of the Earth are known as *superior planets*.

TABLE 1.1 THE MAJOR PLANETS OF THE SOLAR SYSTEM					
	Average distance from Sun (millions of kilometers)	Equatorial diameter (kilometers)	Period of revolution about the Sun	Rotation period	Inclination of orbit to ecliptic (degrees)
Mercury	57.9	4880	88d	59d	7
Venus	108.2	12,104	224.7d	243d	3.4
Earth	149.6	12,756	365.26d	23h 56m 4s	0
Mars	227.9	6787	687d	24h 37m 23s	1.9
Jupiter	778.3	142,984	11.86y	9h 55m 30s	1.3
Saturn	1429	120,540	29.46y	10h 39m 20s	2.5
Uranus	2875	51,100	84.01y	17.24h	0.8
Neptune	4504	49,528	164.8y	16.1h	1.8
Pluto	5873	2302	248.5y	6d 9h 18m	17.2

Earth and Mars, like Mercury and Venus, are essentially rocky planets, but beyond Mars and the asteroid belt lie the gas giants – Jupiter, Saturn, Uranus and Neptune – all with deep, dense atmospheres. The slower-moving superior planets take longer to traverse a given area of the sky: if Mars travels through a constellation in two months, Saturn will take about two and a half years and Neptune over fourteen years. One useful result of this is that once one of these planets is in our night sky, it will remain visible for some years (or months in the case of Mars).

All the planets proceed at their varying speeds in an easterly direction, but one line-of-sight effect (which occurs most dramatically in the case of Mars) may puzzle newcomers. Occasionally Mars checks in its easterly movement, appears to move west for a short while, and then resumes its eastward journey. This is called *retrograde* motion. It happens because the Earth moves faster than Mars: the Earth's year is not far off half that of the Red Planet. Periodically the two bodies are in relative positions on the same side of the Sun whereby the Earth catches up with Mars and passes it. To observers on the Earth, Mars appears to stop and perform what is called a retrograde loop, after which its normal apparent motion is restored (see Chapter 14).

Since the planets are all in orbit about the Sun, it will be evident that, unlike the stars, their positions in the sky cannot be represented on an unchanging map. Still, the normal and quite logical method of showing their positions month by month is to superimpose them on a background chart of the stars.

The Moon

The Moon can dominate the sky on many nights, particularly when it is full or *gibbous* (between half and full). It shines, like the planets, by reflecting light from the Sun. It appears so bright because it is in a largely dark sky and there is nothing to rival it, but in fact its dark surface reflects only 7 percent of the incident sunlight. In this respect it is markedly inferior to Venus, for example, but from the Earth there is a lot more of it in the sky!

The Moon moves eastward in its elliptical orbit at the rate of about one diameter per hour, or 13° in 24 hours, against the celestial background. This accounts for the fact that it rises later each night, by about 45 or 50 minutes on average. But this time lag can be much shorter. When the angle of the ecliptic to the horizon is very shallow, and from one night to the next the Moon's eastward motion places it only a short distance beneath the horizon, the retardation can be as little as 20 minutes. The opposite occurs when the ecliptic slopes more steeply to the horizon, when the retardation can be over 1 hour.

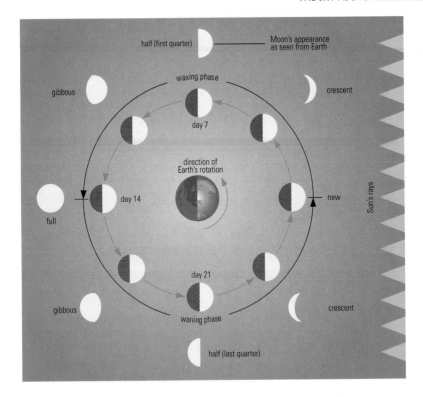

Figure 1.3 *The phases of the Moon. As the Moon moves in its orbit, the proportion of its illuminated side that is visible from the Earth changes. At new Moon, the sunlit hemisphere is turned away from us, and we see only the night side. As it moves from new to full, the Moon is said to be waxing as it passes through the crescent, half and gibbous phases. The waning Moon passes through the same sequence but in reverse. The half phases are often called first and last quarter.*

The Moon's *sidereal month*, the time it takes to return to the same point in its orbit as seen against the background stars, is completed in about 27.3 days. This is also the period taken by the Moon to spin once on its axis, so we see broadly the same hemisphere all the time from Earth. (The far side was not seen until the coming of the space era.) What is called the *synodic month* – the period between successive alignments of Earth, Moon and Sun – is approximately 29.5 days, and this is therefore the period between one new Moon (or one full Moon) and the next.

The phases of the Moon are illustrated in Figure 1.3. This shows that a waxing crescent Moon of a few days is always an early evening object,

while its waning counterpart can rise only shortly before dawn. Similarly, a full Moon must rise in the east as the Sun sets in the west. Artistic licence – or ignorance – in paintings and composite photographs leads all too often to the Moon being depicted in a manner which is physically impossible.

One interesting fact is that, as seen from the Moon, the Earth is in the complementary phase. For example, at times when a waxing crescent Moon is in our skies, a Moon-based observer would see a waning gibbous Earth. While this can be inferred from Figure 1.3, the Apollo lunar missions supplied tangible photographic proof. The lunar landings required a relatively low Sun angle so that the astronauts would have optimum shadow detail. This would give them the clearest view of the surface, essential in making last-minute decisions during the final approach to touchdown. The desired angle was 10°. The first lunar landing mission, Apollo 11, was scheduled to land in the southwestern corner of the Sea of Tranquillity in July 1969. New Moon was on July 14, and a 10° phase angle would occur at the landing site on only one day that month – the 20th. All other mission details (such as the launch from Florida on July 16) were shaped to this one end. As the crew entered lunar orbit on July 19, they took pictures from above a 5-day waxing crescent Moon of a noticeably gibbous waning Earth. When the lunar module *Eagle* redocked with the command module *Columbia* late on July 21 after the momentous landing, the Earth was photographed at last quarter, just as the Moon was at first quarter.

Eclipses

One final point about the phases of the Moon needs explaining. From Figure 1.3, it would be quite logical to assume that solar eclipses occur every time the Moon is new, and lunar eclipses every time the Moon is full. In fact, both sorts of eclipse are relatively infrequent. The Moon's orbit is inclined at about 5° to the ecliptic. When the Moon passes between the Earth and the Sun, it is usually above or below the plane of the ecliptic. It is only when the Moon is at one of the *nodes* of its orbit (the two points at which its orbit intersects the ecliptic) at the time of new Moon or full Moon that the three bodies are aligned, producing a solar or lunar eclipse. Partial eclipses take place if the alignment is not quite perfect. We owe the existence of the beauty of a total solar eclipse to the sheer coincidence that, as seen from the Earth, the two other bodies are about the same angular size.

This chapter has concentrated on explaining the general scheme of things. Other bodies of the Solar System, such as comets, meteoroids and interplanetary dust, are discussed in later chapters.

Another world

Many forms of photography are difficult or demanding, and sometimes even dangerous, particularly in professional practice. As far as the amateur is concerned, astrophotography makes demands of a technical kind as well as on personal attitudes. The technical demands, moreover, involve some features which will be new even to experienced "everyday" photographers. Astrophotography may be described, indeed, as another world.

Location and exposures

Before anything can be done, the astrophotographer has to search for the subject – a task which most other photographers do not face. When the subject is the Moon the exercise is usually very easy (the note of caution is sounded because how many readers have attempted to locate a newly risen, totally eclipsed Moon?), but most other targets are more difficult. Locating a constellation and checking that it is all within the field of view of the chosen lens requires some elementary astronomical knowledge. And, as the subjects become fainter and the powers of magnification higher, the search becomes harder. This leads to consideration of the low light levels encountered by the astrophotographer, and the resulting lengthy exposures. The classic everyday exposure of 1/125 of a second at $f/11$ may well be suitable for photographing a full Moon with a film of moderate speed. But, as one moves to subjects other subjects, such as stars or meteors, exposures lengthen considerably. For example, an exposure not of 1/125 of a second but of 125 seconds, which many everyday photographers will never have used in their lives, would be regarded as quite short for some subjects. And, as one progresses to more demanding subjects, exposures of many minutes become the order of the day (or, rather, of the night).

There is a corollary to this consideration of low light levels. A keen everyday photographer fully realizes the importance of focusing accurately (many cameras now accomplish this automatically, of course) and will make this an important albeit obvious part of technique. Usually such a procedure is easy. Life is not quite so easy for the astrophotographer. This may sound very surprising, because a moment's thought will indicate that only one focusing distance is needed in astrophotography – infinity. However, while virtually all shorter focal length lenses have a fixed infinity setting, some top-quality telephoto lenses of modest focal length, around 200 mm or more, can be focused beyond the nominal infinity setting to compensate for temperature changes. And this is also true of most catadioptric, or mirror-reflex, photographic lenses (as well as telescopes). If the target is a dim celestial object, focusing is far from

easy, and the availability of special, bright viewing screens in the more advanced camera systems is a valuable asset.

When we start out in everyday photography, a major concern is to learn the correct exposure for various subjects. As we gain experience, we learn that the matter is not quite so clear cut. Somebody who, for example, likes a contrasty black-and-white negative to print from may well give a different exposure than another photographer despite using a film of the same speed. The non-existence of what might be called universally correct exposures for a range of subjects is very much part of the experienced astrophotographer's knowledge. Any exposure aimed at achieving high quality is the product of weighing up a complex combination of factors involving equipment, film, subject, procedures and conditions, and can vary greatly. A straightforward example is that of the Moon photographed at different times after it rises. An exposure made as it comes into view over the horizon, and shines through the maximum thickness of atmosphere, could easily differ by a full stop (see page 24) from one made when the Moon is at its maximum altitude, on the meridian, and shining through the minimum thickness of atmosphere. Similarly, some stars (those called, appropriately enough, *variables*) and the planets (as orbital motion takes them farther from or closer to us) show variations in brightness quite separate from the effects of the atmospheric conditions under which we view them. Calculating exposures will be dealt with at greater length later, but it is appropriate here to stress the need to allow for variations. In practice, this means making a number of exposures, some shorter and some longer than an exposure time indicated by calculation and/or experience. This is known as *bracketing*.

The variables facing the astrophotographer constitute the major reason why it is so important to get into the habit from the beginning of keeping detailed notes – something the everyday photographer does not normally need to do. Such notes should include information about the equipment/film combination used, as well as the local viewing conditions and other relevant factors upon which no distant "expert" can meaningfully advise. It is on the basis of these notes that subjects can be returned to and tackled with more confidence, new ones approached with greater insight and, in general, experience gained and progress made.

Focal ratio and focal length

Although it will be dealt with later in more detail, there is a major difference concerning photographic theory and practice between astrophotography and many other forms of photography. This difference is fundamental and needs to be understood clearly by the newcomer. To the everyday photographer, the measure of the speed of a lens is its *focal*

ratio, known otherwise as its *f-number*. The focal ratio is one vital factor in the calculation of a photographic exposure (the other three being shutter speed, film sensitivity, and the brightness of the subject). It is a value derived by dividing the *focal length* of the lens by its diameter. Focal length is the property of the lens that controls the scale of the image: the longer the focal length, the larger the image. Thus a 25-mm diameter lens with a focal length of 50 mm is referred to as an $f/2$ lens.

The focal length of a lens has a direct bearing on the image size of a subject. For a particular lens diameter, a longer focal length will spread the image of a subject – formed from the same amount of light – over a greater area of the film. The lens is then said to be *slower*, because it will take a longer exposure to build up an image of a particular density. Similarly, a lens of shorter focal length (but of the same diameter) will concentrate the image into a smaller area of film, so that a shorter exposure will produce an image of comparable density. Such a lens is said to be *faster*. If we double the focal length the area of the image is four times greater, for it is proportional to the square of the focal length. So, if we double the focal length of a 50-mm focal length $f/2$ lens of 25-mm diameter, we have a 100 mm/25 mm = $f/4$ focal ratio lens. The everyday photographer understands the importance of *f*-number in exposure calculations, but in astronomy a new situation is confronted.

When we photograph the Moon, or a comet, or an aurora, the size of the image on the film relates directly to the focal length of the lens we use, just as it does when we photograph everyday subjects. The Moon, which is quite a reasonably sized disk when recorded on the film frame of a 35-mm camera fitted with a 250-mm focal length lens, doubles in size when a 500-mm focal length lens is used instead. Astronomical subjects of this kind behave just like those photographed by the everyday hobbyist, and astronomers and astrophotographers refer to them as *extended objects*. Now to the major difference. The stars are so far away that, to all intents and purposes, no matter how great the focal length of the lens, they can be rendered only as point sources. They are not extended objects, and the measure of how fast or slow a lens is in recording them is judged instead by its diameter, not by its focal ratio. The same applies to the planets, up to the point at which (since they are not so far away) we reach a focal length sufficient to record a particular planet as something more than a point of light. That planet then becomes an extended object, and once again focal ratio becomes a major concern in calculating exposures.

This point has been stressed early in the book because it is a potential source of confusion, even to quite experienced photographers. If you asked them to choose the faster of two lenses, a 35-mm $f/1.4$ and a 180-mm $f/2.8$, quite understandably they would choose the former,

and they would be correct for extended objects. But for photographing the stars they would be wrong, for the former has a lens diameter of 25 mm (35 mm/1.4), whereas the latter has a diameter of over 64 mm (180 mm/2.8). Hence, when using the same film, a camera fitted with the 180-mm lens would record a considerably greater number of fainter stars over a given period of time than would a 50-mm lens.

While we are considering definitions there is one other potential source of confusion between astronomers and photographers that needs to be highlighted. It arises from the manner in which the two groups refer to telescopes and lenses. The figures "35 mm," "180 mm," "250 mm" and so on have already been used here in referring to lenses. All photographers will recognize these to be an indication of the focal length of the lenses, and thereby of the relative size of images produced on the film. However, when such figures are used by astronomers they refer to the diameter or *aperture* of a telescope objective or lens. Their main concern is the light-gathering capability of their telescopes (just as the above references to lens diameters concern the speed of the lens in capturing stars as point sources). Throughout this book such figures will be used in the photographic sense of focal length; if the diameter of a lens is being considered it will be referred to quite specifically as such. Fortunately, focal ratio has the same meaning for both astronomers and photographers!

A question of history – and squaring

Many terms from the early years of photography continue to be used. For example, *f*-numbers or focal ratios are often referred to as *stops*. This word dates from the time when the full diameter of a lens was made smaller by placing in front of it a metal plate containing a series of circular holes of different diameters. The exposure was modified according to the stop placed in front of the lens. Aperture is another term used loosely to mean stop or *f*-number. Nowadays, the focal ratio is altered by an iris diaphragm, consisting of a number of blades which close in from the edge of the lens or open out when a ring on the lens is rotated.

It is reasonably easy to understand how an *f*-number is the result of dividing the focal length of a lens by its absolute diameter. And it follows quite straightforwardly that the lower the *f*-number, the faster the lens – in much the same way that the lower a golfer's handicap, the better the golfer, and the lower a star's magnitude, the brighter the star (see Chapter 1). But the apparently haphazard sequence of the actual *f*-numbers, with values such as *f*/1.4 and *f*/5.6, needs some explanation. The amount of light a lens transmits is proportional to its area, which in turn is proportional to the square of its effective diameter. Although some rounding off has to take place, squaring the *f*-numbers gives a far more understandable relationship, as shown in Table 2.1.

Thus, in order to halve or double the amount of light transmitted by the lens, the photographer changes the *f*-number one stop higher or lower, respectively. There is a similar relationship for shutter speeds. As a result, an exposure (that is, the amount of light reaching the film, which is governed by *f*-number and shutter speed) can be held constant while the shutter speed and aperture are altered in a complementary fashion to meet the demands of a particular situation, such as subject movement.

TABLE 2.1 THE SEQUENCE OF *F*-NUMBERS AND THEIR SQUARES									
f-number	1.4	2	2.8	4	5.6	8	11	16	22
squared value	2	4	8	16	32	64	128	256	512

To give an example: an exposure of *f*/8 at 1/125 of a second is equivalent to one of *f*/11 (one stop less light) at 1/60 of a second (one shutter speed more time), and also to one of *f*/5.6 (one stop more light) at 1/250 of a second (one shutter speed less time). This straightforward relationship (which is valid in astrophotography except for lengthy exposures, see Chapter 4) enables most of the target exposures given in this book to be extrapolated to give different shutter speeds and apertures provided the mathematical relationship at the starting-point is maintained.

Numerous problems

Astrophotography is set apart from other forms of photography by natural and human factors which have nothing to do with purely photographic matters. So far as nature is concerned, the everyday photographer often seeks ideal circumstances but can usually make do without. But how do you photograph the stars through clouds? Further, although clouds may not be present, the photographic or observing quality of the atmosphere can vary greatly (astronomers usually call it the *seeing*). It may surprise the newcomer to learn that a seemingly beautiful night with a clear sky full of twinkling stars is often a sign of considerable atmospheric turbulence, and therefore of bad seeing. On the other hand, nights ostensibly less clear, with a little high haze, can be much better because the haze results from less disturbed atmospheric conditions. Only experience and results on film can provide the key. Sometimes even the major subjects in astrophotography can conspire against us. All too often the Moon will be strong when we want to photograph meteors – all but the brightest of which are thus rendered invisible.

Obviously, by definition the astrophotographer will most often operate at night. Whether early or late, the delights of, say, the British climate or that in many parts of the US can create problems not faced in some other parts of the world. Condensation will form once the temperature of the front element of a lens falls significantly below that of the surrounding

air. (It is significant that astronomers use the term "dew cap" for what photographers call a "lens hood.") The problem can be dealt with, but it does demonstrate the greater challenge to the astrophotographer posed by cold temperatures. There is a serious need to dress warmly and not be dissuaded by any comments about looking as though we are going to the Arctic. And on very cold nights we may feel like moving around, stamping our feet or beating our arms to help the circulation – but not during a lengthy time exposure, because of the resulting vibration.

We humans compound natural problems. Urban areas of many countries are swamped by *light pollution* which makes astronomical observing difficult if not impossible, and astrophotography often even more so. As citizens ourselves we understand the need for much of this lighting. But as astronomers we may be forgiven for looking quizzically at the bulk of streetlights, which are designed in such a way that they direct almost as much light upward (and uselessly) as they do downward, where it is wanted. There are many other contributors to light pollution: the bright neon advertisements which are seen by few human eyes during the small hours; floodlighting of sports grounds, buildings and car parks; lighting at shopping precincts, industrial plants and filling stations; and security lighting, on both commercial and domestic premises. In towns we no longer have a dark sky – it is all too often an orange–grey. Attention has been drawn to the inefficiency and waste of energy resulting from badly designed lighting, as well as to its damaging effect on astronomy, by principally the International Dark-Sky Association and its national affiliates. Significant gains have been made, but it is a hard struggle. In the short term, we may have to be prepared to travel to find a dark sky.

Even in our own gardens and backyards we cannot be apart no matter how we try. As we endeavor to photograph an intriguing conjunction of Mars and Jupiter, we may wonder why the image suddenly begins to dance and break up. Then we realize that the Earth's rotation has brought the two planets directly above the chimney or flue of a nearby house. Perhaps we are in the middle of a lengthy time exposure when a neighbor opens the kitchen door and a bright light imperils both the exposure and the dark adaptation of our eyes. And who can blame the neighbor's dog, on its final inspection tour of the garden, for reacting noisily to the suspiciously muted sounds being made by the astrophotographer on the other side of the fence?

Eventually the sounds of the day's activities begin to fade. Perhaps a cat is delighted to find that somebody is in the garden at an unlikely hour, and comes over to enjoy a pat. Later, one may hear the unmistakable shrieking barks of a fox, or a faint snuffling sound which is puzzling until a family of hedgehogs is located by torchlight/flashlight. Of course, there is need to concentrate on the work in hand but the small

hours are a time for philosophizing, too, particularly if one is alone and not working with a companion or group (not an occupation for the nervous, perhaps). One might deliberate on the apparent superficiality of civilization, and on how easily the sounds and semblance of everyday life disappear as the night gets deeper.

Astrophotography is not for those who cannot resist the comfort of retiring to a warm bed, nor for those unprepared to rise from one during the night. These are the disciplinary demands of the calling: if an astronomical event occurs in the early hours then the staunch astrophotographer must be up to record the event – unless, for the lucky few, automated equipment is left on patrol. Similarly, in areas where the weather is fickle we must strive to be resolute and photograph an object of interest as soon as the weather allows. To put it off because there is something of interest on TV reveals that we are not made of the "right stuff."

Yes, astrophotography and some philosophizing go hand in hand, and we realize our vulnerability to Murphy's law, which is usually referred to by astronomers as Spode's law. This states not only that if something can go wrong it shall, but also that it shall go wrong in the worst possible circumstances. Thus a lengthy time exposure will be ruined by a cat knocking the tripod (or the astrophotographer sneezing and hitting it with an arm), not at the beginning of an exposure but just before the end so that the maximum amount of time is wasted. Similarly, if due care is not being taken, it will be at the end and not the beginning of a session that the astrophotographer will discover an equipment malfunction.

When this slightly tongue-in-cheek account of the astrophotographer's world is read by likely recruits, there is a chance that they might be dissuaded from attempting to enter it. (It could have been even worse: the saying that the average success rate in astrophotography is perhaps one in twelve or twenty-four exposures if the photographer is very good, or lucky, has not been mentioned!) This would be a great pity. It is true that to do reasonably well and to progress, even in the early stages of astrophotography, requires application and a systematic approach – qualities not to be found in the casually interested or those who wish a subject to be "easy." But what enjoyment is there, and what sense of achievement, in practicing what is easy?

For those willing to make the effort, to learn from mistakes, and to suffer the inevitable consequences of Spode's law with fortitude and a sense of humor, the rewards and enjoyment are great. There is above us a magnificent panorama, and to seek to capture parts of it on film or digitally is a task of endless challenge which makes the successes all the sweeter. This book is intended to help you if you wish to take up that challenge. If you are a photographer already your experience will be of some help, even though astrophotography is "another world." Read on ...

Equipment

The camera

It is as well to state the bad news first. "Throwaway" cameras, together with compact and completely automatic models, all of which have been so successful in recent years, are totally unsuitable for astrophotography. This is because they have no B shutter setting to permit the manually controlled time exposures that are such an essential part of astrophotography. (The B stands for "bulb," the pressure device with which the shutter was originally controlled.) This sweeping statement is slightly unfair, in that it is possible to use this type of camera loaded with fast film to photograph a pictorial sky scene at twilight, featuring perhaps clouds with the Moon and very bright planets. But this is the extent of their capability, and they cannot be regarded as of sufficient importance to warrant inclusion in an analysis of suitable cameras.

Today's ordinary, keen photographer has three basic types of camera from which to choose. In the *single-lens reflex*, the subject is viewed through the lens itself by means of a mirror, which is flipped out of the way at the moment of exposure. In the *twin-lens reflex*, one lens is used to expose the film, while the photographer views the scene via a second lens, usually located above the first. With both these types the photographer sees the image focused on to a large glass viewfinder screen. With the third type, the *rangefinder* or non-reflex camera, the photographer views the scene not via a lens but directly through a viewfinder frame. The second and third types were introduced long before the single-lens reflex became available.

Now, as far as astrophotography is concerned, the rangefinder camera can be employed at least for star photography. Similarly, a twin-lens reflex would be suitable for photographing constellations, and its right-angle viewing system would have the added advantage of making things more comfortable for the photographer (see page 31). However, a basic limitation of both types (with one or two exceptions, such as the Leica rangefinder cameras) is their inability to accept interchangeable lenses. It is this feature that over the past decades has led to the overwhelming popularity of the single-lens reflex, commonly known as the SLR. In some ways this name is inappropriate because the camera's major feature of accepting interchangeable lenses really makes it a multiple-lens reflex.

This versatility means that, using different lenses, the photographer can record very extensive constellations at one extreme, and high-quality close-ups of the Moon at the other. This facility may not be quite as essential as the B shutter setting, but it does enable most areas of astrophotography to be explored. Moreover, the versatility of the SLR and the fact that the best models are the basis of an entire system of

photography that can accommodate the increasing skill and interest of the enthusiast make them the optimum choice for the astrophotographer. Medium-format SLRs (cameras using a 70-mm or 120-mm size film roll) are available as well as 35-mm models, but since they are regarded for the most part as cameras for professional use, this discussion will concentrate on 35-mm models.

It may be that some readers of this book are considering buying a camera. There are at least three options, depending on how much money is available. The first is to purchase as new one of the lower-priced SLR models offering a reasonable number of the features that are available on the more expensive models. Such cameras are usually robustly built, have the great advantage of not being automatics nor being dependent largely or wholly on battery power and may be regarded as the next step for the developing photographer. Various models in the Russian-built Zenit range are good examples of this type. The Zenits have the further attraction of being available often in a kit form which includes an adapter with which the camera is fixed to a telescope and also a cable release.

The second option is to purchase a used model of one of the leading makes from a reputable dealer. There is a need to select carefully, but in this way an excellent camera providing most of the features required, plus an extensive range of lenses and other items, may be purchased at a cost considerably below new. Cameras made by the likes of Nikon, Canon, Olympus, Minolta, Practika, Contax and Leica come immediately to mind. Some models will have been discontinued and the attraction of a number of these is that they will not be largely automatic models and will therefore possess mostly mechanical functions. Classic examples of such cameras will be readily recognized by older, experienced photographers – Nikon FMs, Olympus OM-1s, Canon F1s, SRT-101s from Minolta and not to forget the Pentax K-1000.

The third possibility, of course, is to buy as new one of the latest models from a leading manufacturer. Clearly there will be differences of quality between the cheaper and more expensive models too, although this may not always be readily apparent to the newcomer. The choice is one for the individual, and must reflect personal circumstances. There is, however, one encouraging aspect, whatever choice is made. Although the purchaser may have astrophotography very much in mind, these cameras are suitable for most forms of photography and so are likely to be used extensively. And, should the individual regrettably decide to give up astrophotography or photography altogether, the appeal of the cameras is such that a ready market should be found for them.

Many of today's cameras have automatic exposure systems, but, while possible uses here and there are mentioned occasionally in this book, effectively they play no part in astrophotography. The nature of

most astronomical objects is such that automatic exposure systems, although extremely sophisticated in dealing with the great variety of everyday subjects, cannot cope. (Hence the reference above to the suitability of older and, by definition, manually operated cameras.) One other feature of many current cameras is a dependence to a greater or lesser degree on battery power to perform various functions, especially to operate the shutter. This is an important consideration for the astrophotographer, since long exposures will often be employed, and continual use of the B shutter setting drains batteries faster than normal shutter speeds. Some very advanced and successful makes of camera are totally dependent on battery power for all functions.

Such dependence on batteries creates a phobia in the minds of some photographers about the total failure of a camera at a critical moment (Spode's law again). This fear seems somewhat exaggerated, for all that is required is care in ensuring that spare batteries of the right type are always carried. (A more serious problem is the possible drop in battery power caused by low temperatures.) In any case, some models offer a flexibility in shutter operation. Thus the Canon F1N has a hybrid electromechanical shutter mechanism in which the B setting can be mechanically operated without battery power, and the Nikon F3 has a mechanical shutter release which also provides a time exposure capability.

Clearly, a detailed review of this subject is not possible here, but it is a point for consideration by those contemplating a camera with astrophotography principally in mind. The above reference to the mechanical or non-battery operation of the B setting should not be confused with the manual operation of a camera's exposure controls – that is, the ability to switch from an automatic exposure mode to a manually controlled mode. Most moderate to expensive 35-mm SLRs have this facility, which, as already stated, is essential for astrophotography.

There are a number of other features of a camera which, although not essential, are highly desirable. In everyday photography, the 35-mm SLR is typically used at eye level, the subject being framed through the camera's viewfinder. In general this is a comfortable position for the photographer and involves no strain. An important item of equipment for the astrophotographer is a tripod, upon which the camera is mounted and may then be pointed at varying angles toward the sky. However, tripods usually extend to no more than about a meter, so the photographer has to bend to view the scene through the finder, the more so if the camera is aimed at or near the zenith. This is more troublesome for tall people and those with any back problems. Some means of viewing the sky by looking down toward the camera (as an astronomer uses a star diagonal at the telescope) will therefore be a great advantage for all astrophotographers.

What is possible will depend on the particular camera system in use. On some cameras from which the standard viewfinder cannot be removed, a right-angle finder can be attached. This has an inevitable effect on the amount of light being transmitted to the eye. More preferable is to use a camera with a removable viewfinder, and to replace it with one of the various forms of *right-angle viewer* that are available (see Figure 3.1). These can be as relatively simple as what is normally called a waist-level finder, where one looks down at the camera viewing screen via a small magnifier which facilitates focusing, to more complex units affording greater magnification with individual eyesight adjustment. The system chosen must depend on camera type and the individual's purse, but both back and eyes benefit from the use of such a viewer and the results achieved can only be better. One feature of many right-angle viewers that may be disconcerting at first is that they reverse a scene from left to right. This can make the task of newcomers, trying to find their way among the constellations, just that little more difficult.

Also desirable is the facility to change from the normal viewing screen supplied with an SLR to one more suitable for astrophotogra-

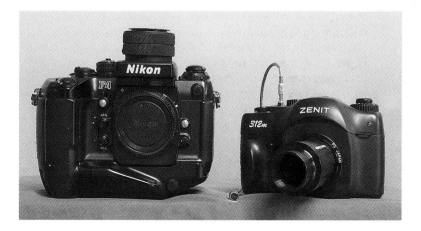

Figure 3.1 *Two single-lens reflexes. The Zenit 312m camera at right is a modestly priced camera often sold as a ready-to-use kit for the beginner astrophotographer. Here it is seen with its standard lens removed and with an adapter for mating it to the end of a telescope fitted. A cable release is also in place. The Nikon F4S at left is an advanced instrument (now discontinued) which has many features that cannot be used in basic astrophotography. However, the right angle, 6 × magnification viewer shown is of great value at the telescope, as is the extremely smooth operation of mirror flip-up and shutter found in a camera of this quality.*

phy. Focusing at very low light levels can be difficult, particularly when long lenses are in use, and in photography through a telescope. The screen pattern and central rangefinder disk on many everyday viewing screens serve no purpose in astrophotography. Two interchangeable screens are of value. When starting out, constellations and stars will be the most frequent subjects and an uninterrupted, fine-ground matte screen is the most suitable. In tackling subjects like the Moon or the planets at high magnifications, a screen with a central clear spot and a cross-hair for use in parallax focusing is an advantage. In parallax focusing the eye is moved very slightly from right to left and back again, and if the cross-hair stays in the same position relative to the subject then the latter is in focus. It is a technique that takes some getting used to, but is most effective when learned.

Two other camera features are valuable when working at slow shutter speeds. Exposures longer than a few seconds present no problem if the black card technique (see Chapter 5) is used. However, between such lengthy exposures and very fast ones is a no-man's-land where the results are highly vulnerable to camera shake and vibration. In these cases, the ability to lock up the SLR mirror, which always creates some vibration when it flips out of the light path before the shutter is opened, is most useful. The self-timer (or delayed action release), which enables the shutter to be fired after a period of a few seconds, is also of value in that its use removes the possibility of actions by the photographer causing the camera to shake, even when a cable release is used.

Such features may appear somewhat over-elaborate, but they can play a definite part in the quality of results. Most are present on top-quality cameras, and it is appropriate that anybody planning a purchase with astrophotography in mind should be aware of the possibilities, though personal budgets may well limit the options. There are other features too. Many cameras now offer slower, manually set shutter speeds from 1 to 8 seconds, several going up to 30 seconds. This reduces the emphasis on using the B setting. A few cameras, such as the Nikon F3 and F4, have a mechanical (non-battery powered) T setting – the T stands for "time" – which performs the same function as B but does not require the use of a cable release. Instead, the shutter is fired and stays open until the shutter speed ring is rotated to another value. Other cameras have a switch enabling the double-exposure prevention device to be overridden, which is helpful when you are making multiexposure images of the Moon and Sun. *Data backs*, which print the date, exposure data, or reference numbers on or between frames, are growing steadily more popular. And, while normally costing a little extra, the choice of a totally black finish to the camera is well worthwhile because it helps to suppress reflections,

whether one is engaged in photography at night or perhaps the subsequent photographic copying of originals.

Photographers tend to take a great interest in the technical explanation of how photographs were obtained. In this book, therefore, considerable detail is given about equipment and films. I have for many years been a user of Nikon SLR camera systems, and have found that they meet virtually all my demands. Nikon is a leader in SLR photography, but there are a number of cameras from other manufacturers that are capable of yielding similar results. A review of pictures published in the astronomical press will give information on what cameras are used. Ultimately, it is a matter of individual choice.

Lenses

Just as it is possible to give only limited guidance on camera choice, so it is for lenses. In the final count it is the picture a lens helps to create that is the crucial test, and that test involves a combination of other factors – film, exposure, conditions, and so on – which can either enhance or limit the performance of any lens. With that in mind, it is possible to offer some general observations on the lens in astrophotography.

First and foremost is the fact that astrophotography presents what is arguably the most severe test possible for a lens. All lens systems have potential aberrations which designers endeavor to limit by means of compromises that vary according to the type of lens. Astrophotography tends to press these compromises to the limit. During our first attempts at photographing the stars, we endeavor to "snatch" pictures by using a very fast film with a fast lens set at its maximum aperture. When an everyday photographer uses a lens in this way it may well be to capture a nighttime or available-light scene containing varying blocks of light and shade, and probably "busy" subject matter, to draw the eye. Lens aberrations will be scarcely noticed.

In a constellation image, however, there is only a dark sky with points of light, and any distortions will be revealed very clearly. When a fast lens is used for star photography there is almost certain to be some *coma*, in which points of light are spread into trumpet-shapes, and possibly *vignetting*, a darkening of the image toward the edges of the field of view. In the same way, most lenses in everyday photography yield their best performance when stopped down two or three stops from full aperture, whereas the astrophotographer often wants maximum speed. One or two lenses, such as Nikon's 58-mm f/1.2 Noct-Nikkor, have been designed for optimum correction of coma, but they are very expensive. So, for the most part, we have to make the best of what are often excellent products used in the most disadvantageous way. Various ways of endeavoring to do this appear in the pages of this book.

A second observation is a corollary of the first. In reviews of a lens, it may be stated that laboratory tests showed the lens to be capable of resolving so many lines per millimeter – one of the recognized performance standards. That information is worth knowing, but we must remember that for astrophotography the lens is not going to be used in optimum circumstances, and certainly not in a laboratory. We need to know about such factors as flare (internal reflections) and edge definition when the lens is used at maximum aperture, not in an "empty" performance under ideal conditions – although all these factors may point to the same conclusion.

The Japanese in particular have developed a flourishing industry of independent lens manufacturers as distinct from camera manufacturers making their own products. Newcomers to photography always ask for advice about this matter since the independents' prices are usually (although not always) lower. Generalizing is difficult, but I feel that in the main we get the lenses that we pay for, though the differences may not be readily apparent. Thus, in general use a lens designed and made by a leading camera manufacturer and one made by an independent may not seem to differ in optical performance. But it is more than likely that the mechanical strength of the former's lens will be superior, enabling it to withstand rougher treatment, and that optically it will have the edge when used under the most demanding circumstances – which certainly occur in astrophotography.

More specific suggestions can be made about the most suitable focal lengths for use in astrophotography. For recording the constellations, a normal 50-mm focal length lens, which the everyday photographer is likely to have already, is perfectly satisfactory, though a somewhat wider-angle lens of around 35 mm will be needed for more extensive constellations (see Figure 3.2). Notwithstanding the potential aberrations, the lenses should be as fast as possible. At the other extreme, photography of the Moon and Sun really demands longer focal lengths, and a 500-mm mirror-reflex lens, which is smaller and lighter than conventional designs, is an admirable starting-point, even if it is of fixed aperture.

While there are many bargains available, our pockets are not limitless, and perhaps three lenses will be the most that many of us can afford. In that event, a strong case can be made for the third lens being a moderate focal length zoom lens, say from 35 to 105 mm or perhaps a slightly more extended 20 to 120 mm. These lenses have improved greatly in quality in recent years. While not as fast as standard lenses, they are by no means slow. They provide a flexibility, when used with higher-speed films, which is valuable when photographing what might be described as the more pictorial scenes, such as the Moon and planets at twilight with interesting foreground detail.

Figure 3.2 Three lenses which should encompass all of the uses an astrophotographer could contemplate. All are Nikkor lenses. At left is a 35-mm f/1.4 wide angle, which is valuable in constellation photography and for recording conjunctions of planets when they are widely separated across the sky. The f/8, 500-mm focal length mirror-reflex lens at center is used to record good-sized disks of the Moon and Sun (the latter with appropriate filters in place). In addition it is a relatively small and light lens which can be used for many other purposes, such as sports and bird photography. The lens at right is a 35–105-mm f/3.5 zoom. It is not always possible to transport a battery of lenses, and a zoom can be valuable because of its versatility. In previous years their quality could be suspect but that is not the case today.

As with cameras, the use of these and other lenses is not limited to astrophotography. The wide-angle, fast lens may be used for "slice of life" candid photographs, while the long lens can be used for bird or sports photography. There is no need for the lenses to be idle between sessions of astrophotography!

Accessories

There is an old saying in photography that a camera should never be hand-held at a shutter speed slower than the reciprocal of the focal length of the lens in use. This is a rather involved way of stating that if you are using, for example, a 200-mm focal length lens, you should place it on a tripod for any shutter speed slower than 1/250 of a second (the nearest to 1/200). This sound advice, well supported by experience, indicates that in astrophotography a tripod should always be used.

Manufacturers have devoted considerable attention to developments in the design and construction of tripods and tripod heads in recent years, with units made of aluminum and carbon fiber proliferating. Usually lightweight, they are versatile enough to deal with most photo-

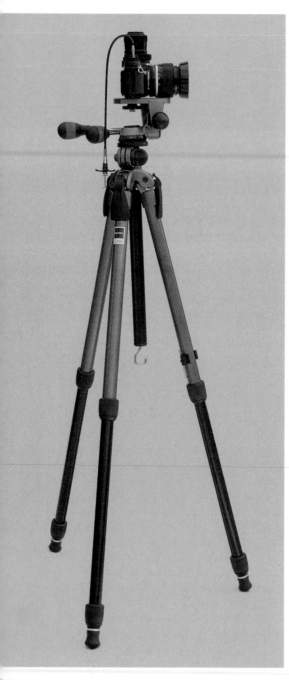

Figure 3.3 *A tripod is vital for virtually all astrophotography until one reaches the stage of mounting the camera on a special drive or the telescope. The tripod must be firm and be able to bear the weight of long and heavy lenses without "whip" and without the head of the unit where the camera is fitted sagging or moving. Contemporary materials such as carbon fiber have greatly improved the strength:weight ratio of tripods. The Gitzo model shown here is composed of carbon fiber and while able to bear considerable weight well is itself only 2 kg in weight. The handles of its three-axis head can be seen just beneath the camera. This tripod is a general purpose model and is one of a rapidly growing number in which the camera head is mounted on a central boom which can be moved in virtually all directions to facilitate the photography of objects that are low down or in other awkward positions relative to the tripod.*

graphic tasks. However, the extreme demands of astrophotography – the frequently lengthy time exposures, use of long focal length lenses and of "in-between" shutter speeds (see page 32) – all demand the minimum of whip or movement in a tripod and therefore a hard scrutiny of any modern lightweight tripod that one is contemplating purchasing. Some will pass the test, and their portability will be an attractive bonus. However, while it would be wrong always to equate rigidity and firmness in a tripod with weight, and there might be a price to pay in lack of portability, there is a temptation to advise that if a second-hand professional tripod of considerable weight can be found at a reasonable price then it would be a useful investment in the quality of the end product – the image.

One detail in particular should be checked when buying a tripod. When the camera is fixed to the tripod, is it possible to angle the camera platform so that the lens points directly upward? This facility will be needed from time to time, and various handles and other projections on some designs of tripod make it very difficult or impossible to aim the camera at an elevation of 90°. If a tripod is otherwise satisfactory, the problem can be overcome by attaching a heavy-duty ball-and-socket head, but it is obviously an advantage if this further item is not required.

Various types of cable release are available. (As already noted, one is not required if the camera has a T shutter setting.) They differ chiefly in the manner in which the cable is locked, the size of the plunger head, and their length. The release is one item which is essential for the astrophotographer but yet is not costly – a pleasant change.

The everyday photographer, particularly if an enthusiast, is likely to use filters quite frequently. It is my experience, however, that they play a far more limited role in the early stages of astrophotography, although they come into greater prominence later. Early on, it is sound policy to regard a filter as constituting two more surfaces through which an already limited amount of light has to pass, and therefore as something to be dispensed with. (Every time a light beam encounters a surface, it becomes a little weaker.) An exception might well be a deep-red filter to reduce the effects of light pollution when using black-and-white film.

There is one final observation to be made. It does not concern astrophotography only – indeed, it concerns all photography – but it is still worth making in this context. Manufacturers of cameras, accessories and films publish instruction booklets and leaflets. They have an obvious, commercial incentive for customers to derive the greatest value from their products. Usually the instructions are extensive and extremely helpful in using, and exploring the potential of, the products to the full. All too frequently, however, photographers pay scant attention to the information supplied with what can be a very expensive purchase. This is short-sighted, and limits the development of the individ-

ual's skill. Get out the instruction booklet for your camera again (can you put your hand on it immediately?), and read it. It will be very surprising if you can say that you know it all.

Non-photographic items

In the early years of photography there was no sophisticated shutter mechanism. The sensitized paper or plate was so slow that the "artist" used a hat or lens cap to uncover the lens for an exposure that ran into many seconds. For lengthy time exposures the astrophotographer imitates the early pioneers by using a large black card, which may be cut from a box in which photographic paper is supplied, or something similar. The technique is elaborated in Chapter 5.

A white-light torch/flashlight is useful for checking the observing site for obstructions before a session, and to make sure nothing is left behind afterward. The provision of a red-light torch needs a little more explanation. Our eyes' capability of adapting to darkness has already been explained, in Chapter 1. In working around our camera, altering its controls and making notes, we need some light. However, the light from an ordinary torch would appear blindingly bright to our eyes and, of course, ruin our dark adaptation, which it will take time to regain. It so happens, however, that the dark-adapted eye is least sensitive to red light. So, while a red light is sufficient for the astronomer's or astrophotographer's needs, it does not affect dark adaptation, or at least does so only minimally. Specialist astronomical stores sell red-light torches/ flashlights, but it is easy enough to locate a piece of dark red plastic about the house or toolshed. Bicycle rear lights are not recommended: they are efficient for their intended use, but tend to be far too powerful for our purpose.

The provision of an electronic timer (as opposed to the use of a watch) for carefully timing long exposures is a matter of personal choice. The advantages of the countdown timer of the type used in kitchens or photographic darkrooms are that the (usually) LCD time display is easily set by buttons or some other means, and an alarm sounds at time zero. A watch is smaller and therefore more difficult to operate, particularly when fingers are beginning to get cold.

Finally there are the notepad and pen, which are regarded so highly by astrophotographers. No guidance is needed on the former, but some of the generally available ballpoint and other pens deal poorly with the task of writing on paper that is becoming damp in the night air. A plastic cover could be used to prevent this, but I have found that the Fisher pressurized cartridge pens that became popular following their use by flight crews in the US space program write satisfactorily on damp paper. Doubtless there are other types. Of course, you may choose to avoid the dampness problem by using a small tape recorder instead.

Films

Some years ago the late Dr. Edwin Land (of Polaroid fame and a distinguished photographic scientist) commented that film was still in the stone age and was capable of great improvement. The quality of films generally has improved enormously since, partly in response to the challenge from digital systems, which are discussed in Chapter 15. The result is that today the amateur has a very wide range of high-quality color transparency, color negative–positive and black-and-white films from which to choose (see Figure 4.1).

Two points must be stressed before we proceed to a general consideration of films that are most suitable for the beginner in astrophotography. In part because of intense competition between the manufac-

Figure 4.1 We are extremely lucky in the numbers and different varieties of film that can be pressed into service in astrophotography. Since such generally available films as those shown here are primarily intended for a much wider market, some prove unsuitable and the features of others are changed at short notice in response to commercial demands. The sensible course of action is to test a film or films to establish which one does the job you want it to do best. A useful guide is provided by the quite frequent magazine reviews.

turers and in part because of the pace of technical developments, the films available can change in specification and their color reproduction characteristics very swiftly. On the one hand this means that, since the images in this book have been exposed over the course of a couple of decades or more, some of the film names appearing in the captions are no longer available. On the other, it means that it is pointless analysing in great detail the characteristics of films which are available at the time of writing because during the lifetime of this book the situation is almost certain to change considerably. Therefore it seems sensible to devote a table (Table 4.1) to recommendations of current films in the various categories that astrophotographers should consider testing but not to go into great detail about them. More usefully, most attention is devoted to general considerations of the demands made on film by the astrophotographer and the manner in which the best results may be obtained. In addition, study of the detailed captions in this book will give valuable information on how to fit different film types and speeds to particular subjects.

The second point concerns my personal attitude to the contending virtues of color transparency as distinct from negative–positive film (usually called "print film" for short) as it affects the budding astrophotographer. I consider that transparency film is the best color material on which to start experimenting. This may seem a little strange because negative films yielding color prints are the almost universal choice of the typical amateur, with transparency film trailing a long way behind. The reason lies in the nature of the subjects that the budding astrophotographer will be photographing. The typical photo-shop lab offers a good service in processing and printing films of conventional scenes. But a night sky with stars, an aurora, or a meteor trail crossing a starscape are not conventional subjects. What we are asking the lab to do is make a color print from a masked (orange) negative without knowing even the approximate color of the original subject. This is a difficult task, and the risk of disappointment is high. Thus, although color negative films are of excellent quality and yield good results, even when underexposed or, in particular, overexposed (their *latitude*, as it is called, is much better than that of transparency films), my advice is to stay with transparency films until experience has been gained. It has to be acknowledged that many advanced astrophotographers make considerable use of negative color film because of the options it offers them for subsequent darkroom manipulation (and now digital scanning and manipulation) but in the early days I believe that it is best to use a film that yields a positive color image once processing has been completed, without any further demands being made on photographer or darkroom worker. Nonetheless, negative films are included in the table.

TABLE 4.1 - FILMS

FILMS – COLOR TRANSPARENCY

| Manufacturer | Film speed | | |
	slow	medium	fast
Agfa	RSXII 50 RSXII 100	RSXII 200	*
Fuji	Velvia (50) Provia 100F Sensia 100	Provia 400F Sensia 200 Sensia 400	Provia 400F` (Push process to EI4800)
Kodak	Elite Chrome 100 Ektachrome E100S	Elite Chrome 200 Elite Chrome 400 Ektachrome E200 Professional	Ektachrome E200 (Push process to EI1000)
Konica	Chrome Centuria 100	Chrome Centuria 200	*

FILMS – COLOR NEGATIVE (print film)

| Manufacturer | Film speed | | |
	slow	medium	fast
Agfa	Optima II Prestige 100	Optima II Prestige 200, 400	Vista 800
Fuji	Fujicolor NPS160	Superia 200, 400 Fujicolor NPH400	Superia 800, 1600
Kodak	Royal 100	Royal 200, 400 Supra 400	Supra 800
Konica	Impresa 50 Centuria Super 100	Centuria Super 200, 400	Centuria Super 800, 1600

FILMS – BLACK-AND-WHITE NEGATIVE

| Manufacturer | Film speed | | |
	slow	medium	fast
Agfa		Agfapan APX400	*
Fuji		Neopan 400	Neopan 1600
Ilford		HP5 Plus, Delta 400	Delta 3200
Kodak		Tri-X (400TX) 400 TMax	P3200TMax

FILMS – BLACK-AND-WHITE CHROMOGENIC

Manufacturer	Name		
Ilford	XP2 Super		
Kodak	Professional T400CN		
Konica	Monochrome VX400		

This list is not comprehensive. Company web pages can be checked for full lists and notices of changes: http://www.agfa.com; http://www.fuji.co.uk; http://www.ilford.com; http://www.kodak.com (http://www.kodak.co.uk for Eastman Kodak in the UK); http://www.konica.com.

An "abnormal" use of color film

In Chapter 2 the point was stressed that astrophotography is "another world" – and nowhere is this more so than with films. Almost without exception, the films used by the amateur astrophotographer have been designed for normal use and for the reproduction of typical, everyday scenes such as flowers in the garden or people's faces, though obviously the faster films are meant for occasions when light levels are lower. The films are not manufactured so as to produce their best results in recording the frequently exotic objects that are the astrophotographer's subjects. One important aspect of this difference is the way in which the films are tailored to be used at shutter speeds between about 1/10 and 1/1000 of a second. Some astronomical subjects can be photographed at such speeds but most cannot, and this introduces an important problem (known as *reciprocity failure*) that will be discussed below, and mentioned quite frequently thereafter.

In choosing films for use in astrophotography there is a constant temptation to select materials that are very sensitive to light – fast films. Often such films are a necessity, for example when photographing constellations with a fixed camera. However, for subjects that do not require very fast films in the ISO 1000 range, a slower material should be selected. (ISO stands for the International Standards Organization, which devised the present system for rating film speeds: the higher the number, the faster the speed. The values are essentially the same as the older ASA ratings.) The reason is a simple one: all other things being equal, slower films yield better quality than faster films, and pictures exposed on them will be of higher definition and less grainy. While some photographers use fast films as a form of "one-upmanship," their results illustrate the truth of the photographic adage that we never get something for nothing. Fast films should be used with discretion.

The principal film manufacturers – including such names as Agfa, Fuji, Ilford, Kodak and Konica – between them offer an extensive range of products. Films rated at up to ISO 100 in speed can be described as slow, characterized by very high quality, good color saturation and lively contrast (the difference in density between the shadows and the highlights). Their use in astrophotography is limited to subjects where light is abundant, chiefly the Sun and the full Moon. Films between ISO 100 and 400 are now described as of medium speed, and are used where light is at rather more of a premium (for example, when photographing the crescent Moon). The quality of these films is still high, but, because of their increased speed, the images are grainier and of lower resolution and contrast. The third group of films, introduced in relatively recent years, attain claimed speeds of ISO 1000, 1600 and even 3200. Their far greater sensitivity to light

results in yet lower resolution and contrast and higher graininess, as well as what might be described as "background noise" ("fog," in photographic terminology, which is the inherent density found in an unexposed but developed film). Typically, these are the films that newcomers to astrophotography will use with a fixed camera to capture images of the constellations that are free from star trailing caused by the rotation of the Earth (see Chapter 8).

Reciprocity failure

In general, the slow- and medium-speed films are exposed using shutter speeds not too dissimilar from those of everyday photography. But when they and the ISO 1000-plus films are exposed for periods longer than 1 second, then reciprocity failure must be allowed for. Theoretically, similar amounts of light should affect a film in the same way, whether the light arrives over a short or a long period of time. For instance, half the amount of light for twice the time should have the same effect as twice the amount of light for half the time. This is an example of what is known as a linear effect. Unfortunately, it does not work like this with photographic film. Because of low-intensity reciprocity failure (we need not worry here about the high-intensity form), lengthy exposures have to be far lengthier. The reason for this is complex, but can be explained by an analogy. In a normal person-to-person conversation in a room, each participant will have little problem in comprehending and remembering what is being said. However, if they are at opposite ends of a hall, and one is speaking very quietly and only at infrequent intervals, it will be difficult for the other person to hear what is being said and to maintain a high degree of attention for very long. In this case, the message will take longer to get through and to register.

Manufacturers tend to supply more data about reciprocity failure for their black-and-white materials than for color, but these data nonetheless give a useful indication of the effect. Thus Kodak recommends no compensation for shutter speeds of up to 1/10 of a second for a wide range of its black-and-white films, but longer exposures have to be compensated for. In the case of an indicated exposure time of 100 seconds, either the aperture should be opened by three stops, or the duration of the exposure increased to 1200 seconds – from less than 2 minutes to 20 minutes!

Color film suffers from a major additional difficulty with lengthy time exposures in that it basically consists of three layers sensitive to the three primary colors – red, blue and green. These layers are carefully configured so as to provide a natural color balance over the normal exposure range. However, once that range is exceeded the balance can break down and the colors go wildly astray. One or two of the film man-

ufacturers give guidance both on the filters that will correct gross anomalies of this kind and on the number of stops extra exposure that should be given, but one gets the distinct impression that they are much happier when exposures are no longer than a few seconds at most. Out of necessity, astrophotographers take little notice of the advice!

This may begin to sound very forbidding. In practice, though, at least some of the films perform well, and indeed far better than we have any right to expect, when subjected to circumstances for which they were not designed. The exposures likely to suffer from the effects of reciprocity failure are, as indicated by the figures above, those of a few seconds – shots of lunar eclipses or aurorae, for example – up to constellation photography lasting many seconds or, when using a manual guider (see Chapter 8), some minutes. Lunar eclipses and aurorae are likely to be less frequent subjects for the newcomer's camera, and reliance can be placed on bracketing to achieve a satisfactory result, but constellation photography is another matter. For this you should test the leading high-speed films to see how they perform against one another. Take care to see that tests are soundly based. Factors over which you have control should remain constant: for example, use identical photographic equipment and operating procedures. But other factors, such as the seeing, can vary considerably, even over a short period of time. As far as possible, like must be compared with like.

The test program may be shaped according to the exposure times indicated in Chapter 8: stepped from, say, 10 seconds, through 20 and 30 seconds, to 1, 5, 10, 15 and 30 minutes. Always bear in mind the need for minimum possible light pollution: go out into the country if you can. For exposures of this length there is little published information on reciprocity failure, and we have to find out for ourselves how a film performs under our particular conditions. To unravel apparent differences in film speed from the differing reciprocity characteristics is time-consuming, but in fact is unnecessary since in the end it is the films' overall performance that we are judging one against the other. Color quality is largely a matter of subjective opinion at this early stage, although as experience is gained one's opinions on how well a particular film renders astronomical objects becomes better informed.

Maximum density and "push-processing"

A critical element in color acceptability for the astrophotographer is the appearance of a film's maximum density. This is normally referred to as *D-Max* for short. Strictly speaking, D-Max is the density produced in those areas of a developed film that have been totally unaffected by light – for example, the borders of images and the ends of the film roll. However, for our purposes a film's D-Max

characteristics will have an effect on those areas of a picture that have received very little light.

Now, when designing a color film, photo scientists are concerned mainly with achieving the best possible rendering of the individual colors. When combined together in a processed image, the colors may not integrate to a neutral black D-Max. This does not matter much in everyday pictures, because we are not very interested in shadows and do not look at them closely. But in a constellation picture exposed over a relatively short period of some seconds, and with a good-quality dark sky unaffected by light pollution, the maximum density will appear over a large area as the sky between the stars. Any marked color bias in a film's D-Max will then be obtrusive and even objectionable. Over the years I have found films that had an entirely acceptable bluish black D-Max, a moderately acceptable brownish black and a horrible green-biased black. I must stress that it is for the individual to undertake tests and to make a personal choice on the basis of those tests, not my opinions!

Push-processing is much in vogue in color photography generally, and astrophotographers are among its keenest proponents. An outline of color film processing is given in Chapter 13; suffice it to say here that, in the case of transparency film, an effective speed increase can be secured by extending the first stage of development (which develops the silver image). This is because reversal material is processed first to a negative and then to a positive. In a reasonably exposed transparency the shadow densities are considerably less dense than the D-Max, and the full density potential of the material is not used because when projected the picture would appear too dark. However, if the film is exposed at double the nominal rating, more shadow detail (that is, a higher density) is recorded. Because it is a reversal film, if the first development stage is then extended, all the exposed areas (including the shadow areas) are lightened – not darkened, as happens with negative film. So an effective speed increase results. This is not the case with traditional black-and-white films, as will be discussed a little later.

Once again there is a price to pay: graininess increases and the color balance can shift. Nonetheless, push-processing is a technique that can be used to advantage in reducing lengthy exposure times. You may find in certain cases that quality seems very little affected. The film's characteristics have now altered, but I remember an occasion some years ago when I wished to use an ISO 400 rated film. Instead, I used ISO 200 Ektachrome in preference to the ISO 400 equivalent, and push-processed to achieve the higher speed rating. I considered the resulting transparencies to be of better quality than those produced by the higher-speed film.

Newcomers to astrophotography are well advised to weigh up for themselves the various films available in the different speed ranges. Reviews in astronomy magazines are of considerable value (particularly as new and improved or modified films seem to be introduced with astonishing frequency) and can serve to reduce the list of films to be tested. But in the final count there is no substitute for direct experience. In general, frequently changing from one film to another is not wise since it will usually mean that the full potential of any single film is never properly established.

Sometimes, however, new developments can affect choice, both positively and negatively. For many decades Kodachrome transparency films tended to be the high-quality standard against which all other color transparency films were judged (although the speed rating was always low). The appearance some years ago of an ISO 200 version immediately made it a candidate for some astronomical uses previously denied this type of film. Then again, at one time a Fuji ISO 400 color transparency film was extremely popular with experienced astrophotographers, but the color balance of the film was subsequently altered by the manufacturers in a way which was doubtless an improvement for normal photography, but which was generally condemned by astrophotographers. Also, the 3M company used to make a high speed color film which had a greenish D-Max that I did not like at all. Subsequently, however, the company introduced a new Scotchchrome family of films with totally different characteristics, the ISO 400 and 800/3200 versions having an extended red sensitivity which I found excellent for photographing such objects as emission nebulae. Alas the film is no longer available!

In considering the performance of color films, there is one further point that needs to be made. When photographed, some astronomical objects appear very different from how they look to the eye. A classic example is the Orion Nebula (M42). The light from emission nebulae of this type is confined largely to two narrow wavebands. One of these is near the peak sensitivity of the human eye, which sees the nebula as a whitish or light bluish green. This waveband falls between the peaks of the blue- and green-sensitive layers of color film, but the other band, which is not seen well by the eye, records strongly on the red-sensitive layer. Hence the apparent discrepancy and we may choose which we prefer.

Black-and-white films

While color transparency film will doubtless appeal to many newcomers to astrophotography, black-and-white film has much to offer. Since the Moon is a monochromatic object it is best

suited to black and white, and extremely high-quality results can be obtained. On the grounds of cost, black-and-white film is a sensible choice for meteor patrol work and for recording the passage of artificial satellites, for which large numbers of exposures are necessary, and trails are measured direct from the negatives. It is also a good choice for early attempts at constellation photography, for there is no need to print the negative in order to assess one's progress.

What has been said about speed ratings for color transparency films applies also to black and white. Inherently an ISO 100 film will yield finer grain, higher resolution and contrast, and lower fog than an ISO 400 film. However, it is the latter speed of film that will be most used by the budding astrophotographer. As a result of new grain technology introduced by Kodak in the 1980s, it is necessary to identify two general groups of film.

Until the new-technology films were introduced, the workhorse ISO 400 films of professional and amateur photographers alike were Kodak Tri-X (recently renamed 400TX) and what is now called Ilford HP5 Plus. These were, and are, high-quality versatile films with excellent exposure latitude. In astrophotography and other uses the films can be push-processed, with adherents frequently claiming considerable speed gains. In fact, no speed gain is possible. The ISO speed of films of this type is fixed at the time of manufacture, and no amount of manipulation of exposure or development can alter it. The only leeway is the one-third-of-a-stop safety factor that most films incorporate, but this has so insignificant an effect as to be scarcely noticeable.

What has happened when a photographer claims to have increased the speed of a film such as Tri-X is that details in the shadow areas of a picture have been sacrificed, either because they were not considered to be important or because the contrast of the original scene was so low (for example, under fluorescent lighting) that there were virtually no shadows anyhow. But that does not constitute a genuine increase in film speed, and push-processing results in increased graininess, contrast and density overall, with overdeveloped highlights.

The reciprocity characteristics of Tri-X film are of obvious importance when one is contemplating lengthy exposures, and considerable increases in exposure time are needed. Kodak recommends that an indicated exposure of 10 seconds should be extended to 50 seconds, or two stops more, and one of 100 seconds to 1200 seconds – that is, 20 minutes – or three stops more.

New technology films

K odak introduced its family of T-Max films in 1986. Undoubtedly these represented a revolution in black-and-white photography,

and were quickly followed up by other manufacturers – for example Ilford, with its Delta film technology. The T-Max films are based on the tabular grain concept that Kodak first introduced with its color films. By providing a much larger surface area than conventional grains of the same mass, T-grains are able to "capture" more light and adsorb large amounts of sensitizing dyes and other chemicals. The result is fast films with the grain and resolution of medium-speed films, and medium-speed films with the image qualities of very slow films. Additional advantages for the astrophotographer are that the contrast of the T-Max films is considerably higher than that of Tri-X, the fog level is lower, and the reciprocity characteristics are much better. With 400TMax, for example, a nominal 100-second exposure need be increased only to 300 seconds (one-quarter of the Tri-X exposure time) or the aperture opened by one and a half stops (compared with three stops). With 100TMax, the recommendation is 200 seconds and one stop. Ilford's Delta films show a similar, better reciprocity performance, with a 35 second nominal exposure needing to be increased to 225 seconds or 3 minutes 45 seconds.

However, it is in push-processing that the new-technology films may be claimed to have had their greatest impact. The old photographic adage that you can't get something for nothing – that you cannot increase a film's apparent speed without losing quality somewhere else – is still strictly true. However, when it is used with dedicated compensating developers the quality loss in T-Max is so limited that the effective speed can be said to have been altered. This is why Kodak and other manufacturers do not quote ISO values (which are unalterable international standards) for the various forms of new-technology films, but *exposure index* (EI) values. When subjected to push-processing, the films do not build up extreme contrast or grain as do the older, conventional films. It is the development of photographic fog (density introduced by developing chemicals) that limits how far these films can be pushed, but fog does not set in before significant gains in speed have been made. Thus EI 100 films can take a three-stop push to a value of EI 800, and EI 400 films similarly to EI 3200, while the high-speed P3200 TMax can be pushed to a startling EI 25,000 and, some claim, even further.

Speed to suit the occasion

It has been necessary to describe the differences between the traditional and new-technology films at some length. But we should not be carried away by considerations of speed and push-processing. When photographing a full or gibbous Moon, for example, EI or ISO 100 films will be quite fast enough – as will 200 or 400 speed films for

the crescent phases of the Moon. With fast lenses it is doubtful whether a speed of more than 400 or 800 will be needed for early attempts at star photography. The important thing is to take matters slowly and carefully: with (conventionally processed) films of up to EI or ISO 3200 available, you may well see no point in following the enthusiasts of push-processing. Start out at ISO 100 or 400 for your chosen subject or subjects, and move up in speed only if the need appears.

What you will find is that the enthusiasts, in astrophotography as well as elsewhere, are so dedicated to their own favorite film and processing technique that any albeit innocent questioning or criticism is likely to be strongly rebutted. Nowhere will this be more so than in comparing the performance of the older, conventional films with the new – or in comparing the advantages of color transparency film with the negative variety!

Kodak Technical Pan 2415 Film is widely used by astrophotographers, but mainly for deep-sky photography of dim objects and for solar photography through the telescope, which are largely beyond the scope of this book. A brief reference to the film, however, is made in Chapters 6 and 15.

Finally, some readers may wish to test the relatively recently introduced chromogenic black-and-white films. These basically comprise a color negative material which yields a final dye image for black-and-white printing. It is generally agreed that in terms of grain, resolution and tonal scale the film is superior to any other in the same speed group when used optimally. Therefore a test with the Moon as the subject would seem to be eminently suitable. (I have conducted only limited tests with the films but my initial impressions have been favorable.) Since, however, liberties are frequently taken with films in astrophotography, and the special processing of this film as well as the making of prints from it is best placed in the hands of specialist laboratories (although it can be processed in standard color negative–positive C41 chemistry), the potential for the beginner might be limited. Ilford, Kodak and Konica all make this type of material (see Table 4.1).

It is appropriate to end this somewhat wide-ranging review with a final piece of practical advice. When color film is sent for commercial processing, it is vital to remember that laboratories have little experience of astrophotographs and their appearance. Constellation shots cause particular difficulty for operators trying to locate the dividing line between two frames, and your hard-won images may be returned inadvertently cut in two. The best way to avoid this happening is to shoot one or two everyday scenes at the beginning of the film. In this way, both automated color transparency cutting and mounting operations and negative film print production should proceed without problem.

Procedures

The chapters that follow this one concentrate on the photography of specific celestial objects. The manner in which a photographic session is planned and then conducted does not differ greatly according to subject, so to minimize possible repetition in later chapters, outline guidance is given here. Some of the comments may seem elementary but, taken as a whole, they constitute a sound basis upon which the inexperienced can conduct a session with good chances of success.

No vast amount of setting up is required in the initial stages of astrophotography, so we may quite frequently take a chance on the weather. Scattered fair-weather cumulus cloud, for example, should not dissuade us from attempting a program of Moon photography or, depending on the extent of the cloud, constellation photography. However, it is prudent to be aware of likely developments. If the local forecast predicts a warm front moving in, and a glance at the sky reveals extensive cirrus cloud already developing into cirro-stratus toward the horizon, then it would be sensible to postpone any astrophotography.

Similarly, one must be realistic about the potential effect of wind speed on attempts to photograph some targets. Long focal length lenses present a large area to the wind. When they are being used to photograph the Moon, for example – especially at the slower shutter speeds used for crescent phases or, even worse, during lunar eclipses – and it is windy, results are likely to be poor even with the camera mounted on a firm tripod. Quite moderate focal lengths can be affected over long time exposures, and it is a sound general rule to regard windy conditions as being unsuitable for most forms of astrophotography. You might, though, be able to shelter the camera and tripod in some way. Of course, the decision is shaped by events: few astrophotographers would put their cameras away during a major event such as a solar eclipse simply because a strong wind was blowing!

Combating the cold

Astrophotography during the summer months can be a great pleasure (even if at high latitudes night scarcely falls at all), but winter returns all too quickly. No program of astrophotography or observing can be carried out well if you are feeling very cold, so there is an obvious need to dress for the conditions. We are fortunate that cold-weather clothing has greatly improved in recent years. Wear numerous, light layers of clothes so as to trap air for maximum warmth. Thermal underwear should be high on the list of presents for astrophotographers. Remember the need to cover your head, through

which a disproportionate amount of body heat escapes, as well as making sure that your footwear has thick soles to combat the effect of standing on a cold surface for long periods of time. Lightweight padded snow boots (even though there may be no snow) are an excellent choice. Ordinary gloves will spend as much time off cold hands as on them when a camera is being operated, so wear the sort that combines open-ended fingers with a mitten-like cover which can be pulled up over the fingers. Of course, a flask of hot drink is very welcome during lengthy sessions in cold weather.

Dressing for cold weather is part of everyday life in many parts of the world, so there is no need to elaborate on it here. But the point needs to be made strongly for the benefit of newcomers to astrophotography that any idea of just slipping out for a few minutes to dash off one or two exposures is a prescription for misery and therefore failure. It will not be a few minutes, and as the ill-dressed photographer gets colder so the chances of any success plummet.

Preparations

For your first sessions in astrophotography it is a good idea to have an outline program, even if it is just a mental one or headings on a scrap of paper. Perhaps the aim is to photograph ten constellations over a couple of hours as they move close to the zenith, or to experiment with various exposures of the Moon on black-and-white film and compare the results. This is another facet of the systematic approach which has been highlighted already. It is wise, however, not to make the plan too complex or ambitious. Assume that things will always take longer than you think, and plan ten exposures rather than fifteen or twenty. However, have a reserve of targets so that more can be tackled if things do go well.

The planning should include consideration of the most efficient way of operating. For example, if the aim is to record a number of constellations with two lenses of different focal lengths, it is easier to record each constellation using the two lenses before moving on to the next, rather than photographing all the selected constellations with one lens mounted, and then having to repeat the series of camera movements for the second sequence.

With photography scheduled, it is sound to check that the equipment is in working order while there is still time to take corrective action – for example, when shops are still open. It is annoying to commence a session only to discover that the battery of the red-light torch/flashlight is exhausted and that there is no spare. The situation is even worse if it is a battery-powered camera that is affected. The most sensible policy is to maintain reserves of expendable items such as bat-

teries and bulbs, and to purchase replacements on a routine basis as soon as a replacement item starts to be used.

Whether the location initially chosen for astrophotography is in the garden or further afield, check on an earlier night that no lights will shine directly and continually into the camera lens. During sessions, ban all matches, lighters and white-light torches other than your own from the area. Finally, when you come to the actual photography, follow good, sound everyday photographic practice. Make sure the lenses are clean, because you need to capture as much light as possible from your faint targets. If you keep film in the freezer (so as to minimize the chemical changes that inevitably occur as the sensitized film ages), allow several hours for it to come up to room temperature before putting it in the camera. And make sure that, when loaded, the film is being taken up by the film wind (if it is, you should see the rewind crank arm rotating). An ultraviolet filter is often left on the front of a lens not so much for its filtration value, but as protection for the lens's front element. In astrophotography, a filter means two more surfaces through which light from a faint target has to pass, so any UV filter should be removed.

So, the evening is fair, the targets are chosen, and the spirit is enthused. Make a checklist of the items you need for the session. This may sound quite unnecessary, but if you have found a good, dark sky site miles away from home and you arrive there without an important piece of equipment, you will wish you had taken such a precaution.

Equipment checklist

1. Loaded camera, with one or two everyday pictures already exposed at the beginning of the film; lens(es); lens hood; cable release.
2. Tripod.
3. Planisphere/star maps. These will not be needed during photography of the Moon, for example, but are useful to have for identifying objects in the sky that you do not recognize.
4. Timer; black card.
5. Red-light torch; white-light torch.
6. Pen; notebook, with notes on intended targets.
7. Reserves of expendables, such as batteries. Take a second film in case the work goes extremely well, the evening continues fair, and you are inspired.
8. Although not essential, a small picnic table or broad-topped stool is useful as a surface on which to place items not in continual use and too large for pockets: black card, planisphere, lenses (be careful!), and so on. A light-colored surface facilitates finding the objects in the dark.

Before setting up any equipment on the chosen site, sweep the area (whether it is in the garden or elsewhere) with the white-light torch for any obstructions which in the dark could prove dangerous, or at least ruin an exposure as you trip and knock the tripod over. The white-light torch should not be used again until the session is concluded. Full dark adaptation of the eyes can take as much as an hour or so.

The procedure itself

The procedure to be followed during a series of exposures is much the same whatever the target, apart from the extremes of shutter speed that can be used. In the checklist that follows, it is assumed that a fast film is being used for constellation photography with a standard shutter speed of, say, 20 seconds.

Procedure checklist

1. Set the shutter to B. Set the aperture to maximum. Focus the lens on infinity (some people tape it at this position to prevent any accidental alteration). Check that the camera/tripod combination is firm and locked. Set the timer to a chosen duration (20 seconds).

2. Locate the object visually. Frame it in the viewfinder. (Remember that if a right-angle viewer is in use, the image is often reversed left to right, which can take some getting used to when trying to frame constellations.)

3. Place the black card in front of the lens but not touching it. Fire the shutter with the cable plunger and lock it. Wait 2 or 3 seconds for vibrations to dampen, and then remove the card carefully without touching the lens. Simultaneously start the timer. (Locking or unlocking the cable release while holding the card requires dexterity. Some cables make locking easier by using, in place of a threaded nut, a disk which is rotated in advance in one direction so that when the plunger is pressed the cable locks automatically. This still leaves the problem of unlocking the cable, an action requiring two hands, while holding the card in front of the lens. For relatively short exposures such as the 20 seconds assumed here, you can try firing the cable release and holding the plunger down rather than locking it. There is a risk of camera movement if the cable has no slack, but with care this technique can be made to work. Experiment, and judge the technique by the results you get. If the camera has a T setting, a cable release is not required – an obvious advantage.)

4. Hold the card in readiness well to one side of the lens as you observe the area of sky you are photographing.

5. When the timer sounds, place the card in front of the lens immediately. Unlock the cable release to end the exposure, and place the

card to one side. Cut the timer alarm and reset it to 20 seconds, using the red-light torch if the timer does not have an LED display. Wind the film on.

6. Make additional notes on the exposure. Most will have been written in advance, but any changes should be carefully recorded, as well as observations made during the exposure of, for example, any aircraft, meteor or satellite. (With a program such as this there is no need to cover up the lens during the passage of an aircraft and recalculate the exposure time – it is simpler just to repeat the exposure.)

7. Check the front of the lens for condensation (see page 58). Take care not to breathe when close to the viewfinder or lens, otherwise condensation will form immediately.

8. Check that the aperture setting is as required, that the shutter is still set to B, and that the focusing distance is infinity.

9. Return to step 2 and repeat the sequence.

The procedure checklist can be modified for shorter exposures. It may also require adaptation according to the features of the camera in use. If you feel the need, you can draw up your own list.

The problem of movement

The 20-second exposure time for star images assumed in the checklist above is long enough for the black-card technique to be used without it causing problems. But the technique cannot be used with the faster shutter speeds required in photography of the full Moon or Sun. The ideal here is to be using a camera in which the mirror can be locked up so as to remove another source of vibration, together with a self-timer that releases the shutter after a delay, thereby reducing any slight camera movement created by operating the shutter release cable. The delay introduced by the self-timer is several seconds, so the timer should not be used if we are trying to take advantage of a brief period of excellent seeing, which is likely to happen only in advanced astrophotography. If the camera does not have one or both of these features, then there is still a very good chance of getting satisfactory exposures with shutter speeds of, say 1/250 of a second or faster, even with long focal length lenses.

The risk of camera shake and vibrations causing "smeared" images is greatest with shutter speeds ranging from about 1/60 of a second to 1 second or so. These are the speeds used for the crescent Moon, eclipses and some conjunctions, and the problem is compounded when long focal length lenses are selected. Our reactions are nowhere near quick enough for us to use the black card at the faster end of this range,

and it is unlikely that its use will prove very satisfactory at the slower end (our actions occupy too great a proportion of the brief exposure), even though it must be attempted. One small advantage here, however, is that locking the cable is clearly not necessary (nor possible).

Once again, there is little fear of vibration when using a sophisticated camera that features not only a mirror lock but also a self-timer. Such cameras will usually have preset shutter speeds of 1, 2, 4 and 8 seconds (if no higher), so the shutter may be set to these values without using the B setting. It is a different matter for cameras without these features. In the absence of a mirror lock and a self-timer, the use of a bulb (or pneumatic) shutter release cable should be considered because it subjects the camera to less physical movement than a conventional cable does. Ensuring that the tripod is rock steady, choosing wider apertures to get faster shutter speeds, and possibly choosing a faster film (with somewhat inferior grain characteristics) to achieve even faster shutter speeds will all help to reduce vibration or its effects. If you need to use a shutter speed of 1 or 2 seconds and it is not available as a preset speed on your camera, then you will have to practice with the black card to gain as much proficiency as possible. It is impossible to generalize and there are no simple solutions, but something will have been achieved if you become alert to the problems of working in this speed range, especially with long focal length lenses, which exaggerate any image smear. A sound policy is to experiment and to establish the best results that can be achieved with various procedures.

The end of the session

At the end of the session there is continuing need for care. Check that the final exposure has been terminated and that notes have been completed. Never trust to memory! Although you may not have been using the camera's exposure meter system (if it has one), it may have become activated. If it does not cut out automatically after a set period, switch it off now. At this stage the dark adaptation of your eyes ceases to be important. Switch on the white-light torch and gather together all the items of equipment. Whether you are outside your own house or miles away, sweep the site with the torch and make sure nothing is being left behind.

The everyday photographer will not use the B shutter speed very frequently, and after the last exposure it is very easy to forget to unlock the cable release, thereby fogging the shot (and possibly one or two adjacent frames too) as soon as the camera is taken into a brightly lit room. So do that, and check that the film has been rewound. How many of us, at some time in our photographic careers,

have opened a camera back without checking that the film has been rewound? This is sad at any time, but doubly so when the pictures that are ruined represent minutes or even hours of effort in less than comfortable conditions.

When equipment is taken from cold, outside temperatures into a warm room, condensation immediately forms on all exposed surfaces. (Notepaper will have dampened anyway during the session; at home lay the sheets out separately so that they do not stick together as they dry.) It is best not to wipe the surfaces of equipment, but to leave them to dry in their own time overnight. The condensation probably does no harm, but it is natural to feel a little unhappy about expensive cameras and lenses being left in this condition. There is, however, a straightforward way of preventing it. What is needed is a large, clear plastic bag with a ribbed seal along the top, or even a plastic lunchbox, that will take the camera and lenses. Before you come indoors, place the camera with lens still fitted in the bag or box, and seal it. Indoors, condensation will immediately form on the outside of the container, but not on the equipment inside it. It takes some time for the temperatures to balance, and unless there is extreme urgency about the results it seems sensible to leave the camera and lens inside the container until the morning. As to when you remove the film from the camera, get into a set routine. Either rewind the film immediately after ending the last exposure (trying, if you are doing it manually, not to rewind all of the leader – see Chapter 13), extract it from the camera, and place it in a film can. Or, after rewinding carefully, leave the film in the camera until the morning, and unload it when the camera is removed from the plastic container.

The next day, or as soon as possible, all equipment should be checked and non-optical surfaces wiped over with a soft, clean cloth. Use a lens brush or an air puffer to remove any dust from the inside of the camera. Alternatively, use an aerosol can of air – but be very careful to hold it upright, and do not direct a powerful blast of air or propellant from a short distance straight at the focal plane shutter.

Most important of all, check the back and front elements of the lenses that were used during the previous night's session. Since the back element is protected by the camera body when the lens is fitted, it should rarely need attention, but dust, dirt and fingerprints can all too easily affect the front element. First of all, hold the lens upside down and use a lens brush or puffer to remove as much dust as possible. Take a lens tissue (not a spectacle-cleaning tissue, which usually contains silicone and can damage the surface and coatings of photographic lenses), fold it in half several times, and apply one or two drops of lens-cleaning fluid to the center of the pad. Starting at the

center of the lens and, holding the tissue at the edges, wipe in a circular motion outward. You may need to repeat this with a new tissue, but never apply lens-cleaning fluid directly to the surface of the lens because it could seep around the edges and into the lens barrel. As a test of how clean the lens element is, breathe on it. If the condensation evaporates evenly as a gradually diminishing circle, the lens is clean; if patches or spots show up in the condensation, start again. When all is well, replace the UV filter (if you have one) and the rear and front lens caps. All is then ready for next time.

Notes: learning from experience

The manner in which notes are made for a photographic session is a matter of personal choice. Table 5.1 shows how the essential information could be recorded on the page. You may prefer instead to use a small tape recorder for your notes. If you do, it would be wise to keep handy a copy of the note headings shown in Table 5.1 because it is easy to forget to record some of the details. An advantage of the tape recorder, of course, is that you will not suffer from damp paper. On the other hand, electrical devices and cold and damp conditions often do not go well together. It's up to you.

How the notes are used once the film has been processed and the results have been checked is also a matter of personal choice. I usually

TABLE 5.1 PHOTOGRAPHIC SESSION NOTES				
Date:	**Camera:**	**Lens:**	**Stop:**	**Film:**
Subject		Exposure begun/ ended	Shutter speed	Comments

Table 5.1 *A set of headings for recording notes during a photographic session. Some of the main headings can be made into column headings if, for example, different lenses or f-numbers are being used. Also, if you do your astrophotography from more*

than one site, you should note the location. The "Exposure begun/ended" column is useful if, in the absence of a data back recording the time (see page 32), an unexpected (and maybe even unobserved) event is recorded on the film.

transfer as much information as possible to individual transparency mounts or negative envelopes. I record subjects, camera, film and exposure information, together with date, on a plain piece of paper which acts as the cover of a plastic slide wallet, and keep the original notes in the wallet behind the title sheet. Filing by subjects is another approach. It really does not matter what system is chosen, nor how informal it is, provided information on previous successes and failures is readily accessible when you need it for planning another session. Of course, the coming of CCDs and digital cameras, together with home computers, has greatly facilitated the cataloguing of pictures and note taking (see Chapter 15).

Should "failed" images be thrown away? If they are utter failures (such as completely fogged frames), there is no point in keeping them. But if the images are just not very satisfactory, and indeed if they contain any information at all, keep them on file, at least for a few years. Every now and then unexpected celestial events take place and it could be that you were taking a picture of just the right area of the sky at just the right time. Spode's law decrees that this is the very frame you might be tempted to throw away. So think before you discard anything, because you might be able to demonstrate that the law does not always operate!

Combating dew

When air cools and reaches the critical temperature known as the dew point, water droplets condense on any surface at or below that temperature. All too often, despite the use of a lens hood, this surface seems to be the front element of a lens. A lens tissue can be used to remove the condensation but it will quickly re-form. A hair dryer used gently from a safe distance at intervals is effective, even during exposures, provided you and the dryer keep out of the field of view of the lens. But most hair dryers are powered from mains electricity/line current, which may not be available. A battery-powered lens heater is an efficient way of providing just enough warmth to keep the temperature of the front element of the lens slightly higher than that of the surrounding air.

Figure 5.1 shows a heater I have used. The minimum amount of heat required was estimated at 2 watts, powered by 6 volts, and the resistance was calculated at 18 ohms, according to the formula resistance equals voltage squared divided by wattage. The heater consists of a string of six $\frac{1}{2}$-watt, 3-ohm resistors in series to distribute the heat equally around the edges of the lens. A small hole is drilled through the side of a dedicated lens hood to take the wire from the power supply, with the resistors being positioned at intervals around the inside of the lens hood where they are held in place by short strips of electrical tape.

From Ohm's law, according to which current equals voltage divided by resistance, the current passing through an 18-ohm resistance operating at 6 volts is 0.333 amps, or 333 milliamps. Various types of power supply can be considered, but rechargeable nickel–cadmium batteries provide a safe and easily portable solution. A set of four C-type rechargeable batteries (nominally 1.2 volts) has been found to operate the heater for approximately 6 hours before recharging is required.

Materials
- C-type battery holder with snap-on leads
- Four C-type rechargeable nickel–cadmium batteries
- Universal battery charger
- About 2 meters (6 feet) of electrical wire, 16/0.2 gauge or similar, which is long enough to allow the battery pack to be placed beneath a tripod or mount out of the way. This wire is joined by a connector to a second wire about 20 cm (8 inches) in length connected to the resistors.
- Six $\frac{1}{2}$-watt, 3-ohm resistors
- Soldering iron and solder
- Electrical tape

Figure 5.1 A six-resistor lens heater with battery pack and battery charger. The resistors are mounted inside a dedicated lens hood which fits all lenses with a standard 52-mm front thread. The unit is switched on by simply joining the heater wire to the battery pack wire by a connector.

The Moon

In terms of the exposures required, the Moon presents the easiest task for the newcomer to astrophotography since it is a body reflecting light from the Sun – just as the Earth does. (The Moon does it very poorly, reflecting only 7 percent of the Sun's light, whereas the Earth reflects 36 percent, but the situation is directly comparable.) Photographing the Moon is thus no different in principle from photographing a sunlit terrestrial scene. Newcomers will feel very much at home with "lunar" exposures such as 1/250 of a second at f/11. It is natural to think of using color film when photographing the Moon, but the lunar surface is essentially grey. This makes it a prime target for black-and-white film, which also affords an opportunity to deal with some of the problems caused by extremes of lighting contrast on the atmosphereless Moon. Color, however, does come into its own during lunar eclipses.

Although the exposure times can be similar to those for everyday shots on Earth, the focal lengths required for meaningful photography of the Moon are very different. The Moon is one of the Solar System's larger satellites, with a diameter of 3476 km (2160 miles), and it orbits at a mean distance of 384,000 km (239,000 miles). From Earth it has an angular size of a little over $\frac{1}{2}°$, much the same as the Sun's apparent size. In terms of capturing it on film, this size is demanding. There is a useful formula for the approximate image size of the Moon produced by a lens mounted on a 35-mm camera:

lunar image diameter = focal length/100

(The denominator is actually 110, but 100 simplifies the mathematics and is good enough.) This means that every 100 mm of focal length will yield about 1 mm of Moon diameter on the film. So our "normal" 50-mm lens will produce an image 0.5 mm in diameter!

The result of using different lenses

The effect of this is illustrated in Figure 6.1. Pictures of the Moon were taken with 50-mm, 180-mm, 500-mm, 1000-mm and 2000-mm lenses, and the resulting images of the lunar disk have been enlarged by the same factor. While the Moon's image as recorded with the 50-mm lens is extremely small, even with enlargement, some of the dark lunar maria ("seas") can be distinguished. These details are much clearer in the image obtained using the 180-mm lens, in which larger craters such as Tycho in the southern hemisphere are discernible. Numerous craters are apparent in the 500-mm lens image and there are obvious, further gains with the two longest lenses.

The lens, as I have stressed, is only one factor in producing an image, and film is another, major component. Thus if we enlarge a 5-mm diameter Moon image five times and a 10-mm diameter image five times so that there is a fair comparison of lenses, it will be evident that the latter appears to be sharper because the grain structure of the film is less obtrusive.

However, a major reason why lenses of longer focal length give better results is their greater light-gathering capability, so we are back again considering lens diameters. If we limit the consideration entirely to the theoretical resolving power of the lenses, we can calculate their performances in arc seconds from the formula

resolving power = $114/d$

where d is the diameter in millimeters. A 50-mm $f/1.8$ lens has a diameter of almost 28 mm, with an optimum resolving power therefore of 4 arc seconds. The 180-mm $f/2.8$ lens can resolve 1.78 arc seconds, the 500-mm $f/8$ mirror lens 1.82 arc seconds, the 1000-mm $f/11$ mirror lens 1.25 arc seconds, and the 2000-mm $f/11$ mirror lens 0.63 arc seconds. Notice, incidentally, that it is not simply a question of focal length *per se*. The fast 180-mm $f/2.8$ lens has a diameter of over 64 mm, and so has a better resolving power than the 500-mm $f/8$ lens with a diameter of 62.5 mm. It is a question of lens diameter and light grasp.

Notwithstanding this, for good photography of the Moon there is no substitute for focal length (though time-lapse photography, producing multiple images on a single frame, can be made with shorter focal length lenses). With careful exposure and processing, a 200-mm focal length lens will produce a worthwhile image. If, however, a focal length of 500 mm can be used, then, all things being equal, the gain in quality will be significant. Increasingly, everyday photographers are applying their hobby to sports, bird-watching and similar activities in which there is a premium on focal length, and the compact 500-mm mirror lens is becoming particularly popular (see Chapter 3). The power of shorter focal length lenses may be boosted, of course, by the use of *teleconverters*, though there is then a loss of speed.

Once again, it has to be said that in using our long focal length lenses we are not getting something for nothing. The Moon moves in its orbit about the Earth from west to east, but because of our planet's rotation, each night the satellite appears to move in the opposite direction, from east to west, as seen from the Earth. The varying orbital velocity of the Moon complicates any calculations, but on average it is moving eastward in its orbit at about one lunar diameter

Figure 6.1 *Sufficient focal length is critical in obtaining satisfactory photographs of the Moon. In these cropped images, the full 35-mm frame was enlarged to the same degree to demonstrate the results obtained by using (a) 50-mm, (b)* 180-mm, (c) 500-mm, (d) 1000-mm and (e) 2000-mm lenses. Film and processing were standard throughout, but the last two frames were taken during a different lunation (the sequence of phases from one new Moon to the next).

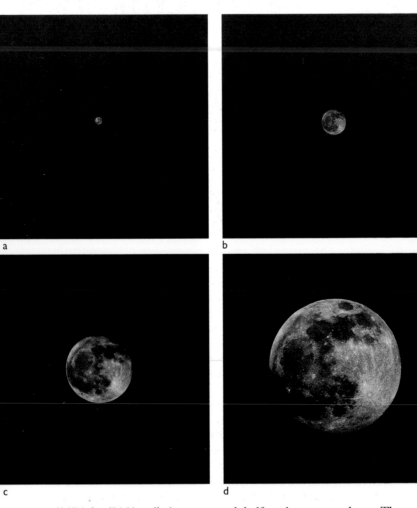

a

b

c

d

(3476 km/2160 miles), or around half a degree, per hour. The Moon's apparent movement in the opposite direction as a result of the Earth's rotation is much faster: a little under 15 seconds of arc per second of time.

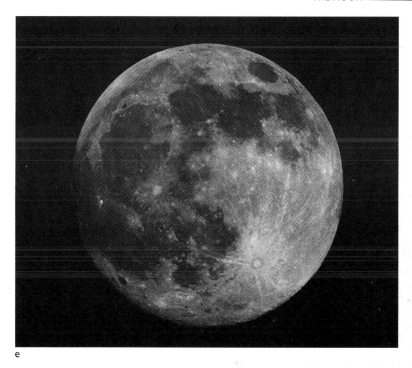

e

Without going into too much detail, the formula that is elaborated in Chapter 8 for securing essentially trail-free images of the stars is also valid for the Moon. Divide 700 (or 500 if we are being hypercritical – see page 97) by the lens's focal length, and the resulting figure is the maximum exposure in seconds that will result in virtually no image movement with a fixed camera. So this threshold exposure is (being hypercritical) 1 second with a 500-mm focal length lens, and only 1/4 of a second with a 2000-mm focal length lens. How feasible are such shutter speeds?

Exposure – and the need to bracket

The Moon is an extended object whose visibility through the Earth's atmosphere varies considerably. Such variation has been mentioned throughout this book, and is another reminder of how necessary it is to use suggested exposures only as a basis for experimentation. With the Moon we also have the variation in exposure necessitated by the Sun's changing phase angle. For example, during the early lunar "morning" (or late "evening"), when the Moon appears to us as a slender waxing or waning crescent, a longer exposure is required than when the Sun is overhead, at lunar noon, when we see the Moon as full. These conditions, fortunately, are more predictable than the state of Earth's atmosphere.

TABLE 6.1 GUIDE EXPOSURES FOR DIFFERENT LUNAR PHASES		
Moon's phase	ISO 400 film	ISO 100 film
crescent	1/125: *f*/8	1/30: *f*/8
quarter	1/250: *f*/8	1/60: *f*/8
gibbous	1/500: *f*/8	1/125: *f*/8
full	1/1000: *f*/8	1/250: *f*/8

These suggested values can be extrapolated for other focal ratios: e.g. the exposure for photographing the crescent Moon with an *f*/11 lens on ISO 400 film would be 1/60 of a second.

The exposures given in Table 6.1 for film speeds that are most suitable for black-and-white work are meant as a guide for your first attempts so that film will not be wasted in wildly inappropriate exposures. Make sure you bracket the exposures. Take one exposure that is one stop (or shutter speed) more, and another that is less by the same amount. For good measure take two more exposures, one two stops more and the other two stops less. Refining the exposures to $\frac{1}{2}$ stop changes will give you even more control. Again, it is essential to follow the good photographic practice that has already been stressed, particularly when the uncomfortable, in-between shutter speeds are indicated. Remember, however, that there are no universally correct answers – only those that work for the individual astrophotographer's particular set of circumstances: equipment; film; processing; and atmospheric and lighting conditions.

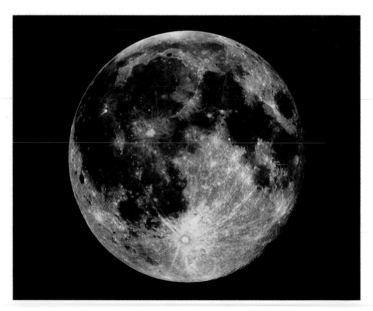

Dealing with contrast

It was suggested at the beginning of this chapter that the Moon is a subject for the black-and-white worker, but this is not to the complete exclusion of color. Color transparency film can be used to record the various phases of the Moon. One interesting experiment is to photograph it when low on the horizon, and then follow it up to its highest point, taking photographs using the same exposure, and compare

Figure 6.2 The effect of film choice and developer is well demonstrated in these two images of the full Moon. For the image below left Kodak Technical Pan 2415 film was used, rated at ISO 100. The exposure was 1/60 of a second through a 2000-mm, f/11 Nikkor mirror-reflex lens. The film was developed in HC-110 (dilution D). Technical Pan is a high-contrast, high-resolution film which helps to compensate for the blandness of the full Moon. The image below right was taken on T-Max 400 film using the same lens, but with an exposure time of 1/125 of a second. The film was developed conventionally in HC-110 (dilution B). Although T-Max has a lively contrast, this print obviously has a shallower contrast gradient than the first image. Printing skills are very important in making comparisons of this kind, and it could be argued that the Technical Pan image should have been printed on a paper that was one grade softer (less contrasty). Of the two original prints the Tech Pan image may appeal because of its greater liveliness, but careful study reveals the T-Max image to have a higher information content.

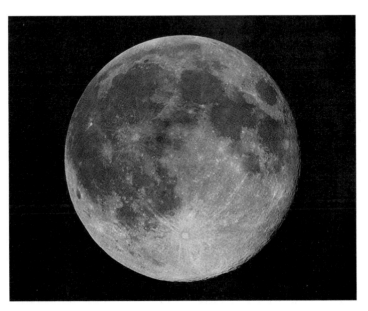

the color reproduction. Near the horizon the Moon is usually more orange, a result of the far greater thickness of atmosphere through which light from the Moon has had to pass.

Nonetheless, black-and-white film provides us with some flexibility in dealing with the contrast problems inherent in photographing the Moon. When the Moon is full, it is the high noon of the Moon's month-long day-and-night cycle. As on Earth, shadows are extremely short and it is difficult to discriminate objects. For the photographer the full Moon is a bland object, and there is a need to enhance what contrast does exist. Within limits, we can pursue a policy which will be familiar to the experienced black-and-white worker. Contrast in a negative is controlled by development, so if we underexpose the Moon and overdevelop we should produce greater contrast and therefore a livelier image. About half a stop of underexposure and one-third of over-development should be the limit, otherwise increased grain resulting from the over-development will become obtrusive in the older types of film. The more versatile newer-technology films will also repay experimentation. But there is another film, which I have used much of the time, that is a favorite of many experienced astrophotographers.

Kodak 2415 Technical Pan is a fine-grain film with extended red sensitivity that is used widely in astrophotography. Its value here is that whereas it can be exposed at a rating of up to ISO 64 to yield negatives with a normal contrast index (a standard measure of contrast in a developed image) of up to about 0.70, it can be rated as high as ISO 200 and then deliver a contrast index which has been claimed to be as high as 2.50. This is a top-quality film which is well worth experimenting with in lunar photography (see Figure 6.2), as well as elsewhere.

With the crescent moon the contrast problem is reversed. The subject is extremely contrasty (particularly at the terminator where lunar day and night meet), and the chances of getting totally dark blacks and featureless bright areas are high. Normally a higher-speed film is used to photograph the crescent Moon and this helps since faster films tend to be less contrasty than slower ones. The wider latitude of a higher-speed film also helps in the attempt to record detail in shadows and yet not lose detail entirely in the bright areas. The technique here is the opposite of that used when dealing with the full Moon: a degree of overexposure, and then of underdevelopment to limit contrast (see Figure 6.3), both by the same proportions as indicated for the full Moon. In both cases choice and manipulation of the most suitable printing papers contribute to an optimum result. A project to photograph the day-old crescent Moon is described in Chapter 14.

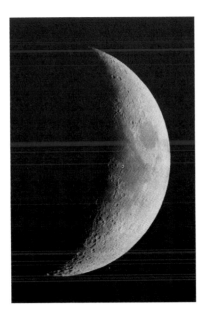 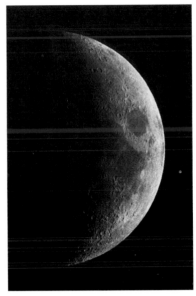

Figure 6.3 *Adjustments to the exposure and development times can help with the control of contrast in photographing the crescent Moon. The image at left was exposed on Kodak Tri-X film for 1/30 of a second through a Nikkor 2000-mm mirror-reflex lens. It is a satisfactory image, but the surface toward the limb becomes steadily more "washed out." The film was developed conventionally in D76 diluted 1 : 1. The image at right was taken on T-Max 400, but whereas the exposure of 1/60 of a second was standard the development time in D76 diluted 1 : 1 was cut by 25 percent. This caused the detail along the terminator (the border between lunar day and night) to be less well delineated, but the bright areas toward the limb have not developed so much and more detail is discernible. This was a useful experiment, but remember that if you are comparing films the tests should be conducted under absolutely equivalent conditions.*

There is one additional point to be made for those who intend to strive for the highest quality images of the Moon. While everything may be done to promote quality during one's photographic activities, it should be remembered that the nature of the Moon's orbit around the Earth results in times of the year which are best for photographing particular phases. Thus a moment's thought will show that the full Moon is higher in the sky during winter months (and highest in December) than in summer – its track being opposite that of the Sun, of course. It may not be so easily realized that the best time for photographing the waxing crescent is in March and for photographing the waning cres-

cent is in September. This does not mean that these are the only times of the year for lunar photography – quite the contrary. But it is at the indicated times of the year that the Moon will be seen through the most shallow depth of the Earth's atmosphere and therefore – all other things (such as the "seeing" and "transparency") being equal – will potentially yield the best chance of high resolution results.

Lunar eclipses

While a lunar eclipse does not have the drama of a solar eclipse, it is a fascinating experience to watch as the Moon declines from its normal brightness, acquiring an orange-red or coppery hue at the height of the eclipse. Fascinating it may be, but the astrophotographer is set a sterner test than when recording normal lunar images.

Figure 6.4 shows broadly what happens in a lunar eclipse. The period from when the Moon first touches the outer edge of the *penumbra* to when it moves completely out of the penumbra on the other side can frequently last for between 5 and 6 hours. The period of totality, when the Moon is wholly within the *umbra* of the Earth's shadow, is much shorter, up to about $1\frac{3}{4}$ hours. When the Moon first moves into the penumbra it looks hardly any different from when it is normally lit by direct sunlight. However, at *first contact* a broad line of shadow (the umbra) begins to move across the lunar surface and has covered the Moon entirely by *second contact*. For photographs of the Moon partly in the umbra and partly in the penumbra, exposure has to be for one or the other since the film cannot handle both extremes of lighting at the same time. Deepest darkness occurs quite logically at mid-totality. At *third contact* the Moon's leading limb begins to move out of the umbra. *Fourth contact* is when the Moon's trailing limb is just about to pass out of the umbra, and then the final penumbral stage begins.

Photography of the various stages of a lunar eclipse is complicated by the relative brightness or darkness of the Moon during totality, its position in the sky, and atmospheric conditions at the photographer's location – all of which could affect exposure times significantly. Although the Earth totally blocks off all direct sunlight from the Moon during totality, the lunar surface is illuminated by sunlight refracted, and reddened, by the Earth's atmosphere. The totally eclipsed Moon is therefore not black but a hue which may be an attractive orange or red or a muted copper, depending on the state of the Earth's atmosphere. During some eclipses the Moon's face appears extremely dark – as happened, for example, after the eruption of Mount Pinatubo in the Philippines in 1991 when vast amounts of ash and dust were injected into the Earth's atmosphere (see Figure 6.5).

Table 6.2 provides a basic guide to exposures for the eclipsed Moon. Often, longer focal length lenses will not be available in the fast focal ratios given in Table 6.2 for exposures within totality. Approximate exposures with slower focal ratios for three films are given in Table 6.3. Yet again, it must be stressed that these exposures are to be used as a basic guide only: experiment to see what suits your equipment and conditions.

The problem of the Moon's movement during an exposure must be considered. A 500-mm *f*/8 mirror lens should yield a good image with

Figure 6.4 (a) A lunar eclipse happens when the Earth moves between the Sun and the Moon. The three bodies are roughly in this alignment once a month (at the time of full Moon). However, because the Moon is inclined at about 5° to the ecliptic, exact alignment – and hence an eclipse – is much less frequent. (This diagram is not to scale.) (b) The various stages of a lunar eclipse as the Moon moves through the Earth's shadow or umbra. The size of the shadow helps to explain why a lunar eclipse lasts much longer than a solar eclipse, which occurs when the much smaller Moon passes between the Earth and the Sun.

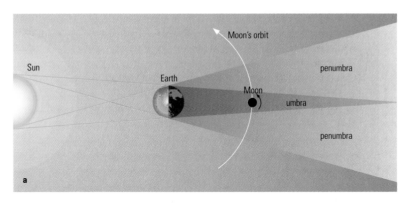

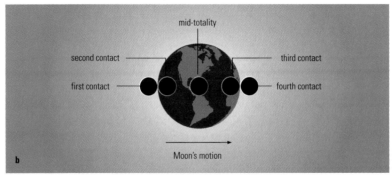

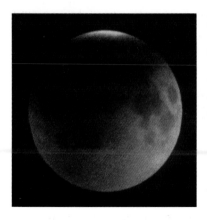

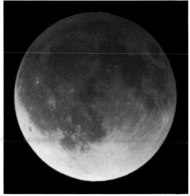

Figure 6.5 The difference that a major volcanic eruption (that of Mount Pinatubo in the Philippines) makes to the appearance of the Moon during a lunar eclipse is well demonstrated here. The image at left was taken on 1992 December 9 during an eclipse of the Moon that was generally agreed to have been one of the darkest in living memory – the result of the enormous quantity of ash injected into the atmosphere in 1991 by the volcano. The picture was taken with a 1000-mm f/11 Nikkor mirror-reflex lens on Scotchchrome 800/3200P transparency film. The exposure was 1 minute, and for an exposure this long it was vital that the camera mount tracked at the correct lunar rate. The picture at right was taken almost $3\frac{1}{2}$ years later, in 1996 April 4, close to mid-totality. A Nikon F4S was loaded with Ektachrome Panther P1600X Professional Film and the exposure lasted for 30 seconds using an f/9 focal ratio. The lighter area at the top of the lunar disk in the first image and at the bottom in the second image indicates that the Moon's track through the umbra of the Earth's shadow was well to the north and the south, respectively, in the two eclipses. (All full dates in this book are given according to standard astronomical practice in the form "year, month, day.")

the fastest films when the Moon is wholly within the umbra, and a reasonable image during mid-totality (even though, assuming the exposures indicated in the tables are accurate, the totally eclipsed Moon requires a 2-second exposure, as against a target of only 1 second from the formula 500/focal length). For the best results during totality, lenses of even longer focal length must be mounted on a camera drive or on a telescope tracking at the lunar rate. However, since the eclipsed Moon is a relatively indistinct object it will still be worth experimenting with a fixed camera and long lenses. Incidentally, it is at a time like this that focusing by the parallax method with a bright screen (see Chapter 3) is a great advantage.

TABLE 6.2 GUIDE EXPOSURES FOR THE ECLIPSED MOON						
Eclipse phase	Film speed (ISO)					
	64	100	200	400	1000	1600
deep in	1/60 s	1/60 s	1/60 s	1/125 s	1/250 s	1/500 s
penumbra	at f/8	at f/11	at f/16	at f/16	at f/16	at f/16
whole Moon	1 s	1 s	1 s	1/4 s	1/8 s	1/15 s
within umbra	at f/2	at f/2.8	at f/4	at f/2.8	at f/2.8	at f/2.8
mid-totality	4 s	2 s	2 s	1 s	1/2 s	1/4 s
	at f/2	at f/2	at f/2.8	at f/2.8	at f/2.8	at f/2.8

A lunar eclipse lasts much longer than a solar eclipse and, unlike a solar eclipse, it is not a spectacle that is restricted to a very limited path across the Earth's surface for a brief time – it may be seen anywhere in the world where the Moon is up (and skies are clear!). Table 6.4 lists forthcoming total lunar eclipses and the locations from where the Moon is in the sky for the entire sequence of events.

Earthshine

A phenomenon much more frequent than a lunar eclipse but one which is intriguing in its own right and a good test of developing photographic skills is earthshine. When the Moon is at crescent phase, the dark part of its disk is sometimes faintly visible. Traditionally called "the old Moon in the new Moon's arms" (although it should depend essentially on whether a waxing or waning Moon is being talked about), the almost ghostly glow is caused by the reflection of daylight from Earth on to the night areas of the lunar surface. The cause is not fully explained in most books, and is interesting.

It must be remembered first of all that the phase of the Moon is the complement of the Earth's phase as it would be seen from the Moon. Thus, an observer on a one- or two-day-old waxing crescent Moon would see a waning, gibbous Earth just pass full. When the waxing crescent is no more than a day or so old, the earthshine effect is difficult to see because the Moon is in a relatively bright sky. But as it ages

TABLE 6.3 GUIDE EXPOSURES FOR TOTAL LUNAR ECLIPSE AT SLOWER F-NUMBERS			
Eclipse phase	Film speed (ISO)		
	400	1000	1600
whole Moon	2 s at f/8 or	1 s at f/8 or	1/2 s at f/8 or
within umbra	1 s at f/5.6	1/4 s at f/5.6	1/4 s at f/5.6
mid-totality	8 s at f/8 or	4 s at f/8 or	2 s at f/8 or
	4 s at f/5.6	2 s at f/5.6	1 s at f/5.6

TABLE 6.4 TOTAL LUNAR ECLIPSES TO AD 2010		
Date	**Areas witnessing entire eclipse**	**Time of mid-totality (UT)**
2003 May 16	Eastern North America, Central and South America	03.40
2003 November 9	Europe, Western Africa, eastern South America, northeastern North America	01.18
2004 May 4	Western Asia, Central and Western Africa	20.30
2004 October 28	Western Europe and Africa, South America, most of US	03.04
2007 March 3	Europe and Africa	23:20
2007 August 28	Central Pacific	10:37
2008 February 21	West Africa, Western Europe, South America, Central and Eastern US	03:25
2010 December 21	All of North America, Central America	08:17
Source: Fred Espenak, *Fifty Year Canon of Lunar Eclipses: 1986–2035*, NASA Reference Publication 1216, 1989.		

to two and three days, it moves higher as dusk falls and faces an Earth which is still only two or three days past full. The disk of Earth looms thirteen times larger (in area) in the Moon's sky than the Moon does in ours, and this coupled with the Earth's greater reflectivity makes it forty times brighter. Earthshine is the result. The effect can still be seen at four days or so, but by then the Earth is waning quite appreciably as seen from the Moon, and more importantly the encroaching glare from the rapidly growing daylight area of the Moon overpowers any lingering earthshine (and stops down the iris of our eyes for good measure). The effect is reversed as the Moon wanes to a crescent.

One may theorize that earthshine should be brighter during the Earth's northern-hemisphere winter. Then the Arctic ice cap is at its most extensive, and large cloud systems occur frequently. At that time too it is summer in the Antarctic, and the southern ice cap will be prominent from the Moon. Ice, snow and cloud are more reflective than the Earth's landmasses and oceans, and should make earthshine brighter. This would make a fascinating, in-depth study (see also Chapter 14). In fact, NASA is currently supporting an Earthshine Project – as part of research into global warming – which is studying the Earth's albedo as revealed by earthshine. This has thrown up some interesting facts, such as earthshine being brighter than average (by as much as 10%) in the months of April and May each year. Changes can occur at much faster intervals: there can be a 5% difference, for example, between the Pacific Ocean (dark) facing the Moon and the largely cloud covered (brighter) Asia doing so.

Photographing earthshine is much like photographing an eclipse. Using 500-mm $f/8$, 1000-mm $f/11$, and 2000-mm $f/11$ lenses and ISO 400 film, I typically bracket from the optimum 1/60 or 1/30 of a second for the correctly exposed crescent itself, jumping to a series of exposures of 1/2, 1, 2, 4 and 8 seconds. Good though naturally varying results for the earthshine usually come from the longer exposures in the sequence. Movement of the Moon during this period must be taken into consideration, but earthshine is only a very low light level, and any movement is difficult to discern. So, as with a lunar eclipse, those without access to a camera mount or drive should not be dissuaded from trying. In my experience, no attempt should be made to photograph earthshine once the Moon is more than three days old. The daylit crescent is then so bright that the shutter speeds selected for the earthshine result in gross overexposure of the crescent, irradiation (the scattering of light through the silver halide crystals in the film) causing light to spread far beyond the crescent itself.

Multi-image frames

Effective images and good instructional material result from a sequence of exposures of the Moon on a single frame (see Figure 6.6). The technique is very straightforward. If your camera has no special switch to disable the double-exposure prevention device, it may be overridden by depressing the film rewind button in the bottom plate of the camera. Then, when the the film lever wind is operated, the film will not be wound on. In a sequence of exposures of this kind, with an interval of some minutes between each pair, it is imperative to remember to operate the override procedure and tension the shutter immediately an exposure has been finished. This must be done as a matter of routine. The work of many tens of minutes can be ruined by leaving this operation until an exposure is due and then forgetting to operate the override. Spode's law strikes again!

We have seen that the image of the Moon recorded on film through a 50-mm lens is very small: 0.5 mm at maximum. However, the attraction of the 27° vertical and 40° horizontal field of view of this lens is that a large part of a lunar eclipse can be encompassed within it. When enlarged five times, the overall image is by no means insignificant, and if enlarged still further it could make quite an impressive record. Obviously settings for the individual exposures have to be modified according to what stage the eclipse has reached. Longer lenses can be used, but the increased diameter of each Moon image, along with the blank space that has to be left between each pair of images, results in a shorter time sequence of the eclipse being recorded. The same technique may be used simply to demonstrate

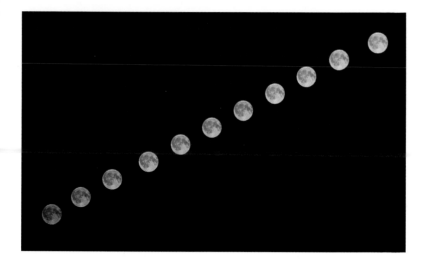

Figure 6.6 *It is relatively easy to override the double exposure prevention device on most cameras and to secure "time lapse" images of this kind. It records the color change which occurs when the Moon rises and shines through a narrower envelope of the atmosphere. The overall color balance is a feature of a particular film (and another film used at the same time is likely to record subtle differences), but the increasing brightness and lightening hue results from reduced atmospheric scattering as the Moon climbs higher. The lens used here was a 180-mm f/2.8 Nikkor and the exposures were made on ISO 400 Ektachrome transparency film. The shutter speed was unchanged throughout at 1/250 of a second and the time between exposures was 5 minutes.*

how the Moon's apparent color changes with growing elevation from the horizon (see Figure 6.6).

Libration

Multi-image frames are a form of what we might call time-lapse photography, although that technique is normally presented in a moving form. An even longer form of time-lapse photography, with images separated by months or even years, can be used to demonstrate the Moon's libration (from the Latin *librare*, "to balance"). This is the apparent wobbling of the Moon on its axis, deriving from at least three causes. It is libration that enables us to see, at one time or another, 59 percent of the Moon's surface rather than the 50 percent we might expect from the Moon keeping the same hemisphere facing the Earth.

Libration in longitude results from the Moon's orbit being elliptical. The Moon's speed varies according to its position in its orbit, but its speed of

rotation is constant. As a result of this mismatch, the face the Moon presents to us oscillates slightly from left to right, and we can see areas further round its east or west limb. *Libration in latitude* results from the plane of the Moon's orbit around the Earth being inclined by 5° to the plane of the Earth's orbit around the Sun. There are times when, because of this, we see more of the Moon's north or south polar region. *Diurnal libration* enables us to see slightly "over the top" of the Moon when it is rising and "under the bottom" when it is setting. This is because the greater radius of the Earth gives the observer several thousand kilometers in height advantage when the Moon is on the horizon. Libration in longitude has the greatest effect, accounting for 8 of the extra 9 percent of the Moon's surface the various librations bring into view.

Images demonstrating evidence of libration are reproduced in Chapter 14. However, it is perhaps appropriate to conclude this chapter by emphasizing that expense is not everything in securing good results in our pictures of the Moon as is demonstrated by Figure 6.7.

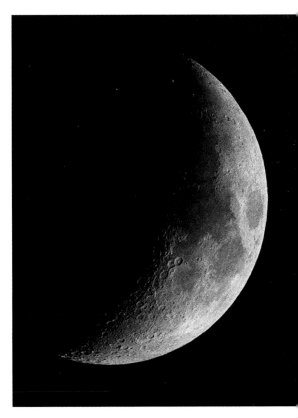

Figure 6.7 *Expense is not everything! Given good conditions, a reasonable quality lens and care even very modestly priced cameras can yield good images of the Moon, which makes an admirable target on which to gain experience. This image was taken with a Zenit 312m camera loaded with ISO 400 TMax Pro film. The exposure was for 1/250 of a second at f/9.*

The Sun

The beginning of this chapter is undoubtedly the most controversial part of the book. Many astronomy authors and other experienced observers are categorical in stating that there is only one safe way of looking at the Sun: to project the Sun's image through a telescope on to a white card which is shaded from the surrounding daylight by some form of curtaining or box, or by a large card through which the telescope pokes. The reason for the warning is obvious. Figures for the amount of solar energy falling on the Earth's surface include so many zeros that our minds cannot grasp the physical facts. However, we can appreciate the calculation that the Sun's surface is well over a quarter of a million times brighter than a sunlit scene on Earth. And even more directly, we know the extreme discomfort (to say the least) we experience when we glance inadvertently at the Sun when it comes out from behind a cloud. Add to this the fact that optical instruments gather far more light and energy than the human eye, as demonstrated when a magnifying glass or lens is used to set fire to paper, and the concern about photographing the Sun will be fully understood.

Safety

Nor are these few facts all. The public interest in looking at the Sun is concentrated almost entirely at solar eclipses, especially a total eclipse. At these times various allegedly safe viewing filters go on sale. But many of them, while offering deceptively comfortable viewing of the un-eclipsed portions of the Sun's disk, are likely to transmit infrared and ultraviolet radiation that can damage the retina without the user suffering pain or distress at the time of viewing. This is because the retina, like the lens of the eye, has no pain receptors. (Although the danger of retinal burns from infrared radiation has always been stressed, recent research has established that there is an even greater danger from UV radiation, resulting in what is called photochemical damage, than from infrared.) Smoked glass is a typical example of an unreliable and therefore dangerous "filter." The behavior of individuals compounds the problem: stories abound of people at responsibly organized eclipse viewing sessions suggesting piercing a hole in a safe filter "to see the Sun more clearly." To be frank, there is little evidence on the incidence of damage to people's eyes on such occasions. But, given the apparent lack of wisdom of some members of the general public, the considerable concern felt about direct viewing of the Sun must be appreciated.

However, this can go too far, as happened in the UK in the run-up to the eclipse in August 1999, when a form of what can only be

described as politically correct hysteria developed, during which government medical officials displayed a total ignorance about how the marvelous phenomenon could be observed safely. For the fact remains that there are indeed perfectly safe filters for observing and photographing the Sun available at modest cost to the observer and to the newcomer to astrophotography. A safety drill does have to be observed, but it is assumed that anybody reading this book will realize the vital importance of following the correct procedure. It should be quite clear which filters are safe and which procedures should be followed, but you can always fall back on good sense and the maxim, "if in doubt, *don't.*" In passing, while the health of our eyes must take obvious precedence over possible damage to equipment, it is worth repeating a further word of warning. One of the world's biggest telescope manufacturers categorically advises against using a telescope to project the Sun's image on to a white card because of the potential damage resulting from the build-up of intense heat within a telescope focused on the Sun. Be that as it may, in this chapter we will concentrate on photographing the Sun during eclipses with basic photographic equipment. Advanced imaging of the Sun is dealt with in Chapter 15.

Neutral density filters

Completely safe filters used for viewing and photographing the Sun must reduce the level of solar radiation by a factor of 100,000 – that is, they transmit just 0.001 percent and block 99.999 percent. First of all, let us deal with a form of filtration which will be well known to keen photographers – although they will not have used it to look at the Sun directly. Any part (no matter how small) of the Sun's visible surface, the photosphere, can be photographed through photographic neutral density filters (ND filters) with a density level of 5.0. This does not mean a 5× filter as everyday photographers understand it. There the 5 refers to the factor by which the filter reduces the light, and hence the factor by which a normal unfiltered exposure must be increased to achieve a comparable result when using the filter. A neutral density value of 5.0 in fact represents a filter factor of 100,000 (i.e. 10^5) – the amount required for photographing the Sun. (This figure of 5.0 should also not be confused with that of an ND filter with a density level of 0.5, which has a filter factor of a mere 3×!)

Gelatine ND filters are available, but since there is no single filter with a density of 5.0, two must be combined: a 4.0 with a 1.0 or a 3.0 with a 2.0. The use of two filters rather than one has no significant effect on image sharpness. The filters must be handled carefully, and a gelatine filter holder is a wise purchase to help protect the filters in use. Remember that (as is the case with all solar filters) the ND fil-

ters are used at the front of the lens; their use at the rear would allow solar radiation into the lens with the possibility of damage from the build-up of heat. The drawback with the ND filters is that they block only the visible spectrum by the required amount, and not the potentially dangerous infrared and UV wavelengths. So additional protection is required for visual observing and, more to the point, for aiming and focusing a camera.

This is provided by black-and-white film of the sort used in ordinary photography. When such a film is fully exposed by unrolling or extracting it from a cassette in bright light and then developed normally, instead of the variety of tones seen in a typical negative the film consists of a dense layer of metallic silver. It has been established that film thus exposed and developed can be formed into a filter with an ND value of 6.0, which provides good protection for the eyes. This density can be obtained by sandwiching two thicknesses of film together (with both the duller, emulsion sides facing inward). 120 size film will provide a reasonable area for comfortable and safe viewing, and 4 × 5 inch film even more so. The film can be mounted in a suitable frame. One medical opinion is that such a filter should be looked through for no longer than 30 seconds at any one time, so as to allow the physiological processes that operate within the eye time to conduct heat away from the retina.

Filtering the Sun's light for photography using these conventional photographic ND filters is thus a two-stage operation. The camera is aimed to frame the Sun, and focusing is accomplished with the homemade viewing filter held over the lens of an SLR camera. Then the viewing filter is removed and the two-layer photographic ND filter screwed into position before exposures are made. At no time when using an SLR should the eye be applied to the viewfinder without the viewing filter in position. It must also be stressed that only viewing filters made from black-and-white film are safe and effective. Color films, whether of the transparency or negative–positive type, are totally unsuitable because they contain very little or no silver when exposed and processed, and it is the metallic silver that protects the eyes. Polarizing filters, too, are unsuitable. The viewing filter itself should not be used for photography, incidentally, because the metallic silver in it scatters light and makes the image slightly less sharp.

Polymer filters

If this two-stage operation sounds too involved, help is at hand. While you would probably not contemplate purchasing a specialist glass solar filter on grounds of expense, perfectly safe plastic equivalents are much more attractively priced, costing about the same as good quality

photographic ND filters. Moreover it is perfectly safe to use these filters for both viewing and photography.

All are polymer based and the longest established is a US product called Solar Skreen, which is composed of two very thin sheets of aluminized mylar. Solar Skreen filters are either supplied in ready-made mounts or in the form of sheets, which can be fitted to the front of a lens simply (albeit carefully) by means of an elastic band. The sheets have to be treated carefully but are surprisingly strong in use and any wrinkles do not impair optical quality. (This is true of all these polymer products.) Any coating can leave small pinholes but the use of two sheets reduces these to a minimum. A drawback of Solar Skreen so far as I am concerned is that to the eye and on film it yields a light blue Sun. This can be largely corrected by the addition in use of a Wratten 21 (orange) filter but this is yet another step.

Other polymer filters do not suffer from this disadvantage. Polymer Plus filters are again comprised of two layers but are coated with a combination of chrome, stainless steel and titanium – the same coating as is applied in considerably higher priced glass filters. Polymer Plus yields an agreeable, light orange colored Sun. It has a companion product called Black Polymer which is a single layer "with absorptive filtering material spread throughout the substrate." Black

Figure 7.1 *Mylar filters are perfectly safe for viewing and photographing the Sun and optically they leave little to be desired – as witness the satisfactory resolution of the sunspots in the image at left. However, the color looks bizarre to many eyes. There is no such problem with images shot through glass filters coated with metal alloys or plastic polymer products as at right – a record of the final stages of the great eclipse of 1991 July 11 as seen from La Paz, Baja California. This was an exposure of 1/250 of a second on Ektar 125 color negative film loaded in a Nikon F4S. The lens was an f/11 1000-mm focal length mirror-reflex.*

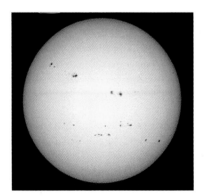
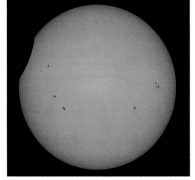

Polymer is a lower priced product which is normally regarded as being most suitable for using with binoculars during the course of a solar eclipse or for studying sunspot activity at any time. A comparison of the Sun imaged through a mylar filter and one yielding a natural color Sun appears as Figure 7.1.

Another polymer filter has been developed in Germany in recent years. Baader AstroSolar film is described as a "specially manufactured streak and blister free foil ... High density coatings on both sides ensure a highly uniform filtering, while neutralizing the occasional microscopic holes in the coating." It is stated that the foil was developed in nuclear and particle physics laboratories. It yields a white, high contrast Sun which, on the occasions I have used it, I have combined with a Wratten 21 filter to yield a light orange solar disk.

While the need for solar filters is a necessity, in contemplating photography during a solar eclipse do not forget all of the good basic rules of photographic practice outlined in Chapter 5. One addition to think about, particularly if the eclipse is to take place in a very hot climate, is a light colored and thin piece of cloth to drape over the camera and the top of the tripod. Metal objects can get disagreeably hot in such conditions and anything you can do to keep the camera (and the film inside) from roasting can only be good.

The nature of solar eclipses

Despite the Sun's diameter being over four hundred times greater than that of the Moon, the two bodies have approximately the same angular diameter as seen from the Earth. An eclipse of the Sun occurs when a new Moon lies precisely between it and the Earth. If at the time of the line-up the Moon is closest to the Earth in its elliptical orbit, at a point called perigee, then the size of the totally shadowed area (the *umbra*) it creates on the Earth is at its largest possible diameter of about 270 km (170 miles). Then, for observers in the optimum position totality can last for the maximum possible time – somewhat over 7 minutes. Often the umbra is smaller, and therefore the period of totality is considerably shorter. If the line-up happens when the Moon is at its farthest point from the Earth (apogee), its disk does not cover all of the Sun, the umbra does not reach the surface of the Earth, and in mid-eclipse a narrow ring of the solar photosphere outlines the Moon. This is called an *annular eclipse* (see Figure 7.2), and tends to attract less interest than the dramatic spectacle of a total eclipse. Weather permitting, such an eclipse will be seen from the far northwest of Scotland and the Isles in the early morning of 2003 May 31. (An annular eclipse must be photographed using an appropriate filter, even though the ring of sunlight, the annulus, is very narrow.) When only a

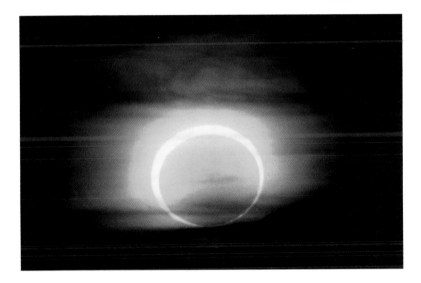

Figure 7.2 *An annular eclipse of the Sun seen from California on the late evening of 1992 January 4. The picture was shot using a Nikon F4S camera fitted with a lens/teleconverter combination which yielded a focal length of 450 mm and a focal ratio of between f/5.6 and f/8. This is one of five auto-bracketed exposures made as the cloud of an approaching front was rapidly thickening. The annulus is complete although it was not perfectly symmetrical. Despite the cloud, the exposure on ISO 400 color transparency film was still 1/2000 of a second.*

segment of the solar disk is occluded by the Moon a partial solar eclipse is seen in those parts of the world where the shadow reaches the surface (see Figure 7.3).

As the Sun and Moon keep pace with each other for two hours or so, a path of totality sweeps over the surface of the Earth at a speed, depending on the elevation of Sun and Moon, of as much as 8000 km/h (5000 mile/h). Along the centerline of the path, totality lasts the longest. Observers outside the path but within the *penumbra* of the Moon's shadow see only a partial eclipse. Solar eclipses and paths of totality are predicted well in advance, and one published list gives details to the year 2510! It is calculated that the average period between eclipse paths crossing the same location on the Earth's surface is about 400 years. Solar eclipses up to the year 2010 are listed in Table 7.1.

First contact is the name given to the moment when the Moon's disk first begins to pass in front of the Sun. A chip out of the Sun appears and grows steadily until only a slender crescent is left beyond the Moon's leading edge. This too disappears at *second contact*, when total-

ity begins. *Third contact* occurs when the Moon's trailing limb coincides with that of the Sun, following which the first sunlight reappears. *Fourth* or *last contact* is the moment when the Moon's disk parts company with the Sun's.

As the slender crescent of the photosphere diminishes and the shadow of totality rushes toward observers, the last remnants of sunlight shine through valleys between mountains on the Moon's leading limb as *Baily's beads*. The last flash of light from the Sun's limb creates what is graphically called the *diamond ring effect*. As this disappears, the gases of the chromosphere are seen for a brief period as a red rim, and prominences – sheets of hot gas or plasma writhing from the Sun's

Figure 7.3 *A partial eclipse with a difference. Those with a technical interest want totally clear skies for eclipse photography of the Sun. However, the presence of some cloud can make for intriguing images. Seen from the UK, there was a partial eclipse of the Sun late in the evening of 1982 July 20. Scattered cloud lay near the western horizon, with quite thick stratus blanketing the bottom of the Sun and thin layers of cloud making the rest of the disk appear almost Jupiter-like. Small flocks of birds flying in front of the Sun are easily seen in the original picture. A sequence of color images was exposed through a 1000-mm f/11 Nikkor lens during the partial eclipse, some with exposures based on the solar disk only (as here) and others based on a reading of the sky.*

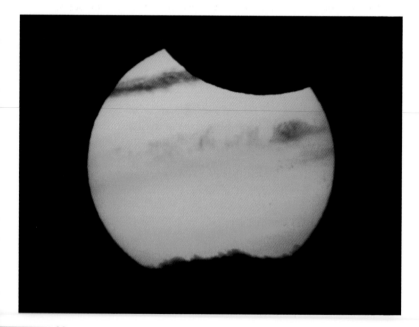

TABLE 7.1 TOTAL SOLAR ECLIPSES TO AD 2010		
Date	**Path of totality**	**Maximum duration of totality**
2002 December 4	Angola, Zimbabwe, Botswana, South Africa, Mozambique, Indian Ocean, southern Australia	2m 04s
2003 November 23	Antarctica only	1m 57s
2005 April 8	Total eclipse over central Pacific; annular eclipse over Panama, Colombia, Venezuela	0m 42s
2006 March 29	Brazil, Atlantic, Ghana, Togo, Benin, Nigeria, Niger, Chad, Libya, Egypt, Turkey, Kazakhstan, Russia	4m 07s
2008 August 1	Northern Canada, Greenland, Russia, Mongolia, China	2m 27s
2009 July 22	India, Nepal, Bangladesh, Bhutan, China, Ryukyu Islands, Pacific	6m 39s
2010 July 11	South Pacific, southern Chile, Argentina	5m 20s
Source: Fred Espenak, *Fifty Year Canon of Solar Eclipses: 1986–2035*, NASA Reference Publication 1178, Revised 1987.		

surface for tens of thousands of kilometers into space – spring into view. The beautiful, pearly hue of the corona develops as totality progresses. On the Earth, a pseudo-night falls and planets, stars and sometimes previously undetected Sungrazing comets are seen clearly. But all too soon the Moon's trailing limb moves on. The sequence of diamond ring, Baily's beads and crescent Sun is repeated, now in reverse order (see Figures 7.4–7.7).

Calculating exposures

There is a natural tendency simply to watch and enjoy what is one of nature's most magnificent displays, but for the photographer determined to record the event there is a need to concentrate on a plan. There are two distinct phases of photographing an eclipse. During the short minutes of totality, when the photosphere is hidden in its entirety by the lunar disk, filters must be removed entirely. At all other times filtration *must* be used. Filtered photographic exposures of the Sun's disk remain the same whether the Sun is full or only the slenderest of crescents is showing. The following formulas give the basis for calculating exposures during these phases of the Sun (remember that the Sun is an extended object):

(focal ratio)2 = film speed \times shutter speed \times 100
or
$$\text{shutter speed} = \frac{(\text{focal ratio})^2}{\text{film speed} \times 100}$$

As an example, for an ISO 200 film and a focal ratio of $f/11$, the second formula gives:

$$\text{shutter speed} = \frac{11 \times 11}{200 \times 100} = \frac{121}{20{,}000} = \frac{1}{165}$$

There is no shutter speed of exactly this value, so we would choose 1/125 or 1/250 of a second as the basis for bracketing the exposures.

Exposures for the various stages of a solar eclipse are largely a matter of experience, but Table 7.2 gives some guidance for the features of totality and for the partial phases. I stress once again that exposures should be bracketed, although pre-eclipse tests of exposures using the type of filter you have chosen can be carried out (at approximately the

TABLE 7.2 GUIDE EXPOSURES FOR SOLAR ECLIPSES						
Film speed (ISO)	Partial phases (filter essential)	Totality (no filter) Baily's beads	diamond ring	prominences	inner corona	outer corona
25	1/125 s at $f/5.6$	1/125 s at $f/11$	1/60 s at $f/8$	1/125 s at $f/4$	1/30 s at $f/2.8$	1/4 s at $f/2.8$
50/64	1/125 s at $f/8$	1/250 s at $f/11$	1/125 s at $f/8$	1/125 s at $f/5.6$	1/30 s at $f/4$	1/4 s at $f/4$
100/125	1/125 s at $f/11$	1/500 s at $f/11$	1/250 s at $f/8$	1/125 s at $f/8$	1/30 s at $f/5.6$	1/4 s at $f/5.6$
200	1/125 s at $f/16$	1/500 s at $f/16$	1/500 s at $f/8$	1/125 s at $f/11$	1/30 s at $f/8$	1/4 s at $f/8$
400	1/250 s at $f/16$	1/1000 s at $f/16$	1/500 s at $f/11$	1/125 s at $f/16$	1/60 s at $f/8$	1/8 s at $f/8$
1000	1/500 s at $f/16$	1/1000 s at $f/22$	1/500 s at $f/16$	1/250 s at $f/16$	1/125 s at $f/8$	1/15 s at $f/8$

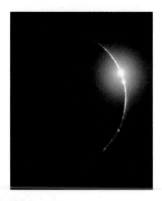

Figure 7.4 Baily's beads recorded just before third contact of the solar eclipse of 1994 November 3 as seen from Chile. The exposure was on ISO 100 Ektachrome film loaded in a Nikon F4S with a 1000-mm lens fitted. Prominences are also seen. The location was deliberately chosen so as not to be on the center line but just inside the boundary of totality: this shortens the length of totality a little but normally increases the chances of observing phenomena such as Baily's beads, the diamond ring and prominences at the solar limb.

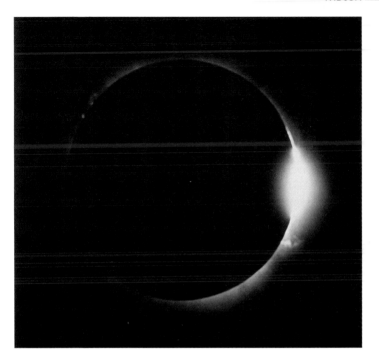

Figure 7.5 *A diamond ring seen at third contact during the 1991 July 11 eclipse. Immediately beneath is an enormous prominence which reminded many observers of the famous Horsehead Nebula in the constellation of Orion. The exposure was 1/500 of a second on Fuji ISO 400 Super HG color negative film. The camera was a Nikon F4S with a 1000-mm mirror-reflex lens fitted. Smaller prominences are seen behind the leading limb of the Moon, and despite the relatively high shutter speed the inner corona is also quite clear.*

same time of day as the eclipse will occur) to get more precise exposure values for photographic coverage either side of the period of totality. High-resolution black-and-white film is normally used in advanced studies of the Sun, but certainly for the amateur only color film can do justice to the glorious sights of totality.

Exposure times are but one of the considerations facing you during the eclipse. As with photography of the Moon, focal length is important and the same approximate formula (focal length/100 = diameter of the disk on the 35-mm film) applies. We must consider also the subject movement threshold for exposure time, given by 500/focal length. Table 7.2 should be reviewed, together with the tentative choice of lens, so that a careful choice of film speed can be made. The best possible

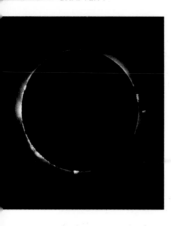

Figure 7.6 While regrettably the southwest of England saw little of the total solar eclipse of 1999 August 11, totally clear skies and high temperatures were experienced by observers who journeyed east to Turkey and elsewhere. A fast exposure of 1/500 of a second on Ektachrome 100VS transparency film at an effective aperture of between f/11 and f/16 using a 500-mm f/8 mirror-reflex lens with a teleconverter added obtained saturated red prominences as well as the inner corona. One prominence at center right appears to have become completely detached from the solar limb.

film quality is important, and in general a slower or medium-speed film should be selected. There is then a penalty in that faster focal ratios or slower shutter speeds have to be used, but the values indicated in the table are by no means too daunting.

Practice in advance

Once again, good photographic practice can help. Your program of photography should not be too complex – quite apart from any other reason, you ought to have some time to enjoy the spectacle. (More to the point, from my own experience over many eclipses I can assure you that you simply will not complete an over-elaborate program of exposures – time during totality goes too quickly!) As already suggested, experiments should be conducted in advance to establish accurate exposures when using the filter, and a careful if brief plan of exposures to be made during totality should be drawn up. (Since your camera will almost certainly be mounted on a normal tripod and not a mount tracking the Sun, you will be surprised, particularly when using a long focal length lens, at how quickly the Sun will move out of the field of view. Note too how the efficient solar filter makes it very difficult to find the Sun in the view finder once you have lost it!) These exposures should be rehearsed at twilight, using a red-light torch/flashlight to alter shutter speed/f-number controls, as you may well need to do this during a particularly dark eclipse. With slower shutter speeds, precise and careful discipline is required along the lines detailed in Chapter 5. Ensure that the tripod is as firm as possible. Resist the natural temptation to rush exposures during totality: allow a few seconds at least to elapse between them so that vibrations induced by firing the shutter and winding on the film have time to dampen out. Make sure, too, that

ample film is available for the planned number of exposures during the few minutes of totality. It would be better to load a new film (possibly of a faster speed) in good time for totality than to run out. Make sure that the film is loaded correctly and is winding on before the great moment arrives. If you do reload some minutes before totality, the period immediately afterward would be a good time to remove the filters and check that focusing, shutter speed and aperture are as required.

An alternative to taking a series of individual pictures is to expose a series of images on one frame (by overriding the double-exposure prevention device), as explained when discussing photography of the Moon. A 50-mm focal length lens has an angle of view, in terms of its diagonal, of 46°. The Sun and Moon move at about 15° per hour, so this is a convenient size for encompassing the entire 2-hour sequence of an eclipse, although the image size of the Sun will be quite small. A 200-mm focal length lens cannot be used to record the entire eclipse, but does give an impressive solar disk, its angle of view of more than 12° allowing approximately ten exposures with pauses of 3 or 4 minutes in between each exposure on the 35-mm frame. Whichever lens you select to achieve the most attractive result, the predicted times for the period of totality should be obtained and an attempt made to commence the first exposure at a time which allows the exposure made at totality to appear in the middle of the frame. This totality exposure will be the only one exposed without the filter in place and the shutter speed/aperture will need to be altered

Figure 7.7 Bracketed exposures made during totality usually record the milky white color of the corona. As exposures lengthen, the inner corona becomes progressively overexposed as the attempt is made to record the dim outer corona. On occasion, however, shorter exposures intended to record the inner corona become tinted by the red of solar prominences and of the chromosphere – as happened here. The exposure was made during the 1994 November 3 eclipse. The exposure was made 1/4 of a second on ISO 400 transparency film at f/11.

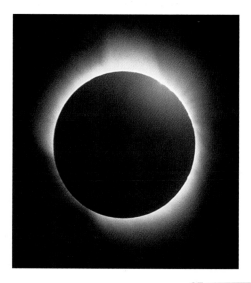

accordingly. Remember to replace the filter immediately after this exposure (see Figure 7.8)!

Secondary phenomena

Outside totality itself, the pressures are not too intense. If you have a second camera available, you can use it to photograph some of the associated phenomena. Once the Moon has started to pass across the face of the Sun, sunlight passing through foliage forms multiple images of the Sun's phase on the ground (see Figure 7.9). The exposure details will be quite conventional for photographs of this effect. During totality the eerie light along the horizon is an intriguing subject: try an exposure of f/2.8 at around 1/60 of a second with ISO 400 film, or just go with your meter. Certainly the most elusive subject for the camera is *shadow bands*, alternating light and dark bands which ripple quickly across the ground and other surfaces, sometimes seen just before or after totality.

Figure 7.8 *Effective time-lapse images do not require exotic equipment – on the contrary, the 50-mm lens comes into its own to accommodate the entire 2 hours or more of a solar eclipse on one frame of film. This record is of the 2001 June 21 eclipse as seen from East Africa. A Nikon F3HP fixed on a tripod was loaded with ISO 100 transparency film: previous tests with this film had indicated an exposure of 1/250 of a second at f/11 through the ND5 filter for the partial phases and a 1/2 second exposure for totality. Fortunately, despite nearby field burning, the sky was clear during all of the exposures, which were separated by 5 minutes.*

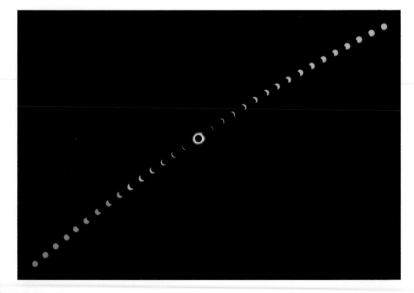

Figure 7.9 *No exposure details are available for this image! The multiple images of a crescent sun cast by the leaves of a tree during the partial phases of a total eclipse constitute one of the pictures that can be obtained with a simple one shot or a totally automatic camera. Just point and shoot unless you need to focus.*

Their cause is not completely understood, but is thought to be irregular refraction of light from the crescent Sun (see, for example, *Sky & Telescope*, May 1991, page 482). Photographing them, even on a specially prepared light-colored surface, is made difficult by their speed of movement and low contrast, and few successful shadow band pictures have been published. Try an exposure of about 1/250 of a second at *f*/1.4 with ISO 400 film. (I must confess that I have never seen the bands, partly because of concentrating on a program of direct solar images.)

If you are preparing a serious program of eclipse photography, any attempt at capturing these secondary phenomena is best left to a companion. During the partial phases of an eclipse, and particularly if you are using a lens of relatively short focal length, do not hesitate to take unashamedly pictorial photographs of the scene (see Figures 7.10 (a) and (b)). Despite my predilection for color transparency film, many experienced astrophotographers prefer the versatility and latitude of negative films. In the case of solar eclipses, since the appearance of the Sun is quite unmistakable and particularly if you are shooting with a lens of long focal length, you may well decide to opt for negative color film. Any

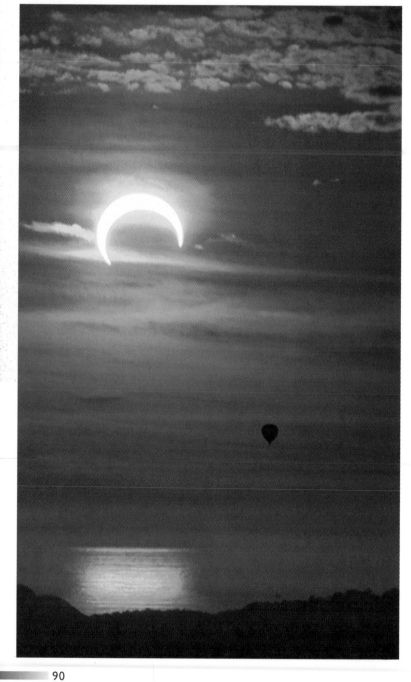

Figure 7.10 If you have the time or if you have another pair of willing hands to take them, "atmosphere" images are everywhere during a solar eclipse. The image at left was taken during the annular eclipse that occurred in California during the late evening of 1992 January 4. One of five auto-bracketed exposures, it recorded an attractive scene showing Sun, (rapidly thickening) clouds, a hot air balloon, and glitter path across the Pacific. The exposure was for 1/2000 of a second. The picture was shot on Ektachrome ISO 100 film loaded in a Nikon F4S camera fitted with a lens/teleconverter combination which yielded a focal length of 450 mm and a focal ratio of between f/5.6 and f/8. The picture at right shows an Egyptian vulture roosting as "night" draws on during the short solar eclipse seen from northwest India in 1995 October 24. Totality was very close and only a thin sliver of the solar disk remained at the time the exposure was (hastily) made using a second, automatic camera with no solar filter fitted. The meter targeted the Sun, which meant the bird and branches of the tree were totally and intentionally underexposed, appearing in silhouette only. The exposure was made on ISO 100 color transparency film.

minilab operator, especially if told what the subject is, should be able to produce good-quality prints and enlargements for you.

Relatively few of us are fortunate enough to see a total eclipse of the Sun. This is a prime reason for joining an astronomical party going abroad (see Chapter 16). In addition, as a member of a group you will find that there are numerous, additional "atmosphere" images to be taken – after a successful eclipse something of a party atmosphere develops – which make good subjects for the camera, particularly if you are planning a photographic diary of the journey. At the other extreme, there is fascinating, more advanced photographic work to be done in studying the Sun (see Chapters 14 and 15). Nonetheless, in terms of emotional impact there is nothing to rival your first eclipse. Good luck!

The stars

The constellations are a natural subject for the newcomer to astrophotography, for identifying and photographing them is an enjoyable and instructive method of exploring the night sky. They may be photographed in black and white or color. Using black-and-white film is an economical way of testing techniques and skills, for you need proceed no further than a black-and-white negative. This can be studied under a magnifier, projected, or used to produce a paper print or positive transparency. But color has a greater drama and appeal. Moreover, color photographs obtained with the minimum of equipment and experience can demonstrate features of the stars which are beyond the capability of the human eye to perceive.

The lenses used to record the constellations are of relatively short focal length, and the best way of finding out which are the most suitable is by practice. Go out with a camera and lenses on a good, clear night, and look through them at constellations that are well placed. The highest in the sky are the most suitable. A star map will help you to locate the constellations in advance, and to appreciate their relative sizes in the sky. Some books give figures for these sizes in "square degrees." These are quite useful and, without opening a star map or even looking at the sky, you will realize that Pegasus at over 1100 square degrees is very much larger than Lyra at under 300. But that does not take us very far because, while we can easily work out the area of sky covered by one of our lenses, constellations come in all sorts of shapes as well as sizes, and can refuse to fit neatly into the rectangular shape of our picture frame. So we need to check at first hand, and the first time out it makes sense not to expose any film, but just to look and learn.

Many of the constellations will fit into the 27° (vertical) by 40° (horizontal) field of view of the standard 50-mm focal length lens. With it, we can comfortably photograph Auriga or Gemini or Cassiopeia in the northern winter sky. It will also cover the whole of Orion or Perseus, but only if the camera is angled so that the long axis of the field of view accommodates the greater "length" of the constellations compared with their "width." Some of the constellations are much smaller – Lyra, for example, fits comfortably into the field of view of an 85-mm focal length lens – while others need the greater coverage (38° by 55°) of a 35-mm wide-angle lens. Ursa Major, Leo, Taurus and Hercules come into the latter category. I should point out that these references are to the full extent of the constellations: the familiar bright stars of Ursa Major or Leo, for example, fit into the field of view of a 50-mm focal length lens but the entire constellations, out as far as their official

boundaries, are far bigger. The so-called Summer Triangle, the beautiful multiconstellation feature formed by Vega in Lyra, Altair in Aquila, and Deneb in Cygnus, also requires a 35-mm lens. Some constellations are even bigger and demand a full 24-mm wide-angle lens. Hydra, the longest constellation in the sky, falls into this category. For those who like a little mathematics, another way of working out this information is to establish the size that a given astronomical object will occupy on a 35-mm film frame. This can be worked out from the formula

image size = $a \times f/57.3$

where a is the size of the object in degrees of arc and f is the focal length of the lens. As an example, the distance from Dubhe to Alkaid at the extreme ends of Ursa Major is 26°, so if we use a 50-mm lens the size of the image is

$26 \times 50/57.3$ = almost 23 mm

which will fit comfortably into the nominal 23×34 mm picture size of a mounted 35-mm slide.

This introduction points the way, but you should set out to gain practical experience of fitting different focal lengths to various constellations. If the ultimate purpose is to prepare a set of constellation slides for teaching, you might consider choosing a single focal length so that the size of the field of view does not alter between slides, as this would confuse students. Similarly, a standard might be established whereby the celestial equator is always parallel to the long axis of the picture frame. The 35-mm wide-angle lens is in many ways suitable, but the inclusion of the larger constellations would call for a 28- or 24-mm focal length lens (despite other drawbacks, discussed later).

Star trails

Before you get into the detail of theory and technicalities, I suggest that you find a sky as far away as possible from city lights, load your camera with a medium-speed color film (ISO 200 or 400, no faster), set a 50-mm lens at f/2.8 (also no faster, even if it does open up to f/1.8 or more), select a number of constellations, and shoot 10-minute time exposures of each. If the sky is reasonably dark, make one exposure lasting about 30 minutes of the Ursa Minor region, preferably with Polaris centered in the frame. Then, turn the camera to the south, identify from the star atlas the constellations on view through which the celestial equator runs, and photograph that region too, also with a 30-minute exposure.

Figure 8.1 The shape of the constellation Orion is unmistakable, even though the stars are trailed. This 10-minute exposure through a Noct-Nikkor 58-mm lens (specially designed for night photography) at f/2.8 was on relatively slow film, ISO 200 Agfachrome Professional, to limit the effect of any light pollution or airglow (see page 102). On faster film, light pollution or airglow would quickly build up a background "fog." The orange of Betelgeuse contrasts sharply with the brilliant white of Rigel and the varying shades of blue of the other bright stars. The Orion Nebula (M42), just below Orion's belt, appears lilac on this film; other films render it slightly more reddish. As it is a dim, diffuse object moving across the film, the saturation is never very strong. Pictures like this are a useful general representation of the colors of the stars (see also Figure 16.1).

When the film has been processed, not only will the 10-minute exposures record the stars as trails, thereby demonstrating the 15° per hour rotation of the Earth during the exposure, but also the trails will vary considerably in color. Exposures made with a driven camera aimed at recording the stars as points of light are often long enough for the brighter stars to overexpose and therefore appear whitish in color. With photographs of trails, the light from the individual stars slowly moves across the film, so the degree of exposure of each part of the film the trails cross is much less, and so more color is present.

The whites, light blues, yellows, oranges and reds in your photographs are not scientifically accurate records of the colors of the stars, since a number of variables are involved, including how well the different color-sensitive layers in the film have been balanced by the manufacturer. Nonetheless, the colors are usually a good approximation, and photographic film has a greater ability to distinguish (and record) the hues than do our dark-adapted eyes. So in photographs we see white Castor next to yellow Pollux in Gemini; the massive, orange-red Betelgeuse in Orion compared with the brilliant white Rigel, which is 60,000 times more luminous than our Sun (see Figure 8.1); and the blueness of Vega in Lyra contrasting with the light orange of Arcturus in Boötes. The different colors of the stars revealed by such straightforward exposures are actually indications of their different surface temperatures. This is the basis of stellar spectroscopy. By studying a star's spectrum, much can be discovered about its physical condition and composition. Spectroscopists classify stars according to their spectral type: from the very hot O-type stars, down through B (hot and white, like Rigel), A (cooler white stars such as

Figure 8.2 Star trails around the celestial pole are among the simplest yet most dramatic images that can be taken with a fixed camera. This is a 30-minute exposure on ISO 200 professional color transparency film using an f/1.4 35-mm Nikkor lens stopped down to f/2.8 to limit any airglow effect. The summit of Teide, the highest volcano in the Canary Islands, adds power to the composition. Polaris in the center scarcely appears to have moved but the extent of movement by the stars toward the edge of the frame is evident.

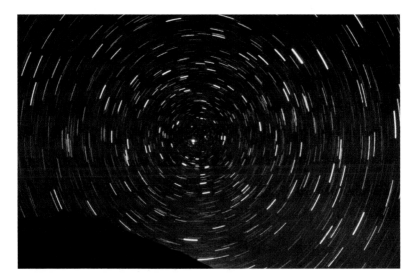

Sirius, the brightest star in the night sky), F and G (yellow like our Sun), to K (orange like Arcturus) and M (orange-red like Betelgeuse).

The picture centered on Polaris (Figure 8.2) will also show different colors. However, its greatest interest is that it demonstrates how Polaris lies very close to the celestial north pole, because it trails very little in photographs taken with a wide-angle or normal lens. The trails of the stars around it increase in length (despite them all having been recorded for the same amount of time) the farther they are from the pole: as their declination decreases, they appear to travel farther (or move faster, to put it another way). This intriguing demonstration of celestial geometry is matched by that in the picture of the celestial equator (Figure 8.3). Here the stars right on the equator appear to be traveling in straight lines and for the greatest distance, while those to the north record increasingly curved (but shorter) trails the farther they are from the equator, and the stars to the south behave similarly, although the curve is in the opposite direction, that of the south celestial pole. Both pictures are quite simple to obtain, yet they suggest extremely well, within the inevitable limits of a flat surface, the three-dimensional nature of the celestial sphere above our heads.

Figure 8.3 *A 10-minute exposure is long enough to demonstrate clearly the apparent paths of stars at the celestial equator. The region shown here is between Leo and Virgo, and the equator is about two-thirds of the way up the frame. At top and bottom of the image it is clear that the star trails arch in opposite directions, toward the north and south celestial poles, respectively. A 50-mm f/1.4 lens was used for this picture, and the original was on Agfachrome 1000RS Professional film.*

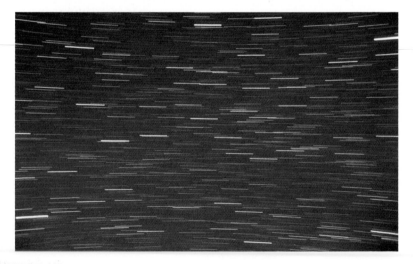

As with many other pictures, the addition of pictorial elements in the foreground can heighten impact – a mountain or castle beneath Polaris or a constellation angled close to the horizon and reflected in water. But the main reason for suggesting starting with the simplest exercises in star photography is that, notwithstanding the simplicity, sound knowledge is derived from the results.

The stars as "points of light"

While photographing star trails is an encouraging and instructive beginning, it will be only a matter of time before the newcomer wishes to record the stars as they appear to the eye. As the approach of this book is to consider astrophotography using essentially photographic rather than astronomical equipment, the major question is how to overcome the effects of the Earth's rotation within this limitation.

In Chapter 2 reference was made to the focal length of lenses, and to the fact that the stars (which are point sources as opposed to extended objects) are so far away that their image size on film is not related to focal length. While we may talk loosely about their images on film as being points of light, this is not in fact accurate. The magnitude of a star, the characteristics of lens and film, the length of exposure, and the state of the atmosphere all affect the end result. A bright star such as Vega, for example, will record on film as a much bigger "point of light" than a fainter star will, and image size will increase with exposure (see Figure 8.4). The concept of the image size of a star on film is important because if there is some exposure threshold below which a star will record without it trailing as a result of the Earth's rotation, then the goal of taking more realistic pictures is within reach.

Some years ago, the American lecturer and writer on astrophotography Barry Gordon devised such a value based on a combination of experience and calculation. He selected 0.05 mm as a trail length which is short enough to be indistinguishable from a point image on a frame of 35-mm film. From there he calculated that for the fastest-moving stars (those at the celestial equator) any exposure in seconds shorter than $700/F$, where F is the focal length of the lens in use, will yield essentially trail-free images. (For the hypercritical, $500/F$ yields a trail length of 0.036 mm, which is nearing the limits of a film's resolution.) The value for stars away from the equator – which, as our trail pictures have shown, appear to move more slowly – grows more in the photographer's favor, and for stars at declination 50° the maximum exposure time goes up to $1000/F$ seconds. This means, therefore, that if we are using a standard 50-mm focal length lens, exposures of up to $700/50 = 14$ seconds are possible before trailing becomes apparent.

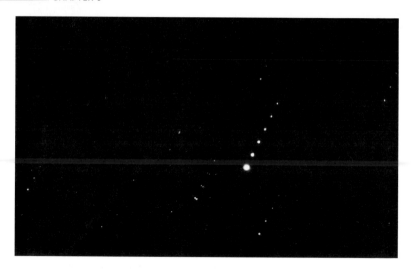

Figure 8.4 When is a point source not a point of light? The answer should perhaps be "always." Lens characteristics (for example, shooting at different f-numbers) as well as overexposure or underexposure can affect the apparent size of a star on film. Here the brilliant star Vega was photographed (together with some nearby companions) using a Noct-Nikkor 58-mm f/1.2 lens. However, the governing factor here is gross exposure. The lens was first opened to its widest aperture of f/1.2, and a 4-second exposure made. After waiting for 2 minutes to allow Vega to move far enough for the next image to be exposed on a different part of the film, another 4-second exposure was made with the aperture at f/2, and so on down to f/8. An ISO 400 black-and-white film was used. This experiment demonstrates how bright stars become overexposed in time exposures calculated to record fainter stars.

Of course, all the other factors must be such as to allow an exposure of this duration. The main factors are film speed, film latitude, lens speed, star magnitudes, and the condition of the atmosphere (which can attenuate the light from stars drastically). Remember, too, that when photographing point sources it is the absolute diameter of the lens that is important, not the focal ratio. As we have seen, a lens's absolute diameter is calculated quite easily by dividing its focal length by its focal ratio; thus, a 50-mm $f/1.8$ lens has a diameter of just under 28 mm. Because there are so many variables, guidance on exposures can only be approximate. Table 8.1 gives suggested exposures for stars to just beyond naked eye visibility (approximately magnitude 6) for various lenses when used at maximum diameter or aperture (that is, not stopped down).

Certain features of camera design, for example the need to reduce vignetting (the darkening of an image toward the edges) to a minimum, and for the back of the lens not to foul the reflex mirror, result in many lenses being constructed in such a way that finding their effective diameter is not a matter of performing a simple division sum, as described above. The front diameter in such lenses is in fact larger than the *f*-number would suggest. The calculations become a little complicated, but the values given in Table 8.1 still provide a good starting-point for experimentation. The wide-angle 24-mm focal length lens would be regarded by the everyday photographer as quite fast, but its diameter is so small compared with the other lenses that relatively lengthy time exposures are required when it is used to photograph the stars. This was why a note of caution was sounded in the previous section when it was suggested on grounds of field of view that a 24-mm focal length lens might be used as the standard focal length for a constellation photography project.

Stopping down a lens inevitably reduces its effective diameter. If the lenses listed in Table 8.1 are stopped down to their next focal ratio value, the diameter too is reduced, to the extent that time exposures on ISO 1000 film have to be increased to those appearing in the ISO 400 film column.

We may now revert to the formula for trail-free star images. Using a 50-mm focal length lens gives us a safe exposure time of around 14 seconds if we assume that we are photographing stars on the celestial equator, but about 20 seconds if our subjects are around 50° declination, say Ursa Major, Perseus, Andromeda, Cygnus or Auriga. The figures for the 35-mm wide-angle lens are better, at 20 seconds and almost 30 seconds, respectively. The 180-mm focal length lens in these two cases yields trail-free time exposures of only about 4 and 6 seconds, but because it has a much bigger diameter it is by no means at a disadvantage. Correlating these figures with those in Table 8.1 indicates that when using high-speed films of ISO 1000 and above in a fixed camera with a fast standard lens fitted, we can secure photographs of stars down to magnitude 6 which are essentially free of trailing.

TABLE 8.1 SUGGESTED EXPOSURE TIMES FOR RECORDING STAR IMAGES WITH A FIXED CAMERA				
Lens and absolute diameter	Film (ISO speed) 200	400	1000	1600
24 mm *f*/2.8, 8.6 mm	15 min	8 min	4 min	2 min
35 mm *f*/1.4, 25 mm	2 min	1 min	30 s	15 s
50 mm *f*/1.8, 28 mm	2 min	1 min	30 s	15 s
85 mm *f*/2.8, 30 mm	2 min	1 min	30 s	15 s
180 mm *f*/2.8, 64 mm	30 s	15 s	8 s	4 s

If we curb our ambitions and aim to record stars only down to magnitude 3, for example, then the exposure times are shortened considerably. With ISO 1000 film and a 50-mm f/1.8 or 35-mm f/1.4 lens at maximum aperture, the required exposure time is only 4 seconds. Even the 24-mm f/2.8 lens yields a more manageable exposure of 30 seconds.

While it is still broadly true that slower films yield higher-quality pictures than do faster films, evolving film technology has created not only a revolution in film speeds but also has made possible levels of quality that were quite unheard of just a few years ago. These improvements have affected black-and-white as well as color film (both transparency and negative). It is these changes that have given the newcomer to astrophotography the chance to photograph the constellations with what is in effect non-astronomical equipment. It is a revelation for people who have been taking astrophotographs for some years to see the way in which exposures of a matter of seconds can in optimum circumstances begin to record diffuse nebulae – objects which previously required exposures of many minutes. These developments are all extremely encouraging, and it is almost certain that the exposures given in this section will be found to understate the potential of some films: for example, one film may have more latitude, or better reciprocity characteristics, than another and will therefore record stars fainter than the target magnitude 6. Thus as part of your test program you should compare different films of nominally similar speed. Color rendering of the dark sky in particular is another important consideration. Most of the films we purchase are intended for general-purpose photography and, when used in the extreme circumstances of astrophotography, can sometimes produce bizarre results.

Despite this optimism, we should be aware that we are pushing at the limits. We are, in effect, "snatching" pictures to combat the rotation of the Earth. To do this we are using fast lenses wide open (here focal ratio and diameter are as one), and once again must recognize that we never get something for nothing. Using lenses in this way exacts penalties. Off-axis coma and other aberrations present problems, and it is an unpalatable truth that wide-angle lenses in particular may perform best at about three stops slower than the maximum (see Figure 8.5). Although not strictly an aberration, vignetting is also likely to take place. We can compensate for these drawbacks to some degree by keeping important objects away from the edges of the field of view whenever possible. But how can this be done with a large constellation which is filling the frame? In some circumstances we may just have to grin and bear it.

Figure 8.5 These three images all feature the unofficially titled Summer Triangle – a most apt description of the asterism formed by the stars Vega in the constellation Lyra (toward the top in all three frames); Deneb in Cygnus (toward lower left); and Altair in Aquila (toward the right edge of each frame). The top image was taken with a 35-mm f/1.4 wide-angle lens on ISO 1000 transparency film with the lens wide open. The camera was mounted on a tripod and the exposure was for 20 seconds only. This tactic succeeds in obtaining the main elements of the asterism very well and limiting any trailing, but the use of the lens at maximum aperture results in the off-axis aberration of coma causing the major stars to appear trumpet shaped. The middle frame is of approximately the same area and was exposed on ISO 400 transparency film through the same focal length lens. But the lens was stopped down to f/2.8 and the exposure lasted for 10 minutes, with the camera being mounted on a camera drive. Many more stars can be seen, and closing down by two stops has greatly reduced any off-axis aberration. The final frame was exposed on ISO 400 Kodak Elite transparency film through an f/3.5 18-mm wide-angle Nikkor lens. Although covering an enormous area, applying the formula for recording stars of focal length divided by focal ratio to find effective aperture, this must be

regarded as a very "slow" lens. The exposure was for 15 minutes using a drive-mounted camera. Despite the slowness of the lens, not only many stars but also the Milky Way itself is well seen. This better than expected result was doubtless due to the characteristics of the particular film used. More information was "hidden" in the image as can be seen in Chapter 15, Figure 15.24.

Sky glow and light pollution

Nor do the problems stem only from within the camera and lens. The very fast focal ratio of our lenses, combined with fast films, records extended objects quickly – and there are two such "objects" which can intrude strongly into our pictures: surprisingly, the night sky itself and light pollution (see below). A phenomenon called the *airglow*, a faint luminosity caused by solar radiation ionizing atoms and molecules in the upper atmosphere, can be recorded in relatively long exposures. If the sky in such exposures appears to be pale green, it could be airglow because this is the wavelength emitted by atomic oxygen. There should be no problem with exposures of up to a few minutes, but airglow could certainly be recorded in the 10- to 30-minute exposures recommended earlier for star-trail photographs. This is why I have suggested that the focal ratio used should be held to $f/2.8$ and no faster. Although not perhaps so exotic, moonlight has an obvious and even more powerful ability to render the fainter stars invisible. In a long-exposure photograph taken when a full or near-full Moon is up, the sky appears almost as blue as it does during the day. A crescent Moon is bearable, but as the phase grows the deep-space astrophotographer admits defeat and turns to tasks such as checking equipment or preparing plans for the future.

Light pollution is a serious problem (see Figure 8.6). In and around large urban areas its effects are obvious. The sky is not black or even dark at all, and only the brightest stars can make themselves visible. The high-pressure sodium streetlights that now predominate in so many localities produce a pall of orange light that covers the sky, and grows brighter the closer our eyes or cameras look toward the horizon. In areas that are lit by mercury streetlights, a greenish blue pervades the sky. At fast focal ratios, color film rapidly records the predominant color of the light pollution, and many of the less bright stars are lost to view.

If you cannot get to a site free from light pollution, its impact can be limited by using slower focal ratios. But this also reduces the effective diameter of the lens, so while the light pollution may be curtailed, the fainter stars will also be lost. A more sophisticated remedy is to switch to a lens with the same diameter (and therefore the same starlight-gathering power) but longer focal length, and hence slower focal ratio. The problem then will be whether the longer focal length (taken with other factors) will permit an exposure short enough to avoid star trailing.

While I do not wish to over exaggerate the limitations imposed on the astrophotographer by light-polluted skies, it can be a serious problem and something of which the newcomer should be fully aware. Creative use of the lens may help, and when you have more experience

you may decide to buy one of the special filters designed to limit the effects of light pollution and at the same time enhance contrast to bring out faint objects like nebulae. The US company Lumicon, for example, has developed a range of such filters for visual observing and photography. These include a Deep-Sky Filter™, a UHC (Ultra High Contrast) Filter™ and an Oxygen-III Filter™. But filters like these are not cheap, and in the end the only effective solution might be to travel to a location with darker skies. Once again, tests should be conducted over a range of time exposures, from say 10 seconds to 10 minutes in a number of steps, and a critical evaluation made of the results.

As experience is gained, star maps or planispheres become easier to read and relate to the sky overhead. To track down fainter objects (and in the absence of a computerized star-finding system of the kind now supplied increasingly with telescopes – see Chapter 15), the more experienced astronomer or astrophotographer *star-hops* from stars whose locations in the sky are known, via less well known stars located on the star maps, until the target object is located. I have found that if the search area has been previously photographed, then star-hopping with

Figure 8.6 Light pollution is a constant problem when making long exposures in film cameras in urban areas. The delightful-looking constellation Delphinus (which does surprisingly look like a dolphin!), between Aquila and Pegasus, appears toward upper right in both frames. The first was exposed in the heavily light polluted skies of my home area for 10 minutes on ISO 400 transparency film at f/2.8 (two stops down on the 35-mm f/1.4 lens). The second image exactly replicated the details of the first, other than being taken in good sky conditions. The difference is dramatic. Filters can improve the situation somewhat but the only solution is to seek out a dark sky (or switch to a CCD if imaging objects covering a very small area).

the aid of a black-and-white photographic print is easier. This is probably because the photograph is more realistic than a line drawing on a star map, particularly in its reproduction of star magnitudes. So our early work may well pay practical dividends in later years.

Tracking the stars

A means of breaking away from the restraints imposed by the rotation of the Earth is to fix the camera to a mount that rotates in the opposite direction so as to compensate. The axis of the mount is aligned accurately on the celestial pole, and the platform to which the camera is attached is driven by an electric motor so as to move through right ascension, parallel to the celestial equator. These mounts are therefore known as *equatorial mounts*. The camera can thus track the stars at a rate equivalent to one revolution in just under 24 hours – the sidereal rate – so that relative to the camera they appear stationary (see the second and third images of Figure 8.5). This is the system used on many telescopes as well as on specially designed camera mounts.

Initially, the beginner will probably consider these equatorial mounts a little too advanced, but good results and valuable experience may be gained from a simple manual mount which can be built without too much difficulty. Designed in the mid-1970s by Scottish astronomer George Haig, it is known as the *Haig mount* or (perhaps with due regard for the modest cost incurred in making it) the *Scotch mount* (see Figure 8.7). Astrophotographers in the US often refer to this home-made piece of equipment as a *barn-door* or *tangent-arm drive*, and there are rival US claims for its invention.

The implications of the use of this or any equatorial mount are immediately evident. Longer time exposures are made possible, and film and lens settings can be selected for optimum effect (such as limiting aberrations) rather than being forced by the need to avoid star trailing when a fixed camera is used. One such photograph is shown in Figure 8.8.

The main base or "anchor" of the Haig mount is a block of wood about 30 cm (12 inches) or so long, with a cross-section of some 7 × 10 cm (3 × 4 inches), as in Figure 8.9(a). One end is sawn carefully at an angle equal to that of the latitude at which it will be used (for example, 51° for the south coast of England or 34° for Los Angeles). A piece of board at least 15 × 30 cm (6 × 12 inches) in area and up to 15 mm (over ½ inch) thick is fixed to the sawn end by glue and/or wood screws. Another board of the same dimensions is attached to it by means of a long hinge (or two hinges very accurately aligned with each other).

A drive screw or bolt is inserted through the fixed board at a distance from the hinges calculated such that one complete revolution of the

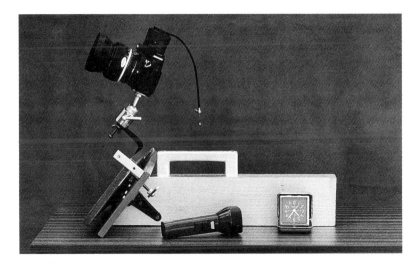

Figure 8.7 *A Haig mount placed on a firm base, with clock and red-light torch/ flashlight. The hinge is on the far side, out of view, but clearly seen is the rotating bolt,* *which at one revolution per minute slowly opens the boards, enabling the camera to track the stars. This particular Haig mount was made by Mr Haig himself.*

screw will move the other board by the correct angular rate to track the stars. This depends in turn on the pitch of the screw (see the caption). A tapped bearing for the bolt may be set into the fixed board, but it is quite adequate to make a slightly undersized hole in the fixed board, work the screw through once or twice, and then lubricate the hole with Vaseline or grease before threading the bolt in again and leaving it in position. A slender strip of metal or thin plywood is attached to the head of the screw so that it may be turned by one finger without setting up vibrations in the mount.

The camera bracket, which can be home-made, as shown in Figure 8.9(a), or a shop-bought photographic ball-and-socket head, as shown in Figure 8.9(b), is fixed to the moving board as close to the hinges as possible to achieve maximum rigidity. A retaining bracket, which prevents the hinge boards from flapping open when the mount is being carried, and a carrying handle are two optional extras fitted to the mount shown in Figure 8.7.

While one or two people claim to have been successful, in my view no attempt should be made to fit the mount to a tripod since it could not possibly be fixed firmly enough. The mount should be placed on a level and wide wall top, a steady table, or some similar surface providing convenient access for rotating the drive screw in time with the

second hand of a watch or clock. Polar alignment along the hinge line is carried out by using a small mirror, as shown in Figure 8.9(c).

I have found the most convenient operating arrangement to be that shown in Figure 8.7, seating myself to one side of the table, with a small clock clearly in view. After preparing the camera, the lens is covered with a black card and the shutter locked open by a cable release. The clock is already running (illuminated by a discreetly angled red-light torch/flashlight), and at a suitable moment, when the second hand is pointing to 15, 30, 45 or 60, the card is removed and rotation of the drive screw is begun. In tests conducted with lenses up to 50 mm in focal length, I have found it entirely satisfactory to move the drive screw by a quarter-turn at 15-second intervals, although once experience is gained it is quite easy to keep pace with the second hand of the clock in a continuous movement. Doubtless, the ingenious will think of ways to power the mount by a small electric motor capable of rotating the bolt at one revolution per minute.

Figure 8.8 A 4-minute exposure of the Taurus area using a Haig mount. Using the mount rather than a fixed camera position enabled the 35-mm wide-angle Nikkor lens to be stopped down from f/1.4 to f/2.8 for better control of off-axis aberrations such as coma. The film was Tri-X, rated at ISO 400 and developed in HC-110 (dilution B). Right of center are the Pleiades, with the V-shaped Hyades cluster and Aldebaran below and to the left. The top of Orion (with Betelgeuse prominent) is at bottom left, Auriga is toward the top left, and part of Perseus lies above the Pleiades.

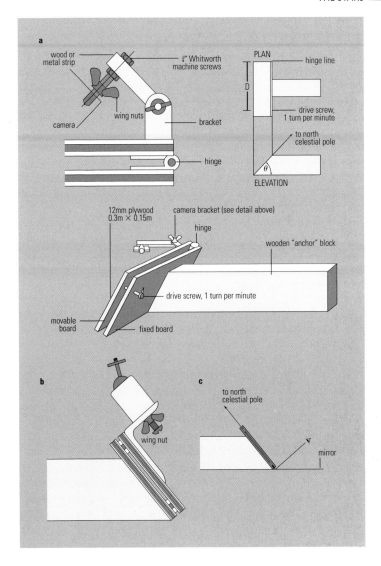

Figure 8.9 *(a) Construction of the Haig equatorial camera mount. Critical dimensions are the angle θ, which must equal the observer's latitude, and the distance D. D is 229 mm for a 6-mm SI or 0 BA screw, with a 1 mm per turn thread; but it is 291 mm for a $\frac{1}{4}$-inch Whitworth screw with 20 turns to the inch. (b) A ball-and-socket head can be used for the camera bracket. (c) Polar alignment is by sighting along the hinge line. The angle of the mirror is not important – it need not be horizontal. (By courtesy of George Y. Haig.)*

The planets

For more than four decades, interplanetary spacecraft operated by NASA in the US and other nations' space organizations have sent back to Earth many thousands of pictures which have been not only of great scientific value, but also often beautiful and awe-inspiring. We have seen as though we were there the alien surface of Venus, the deserts and volcanoes of Mars, the multicolored belts and zones of Jupiter's atmosphere, the exquisite rings of Saturn, the strange distant worlds that are Uranus and Neptune, and the exotic surfaces of the moons orbiting the gas giants. When not searching the far reaches of deep space, the Hubble Space Telescope has also returned splendid images of the Earth's neighbors.

Such pictures may give newcomers to astrophotography high expectations of what can be achieved. It is well to make clear from the outset that planetary photography is one of the most difficult undertakings for even the highly experienced astrophotographer. But all is not lost for the novice. Good pictures can be taken and the much publicized gathering of five planets in the evening sky during April and May of 2002 provided an excellent opportunity to do so (see Figure 9.1). We have to accept the limitations, however, that result from the nature of the planets and of our basic photographic equipment.

Variations in size

Since they are members of the Solar System, the planets are on the Earth's doorstep compared with the stars, but they are still relatively small. Their actual sizes and distances from the Sun are given in Table 1.1 (page 17). Their apparent sizes as seen from the Earth vary according to the positions of the Earth and the planets in their respective orbits (see Table 9.1). At its best, the Earth's nearest planetary neighbor, Venus, is about one-thirtieth the size of the Moon when full. We can work out its size, in millimeters, on a 35-mm film frame from a modification of the formula given in the previous chapter:

$$\text{image size} = a \times f/206{,}280$$

where f is the focal length of the lens in millimeters and a is the apparent size of the object in arc seconds. For Venus's maximum size and a powerful lens of 1000 mm, the formula yields an image size of 0.32 mm. This is certainly bigger than the smallest point sources our lenses and films can resolve and record, but is not very exciting, to say the least. Since Venus at the optimum time is the largest of the planets as seen from the Earth, we are faced squarely with a problem of focal

length. If 0.1 mm is taken as the image size that is the threshold between an object acting as a point source on the one hand and an extended object on the other, then the focal length required to secure it varies from about 500 mm for Venus and Jupiter to not far off 10,000 mm for Neptune. But 0.1 mm is still very insignificant (the dot over an "i" in a very small typeface, perhaps), and to reach image sizes where, all things being equal, some detail can be discerned demands a focal length of around 10,000 mm for Venus and Jupiter and about twice that for Mars and Saturn. This is without considering tiny Mercury on the one extreme and distant Uranus and Neptune on the

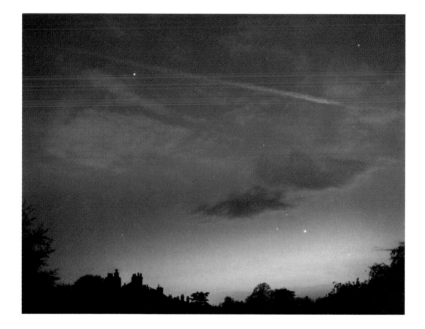

Figure 9.1 *2002 May 4 and the conjunction of five planets is in full swing. As ever, the prime imaging problem was the difference in the magnitudes of the planets, ranging from −4 for Venus to +1.5 for Mars in mid April. In addition, there was always the risk of twilight, dust and cloud toward the horizon making Mercury difficult to record, although it put on one of its better performances and is quite clear in this original image. The identification of the planets and stars is given in the computer program section of Chapter 15 (see page 234). Ektachrome E200 Professional transparency film was loaded in a Nikon F3HP camera with a 35-mm f/1.4 wide-angle lens fitted. This was stopped down to f/2.8 and the exposure was for 1 second. The clouds added to the interest of the picture but patience was required to wait for periods when all five planets were clear!*

TABLE 9.1 APPARENT DIAMETERS OF THE PLANETS, IN ARC SECONDS	
Mercury	5–13
Venus	10–65
Mars	4–25
Jupiter	31–50
Saturn (disk)	15–21
Saturn (rings)	35–49
Uranus	3.1–3.7
Neptune	2.0–2.2
Pluto	0.06–0.1

other. And if those planets are extremely difficult for our purposes (see Figure 9.2), tiny Pluto may be dismissed completely.

Such focal lengths are clearly beyond the newcomer to astrophotography, but fortunately there are some things that can be done nonetheless. The magnitudes of the planets vary according to their size and distance from us but, if we strike an average, all the way out to Saturn they are, even at their very worst, on a par with the brighter stars (down to magnitude +1.4 for Saturn at its most distant).

Table 9.2 gives exposures that can be used as a basis for a first exploration of planetary photography, using two lenses of moderate focal length but quite wide diameters. Remember again that, since the planets behave as point sources at these focal lengths, lens speed depends on absolute diameter, not focal ratio. (While Uranus is marginally within the scope of a fixed camera, Neptune certainly requires a driven camera. Both are omitted from consideration for the rest of this chapter.) Although most of these exposures fall within the category of what earlier were termed "no man's land" shutter speeds, which test our technique to the full, they are nonetheless well within the bounds of achievability. The planets may appear to be small, but out to Saturn at least they are quite bright. This has the additional bonus of causing few worries when we apply the severe 500/focal length test for image trailing.

TABLE 9.2 GUIDE EXPOSURES FOR RECORDING THE PLANETS ON ISO 400 FILM, FOR TWO LENSES		
Planet	180 mm f/2.8, 64 mm diameter	50 mm f/1.8, 28 mm diameter
Mercury	1/15 s	1/4 s
Venus	1/250 s	1/60 s
Mars	1/8 s	1/2 s
Jupiter	1/60 s	1/15 s
Saturn	1/8 s	1/2 s
Uranus	15 s	1 min
Neptune	2 min	8 min

Separated though they are by many tens and even hundreds of millions of kilometers, the planets frequently appear to be close to one another in the sky. These conjunctions are line-of-sight effects which present various types of picture opportunity. In the first instance, the photographer can secure images of planets in the same field of view without too much regard for other objects, such as stars. While a compromise exposure or bracketing will be required if, say, Mars and Jupiter are included together in the field of view (as is evident from Table 9.2), the relative brightness of the two is close enough not to result in severe overexposure or underexposure at any reasonable set-

Figure 9.2 *The constellation Sagittarius frequently holds a rich photographic harvest of objects. Included here in the summer of 1989 are the planets Saturn, Neptune and Uranus, the asteroid Vesta, and a number of Messier objects. The essential requirement for a picture of this kind is a tracking mount, but otherwise all that is needed is care – and a knowledge of this feature-packed area of sky. The exposure was for 25 minutes on hypersensitized 2415 film (see Chapter 15). The camera was a Nikon F4S with a 180-mm f/2.8 Nikkor lens fitted. A deep red filter was used to combat the light pollution, which was worsened by the low altitude of Sagittarius as seen from the UK. Saturn was inevitably overexposed in such a long exposure, but in no way does this spoil the image.*

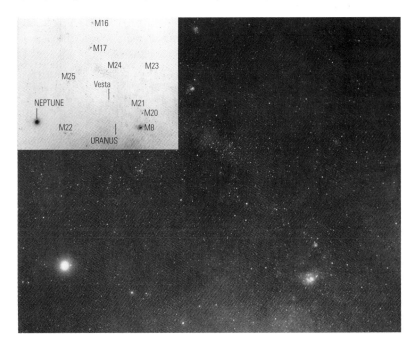

ting. However, beyond satisfying yourself that you can take such a picture, there is little lasting interest in recording two points of light on the same piece of film.

Much more interesting is to photograph Jupiter with one or more of its four major moons – Callisto, Ganymede, Europa and Io. Ganymede is the largest, with an apparent diameter of 1.5 arc seconds, so endeavoring to photograph it and the others (if not hidden by the planet) is a major test of lens resolution in particular and equipment/photographer capability generally. When Jupiter is closest to the Earth, the moons have magnitudes of between 4.6 and 5.7 compared with Jupiter's −2.7, so in any images of the moons Jupiter is bound to be overexposed. With a 1000-mm $f/11$ mirror lens and ISO 400 film, the moons require an exposure of at least 2 seconds (where some slight trailing may be expected), whereas Jupiter itself normally requires only about 1/60–1/125 of a second. A sequence of exposures between the two is indicated, and Figure 9.3 is an example of what can be obtained.

Lunar occultations of planets

It is well within the capability of photographic lenses, especially those of longer focal length, to record occultations by the Moon of planets and stars. As a result of the Earth's rotation the Moon appears to move westward as night progresses, while by virtue of its orbital motion around the Earth it is actually moving eastward with respect to the background stars and planets at a speed of about 1 km/s (0.6 mile/s), or across a space equal to its own diameter in an hour. Inevitably, therefore, it passes in front of other bodies. Such events, known as *occultations*, are awaited with some eagerness by enthusiasts since careful timings of the beginning and ending of an occultation can provide valuable, additional information about the occulted body as well as the Moon's position in its orbit.

The event can be dramatic, too. If the Moon is waxing, the dark lunar limb reaches the star well before the daylit portion and causes it to disappear quite suddenly (demonstrating, incidentally, that the Moon has no appreciable atmosphere: if it had, the object would fade gradually). If the Moon is waning, the reverse happens and an occulted star will suddenly appear when the Moon's dark trailing limb uncovers it. Of course, there are also appearances and disappearances at the bright limb. The leading edge of a full or waning Moon approaching a star or planet can be watched until the last second. And, knowing the speed of the Moon eastward in its orbit, and given advance information on the object's path behind the Moon's disk, a watch will give a good indication of when an object will reappear at the bright limb of a full or waxing Moon.

The disappearance of planets behind the Moon tends not to be so sudden, mainly because unlike stars they have an appreciable angular size, but also because they too are usually traveling with the Moon in an easterly direction, although not as quickly as seen from the Earth. Longer lenses are obviously preferable in recording such an event (see Figure 9.3). While the Moon is an extended object, at the focal lengths necessary the planets separate into a mixture of extended objects and point sources; however, the differences are manageable. Table 9.3 gives some target exposures. With ISO 400 film, a typical exposure for a crescent Moon could well be 1/60 of a second at $f/11$, and that for a full Moon 1/250 or 1/500 of a second at the same aperture. This clearly demonstrates that for the most part occultations taking place during a

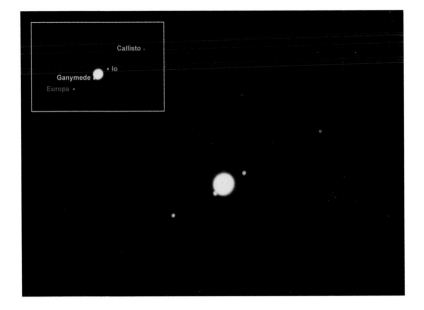

Figure 9.3 Except as a result of post-exposure manipulation, the difference in brightness between Jupiter and its Galilean satellites is too great for a single exposure to record all five bodies satisfactorily. This image was taken on 2002 April 25 with a lens/teleconverter combination yielding a focal length of 3000 mm, which, while it increases the size of the subjects, inevitably reduces the amount of light reaching the film. Jupiter itself reproduced well in exposures of between 1/60 and 1/30 of a second, but the moons required between 4 and 8 seconds, this image being of the latter duration. Jupiter is inevitably grossly over-exposed. The film used was Ektachrome P1600X.

TABLE 9.3 GUIDE EXPOSURES FOR RECORDING LUNAR OCCULTATIONS ON ISO 400 FILM, FOR TWO LENSES. VENUS AND JUPITER ARE TREATED AS EXTENDED OBJECTS		
Planet	500 mm *f*/8, 62 mm diameter	1000 mm *f*/11, 91 mm diameter
Venus	1/2000 s	1/1000 s
Mars	1/8 s	1/15 s
Jupiter	1/250 s	1/125 s
Saturn	1/8 s	1/15 s

waxing or waning crescent phase of the Moon present few exposure balancing problems if Mars or Saturn is the planet that is to be occulted, whereas Venus and Jupiter when treated as extended objects are perfectly compatible with exposures for the full Moon. How to obtain a photographic record of the progress of a lunar occultation is discussed in Chapter 15.

Conjunctions – pictorial opportunities

This all seems a little involved, so it is understandable that for many newcomers pictures of conjunctions of the planets will be the easiest and least demanding in terms of equipment. Unashamedly pictorial views at dusk or dawn may be composed around a very slender crescent Moon and an attractive foreground. This might be composed of trees or buildings, or even clouds – and there is no reason why any of these should not be lit, provided the light source is low level (see Figures 9.4 and 9.5) – and water provides the fascination of reflections. I suggest dusk or dawn photography partly because there may be a chance of capturing Mercury, the elusive planet closest to the Sun. But the main reason is that, although the human eye is not sensitive enough to see them, a relatively long photographic exposure can record delightful hues in the sky which are totally missing from the somewhat sterner exercises on the Jovian moons or occultations.

Usually, the lens for such shots could be the normal 50 mm, although I have found a 35–105-mm *f*/3.5 zoom very useful since it gives a flexibility that is well worth the slight disadvantage of speed loss. Table 9.2 gives target exposures for a 50-mm *f*/1.8 lens and ISO 400 film, which is again recommended because the grain structure of ISO 1000 and faster films becomes intrusive in the lighter skies of dusk and dawn. As the lens will have to be used wide open for the planets, and the values recommended for the Moon are *f*/8 and *f*/11, the Moon is certain to be somewhat overexposed. However, this need not be objectionable with the slender crescent phase. A wide bracketing needs to be attempted, with the longer exposures aimed at securing an attractive sky. I usually employ shutter speeds of 1/60, 1/30, 1/15, 1/4, 1/2, 1, 2, 4 and 8 seconds, with the fastest possible aperture. Although the plan-

Figure 9.4 In a dramatic sky over Houston in Texas, Jupiter is about to be occulted by a waning crescent Moon on the morning of 1990 August 18. Venus can be seen much closer to the horizon. ISO 400 color transparency film was loaded in a tripod-mounted Nikon F4S fitted with a 180-mm f/2.8 Nikkor lens. The exposure, one of a bracketed sequence, was 1/8 of a second at f/8.

Figure 9.5 *Oncoming dawn and dark clouds frame the waning crescent Moon and Venus just as well as a foreground of interesting rocks or trees might have. The sky is still dark enough and the phase of the Moon slender enough for earthshine to be recorded clearly, even though the daylit crescent is over-exposed. To the south (right) of Venus is the "V" formed by the prominent orange star Aldebaran and others, which is known as the Hyades. A 4-second exposure was given on Ektachrome ISO 200 film using an 85-mm Nikkor lens at f/2.8.*

ets vary a great deal in their brilliance (and none more so than Mars, from magnitude -2.9 to $+1.5$), bracketing is a rough and ready means of obtaining some satisfaction (see Figures 9.4–9.7).

The full Moon and Venus may be photographed in the same frame without problem, but the full Moon should be rigorously excluded from pictorial images that include any of the other planets. The attempt to accommodate their lower brightness by increasing the exposure will result in gross overexposure of the Moon and the likely creation of a ghost image of it. This is a form of lens flare caused by double reflection of the bright light source between the internal surfaces of the front and back components of the lens. Most lenses suffer from it to some degree if a brilliant light source is included in the field of view, the ghost usually being inverted and in the opposite side of the picture to the original. The only way to exorcize the ghost is to diminish its effective brightness by stopping down the lens, or to exclude the bright object from the field of view altogether.

I have omitted Uranus and Neptune (though see Figure 9.2) from most of this chapter, and ignored Pluto altogether, but what of Mercury? It must be admitted that the innermost planet of the Solar System is the most difficult subject among the remaining planets. Not only is it very small (its diameter is about one-third greater than the Moon's, although it is much farther away, of course), but also it orbits so close to the Sun that it is never seen in a dark sky from temperate latitudes. It is always quite close to the horizon, where it can be masked by atmospheric haze and air pollution. (However, some help is afforded by the planet being brighter in the first period of an evening apparition and the last period of a morning apparition.)

Figure 9.6 Photographs of planetary conjunctions with the Moon using conventional photographic lenses are enhanced by a colorful sky and an interesting foreground. Both are present in this photograph taken at the Cederberg Observatory in South Africa. A waning crescent Moon and Venus appear in a fiery red dawn sky as seen beyond the outline of one of the domes. The exposure of 1/2 of a second at f/3.5 on Ektachrome ISO 100 film was based entirely on the sky since it was intended that the dome should be a silhouette only. A 35–105-mm Nikkor zoom lens enabled variations in framing to be tried before choosing the best composition.

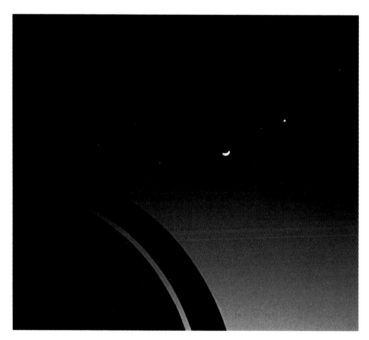

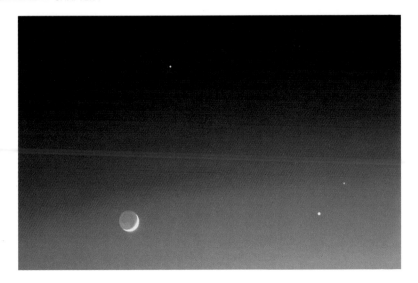

Figure 9.7 On 2000 April 15 there was a gathering of the three bright outer planets – Mars, Jupiter and Saturn – in the evening sky which, according to records and forecasts, was the most compact, visible gathering of the three taking place throughout the 179-year period between December 1901 and November 2080! This image was taken on April 6, a little over a week before, and includes a young Moon exhibiting earthshine. Saturn is above the Moon with Jupiter off to the right (north), and Mars above and to its right. ISO 400 transparency film was loaded in a Nikon F4S which was fitted with an 80–200-mm f/2.8 zoom lens. The exposure was 1/4 of a second.

Mars, because of its small size and all too frequent great distance from the Earth, can be difficult, although it does relent from time to time, as will happen in August 2003 when it will be at its maximum brightness possible when seen from Earth (and its brightest for some thousands of years!). Venus – the traditional evening or morning star – is by far the most brilliant of the planets, so much so that it creates something of an exposure problem when photographed with its less well endowed companions of the ecliptic.

A gathering of five planets

The final requirement for the newcomer to planetary photography is information about phases of the Moon and forthcoming conjunctions and occultations. This will be found in the astronomy magazines, some newspapers and of course in dedicated astronomical computer programs (see Chapter 15). Finding two planets within the field of

view of a normal focal length lens is quite common; three is by no means unusual, but greater numbers are rarer events. The gathering of Mercury, Venus, Mars, Saturn and Jupiter in the evening sky during April/May of 2002 gave rise to considerable publicity in the media. In fact something similar happened in May 2000 but was not seen from Earth because the planets were lost in the glare of the Sun. They will again be in the sky in the early spring and the month of December in 2004 but will spread over a length of 130° in the sky compared with the 60° of the 2002 apparition. After a passage of some decades, they will form a much tighter grouping (less than 10°) in the evening sky on 2040 September 7, but the continuing brightness of dusk will make seeing them difficult. The best view will occur almost twenty years after that when they are seen over a length of 23° due east in the early morning sky on 2060 July 10.

Even for experienced and skillful amateurs with sophisticated equipment the planets remain a stern challenge, as evidenced in Figure 9.8, but what can be achieved is developed further in Chapter 15.

Figure 9.8 This composite image acts as a bridge to Chapter 15, which demonstrates how the CCD comes into its own at the telescope when imaging the planets. The four images that were recorded on film are of reasonable quality but cannot match those taken with digital systems. They were exposed using a 1600-mm focal length, f/9 refractor telescope with eyepiece projection. From left to right: Saturn was exposed on ISO 1600 Professional transparency film for 2 seconds through a 12-mm eyepiece; a gibbous Venus was recorded on ISO 400 film for 1/2 of a second using a 7-mm eyepiece; Mars was recorded using the same eyepiece but the exposure was for 2 seconds on ISO 1600 film; and a 12-mm eyepiece was used to image Jupiter in an exposure of 2 seconds on ISO 400 film.

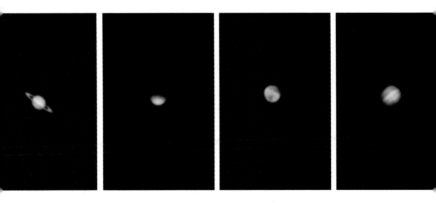

The Earth is a planet, too!

The title of this chapter needs some explanation. Few readers will see anything unusual in finding aurorae and noctilucent clouds featured in a book about astronomy, even if most of us do not see them very often. It may come as a surprise, though, to find phenomena such as rainbows, halos and lightning included here. But should we be surprised? When space artists portray the other planets of the Solar System, what may be called atmospheric and optical phenomena often feature prominently – and quite rightly so, as they lend a sense of reality and help to portray the physical make-up of those planets. I believe that astronomers should go some way along this path in studying the Earth. I realize that some of the subjects dealt with in this chapter might be regarded as "atmospheric physics," but they do portray various aspects of our dynamic Earth. If it were possible for any of us to travel to the surface of Mercury, Venus or Mars, or to orbit the gas giants, we would spend most of our time studying and photographing the kinds of phenomena discussed in this chapter. So why don't we do the same with Earth itself? On our imagined trip to other planets we would be taking many photographs of what on Earth would be called "landscapes" (though of an exotically different type), and we should not proceed too far in that direction. But dynamic and frequently beautiful images of the effects the Sun has on the Earth's atmosphere are themes I believe ought to be included in a book devoted to astronomical photography, particularly as good basic equipment can be used to capture many of these sights. First, though, we look at two striking nighttime manifestations of the Sun's influence.

Aurorae

The aurora borealis, or northern lights, is a nighttime display of shifting colored patterns most commonly seen at high latitudes – for example in Canada or Scotland. ("Aurora" is Latin for dawn.) The aurora australis is the southern hemisphere equivalent, but studies there have been hindered by the fact that the high southern latitudes contain few land areas. However, research into aurorae has intensified since the coming of the space age, and few who have seen them can have failed to be impressed by the images that were beamed back to control centers by spacecraft such as NASA's Dynamic Explorers. One such image showed a huge glowing oval about 4500 km (2800 miles) wide astride the geomagnetic pole and running through Siberia, Scandinavia, Greenland, Canada and Alaska. Whenever possible, the crews of space shuttle orbiters have added to the flow of images. A new view of the aurora, indeed.

The complex interaction between solar activity, the Earth's magnetic field, and the atmosphere that results in the aurora is still being elaborated, and questions remain unanswered. Suffice it to say here that aurorae occur at about 100 km (60 miles) and above in the upper atmosphere, and are linked to solar activity, particularly sunspots and flares. But even for those with scant technical interest, the spectacle of an aurora cannot fail to impress, and it makes a splendid subject for the camera (see Figure 10.1).

Sometimes an aurora is nothing more than a dim glow, not unlike moonlight. At other times we may be privileged to witness an exotic display of arcs, bands and rays in shades of green and red which sometimes hang motionless in the sky, and then suddenly begin rapid shifts and undulations which seem as though they should be accompanied by suitable, awe-inspiring sounds, but which take place in utter silence.

Aurorae vary greatly in brightness, from very dim to an intensity that can light up the surrounding countryside as though it were twilight. This variation in brightness and the large differences in speed of movement pose problems for the photographer, so bracketing is essential. Using a fixed camera with a 50-mm or wide-angle lens at maximum aperture (aurorae are extended objects) and loaded with ISO 400 or 1000 color film, exposures of up to 1 minute should be given for relatively dim and inactive aurorae. When they are bright and highly active, a stepped series of exposures of about 2, 5 and 10 seconds should be made. Anything much in excess of this will risk overexposure and therefore desaturation of color, as well as blurring and merging of the features. Differences between the peak sensitivities of eye and film (and the different UV transmission characteristics of lenses) will not infrequently result in the colors of the film record not according with visual memory.

How often you will have the opportunity to photograph aurorae depends on your geographical location. Most aurorae are confined to high latitudes, although activity can move much further south during periods of maximum sunspot activity. The great display of 1989 March 13/14, for example, was seen as far south as the Caribbean. The increase in auroral activity after the most recent sunspot minimum in 1996 has continued to be slow but there were at least five occasions during 2000 and 2001 when aurorae were witnessed on the south coast of England (see Figure 10.1(a)). Nonetheless, figures published by the Aurora Section of the British Astronomical Association (see Table 10.1) underline the relative infrequency of observed aurorae in more southerly latitudes together with their increased frequency at sunspot maximum (1979, 1989 and 2000)

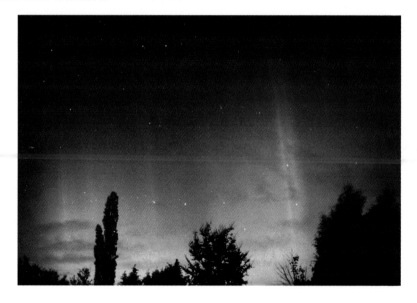

Figure 10.1 2001 October 21 and a coronal mass ejection from the Sun impacts the Earth and leads to aurora activity extending to southern England and beyond. The image at left (a) was exposed for 10 seconds on ISO 1600 color transparency film through a 35-mm focal length wide-angle lens stopped down from f/1.4 to f/2.8. The camera (a Nikon F4S) was mounted on a tripod throughout a series of exposures. The red hues of the aurora were considerable fainter to the eye but the relatively long exposure built up their saturation on the film. The view is to

compared with sunspot minimum (1986 and 1996). Even then, the occasional strong display can still be seen at sunspot minimum, as happened in 1986.

Noctilucent clouds

During summer months, aurora enthusiasts can either rest with the coming of night-long twilight and the midnight Sun, or turn their attention to noctilucent clouds. These are clouds that form at an altitude of about 80 km (50 miles) – above 99.9 percent of the atmosphere and about 65 km (40 miles) above the region of weather. At this height they remain illuminated by the Sun some time after sunset – their name means "luminous night clouds." Once they were believed to consist of dust particles of extraterrestrial origin that had become coated with ice, but a more favored view now is that small amounts of water vapor lifted above the stratosphere by the upwelling of cold air from polar regions freeze into ice clouds in the $-75°C$

the north and the main stars of the Ursa
Major asterism can be seen running
roughly parallel to the horizon where the
red of the aurora merges with light
pollution. In (b), at right, a total difference of
auroral shape and color presents itself. The
image was exposed from within the Arctic

Circle and on the deck of a coastal
steamer subjected to a fortunately gentle
swell which caused slight blurring –
although with an aurora this is very often
not evident! The exposure was made
through an f/1.4 50-mm lens for 5 seconds
on ISO 1000 color transparency film.

(−100°F) temperatures encountered there. Whatever their origin,
when seen edge-on the ice crystals reflect sunlight in white, blue or
gold hues depending on the position of the clouds relative to the hori-
zon, and are so thin that bright stars shine through them. They form
bands, veils, whirls, and billows that have been likened to the "waves
of a ghostly ocean."

Occurring from around late May to August in the northern hemi-
sphere, the clouds are a splendid subject from latitudes up to about 60°
for those lucky enough to witness them. Their movement can be very
fast, in excess of 500 km/h (300 mile/h), so shutter speeds also need to
be fairly fast. Using ISO 200 or 400 color film, an exposure sequence
of 2, 4, 8 and 12 seconds at f/2.8 at least is suggested.

Daytime subjects

The rest of the phenomena discussed in this chapter are to be seen
largely or exclusively in the daytime, and some general remarks

TABLE 10.1 NUMBERS OF AURORAE OBSERVED AT GEOMAGNETIC LATITUDES OF 53 TO 62°N IN YEARS OF SUNSPOT MAXIMA (1979, 1989 AND 2000) AND MINIMA (1986 AND 1996).

Year	Geomagnetic latitude									
	53°N	54°N	55°N	56°N	57°N	58°N	59°N	60°N	61°N	62°N
1979	8	9	20	23	25	62	90	104	138	140
1986	8	8	10	14	15	20	34	44	85	96
1989	2	5	8	17	39	44	71	85	146	154
1996	0	0	0	1	1	2	14	26	27	27
2000	2	2	3	3	3	10	35	42	61	69

Geomagnetic latitude is measured with respect to the Earth's magnetic axis, and differs slightly from geographic latitude. Thus the geomagnetic latitude of the English Channel is 53°N, compared with its geographic latitude of 50°N. The above figures are based on the assumption that if auroral activity is observed at one latitude, it would have been visible at all other latitudes northward.

need to be made. The equipment that has been recommended for most of the subjects covered in this book – the 35-mm SLR camera, a tripod and cable release when lengthy exposures demand them, and (usually) color transparency film – should still be used. (I realize that again I am showing a personal preference in stressing transparency film: many will choose negative (print) color film, as I do myself sometimes as witnessed in several of the images appearing in this chapter!) But there are some additions. Although many of the subjects considered on the following pages are often intrinsically quite bright, compared with their surroundings in the sky they are relatively faint. To deal with this we need to use films which are relatively slow and which as a result have inherently higher contrast characteristics. This means that whenever possible you should use the excellent ISO 50 films that are currently available from Kodak, Fuji and Agfa, with perhaps Kodachrome film to take the speed up to ISO 200 if needed.

Since many of the subjects will be very bright, I need to say a little about how an exposure meter works. It is calibrated on the assumption that a picture has a mixture of light and shade which approximates to an overall medium grey of 18 percent. Confronted with a very light scene, be it a sky, a beach or a snow-covered glacier, the meter endeavors to render it a medium grey, and a disappointing underexposure is the consequence. A rough-and-ready way of overcoming this difficulty is to increase the exposure by one half-stop or a full stop for such scenes. Alternatively, you can take a reading off your hand, or indeed from an 18 percent grey card, which is sold for this precise purpose.

The variety of subjects will also make additional demands on lenses. For some, like rainbows, you will need a wide-angle lens and one

of at least 24- or 28-mm focal length. If you have a very-wide-angle lens of 18 mm, so much the better. At the same time, you may wish to concentrate on particular phenomena, such as parhelia (see page 130), for which a zoom lens would be an advantage. If you have one of the ever more popular shorter zooms of 35–105-mm or 24–120-mm focal length, this will prove useful – particularly if you can extend its range by adding a ×2 teleconverter, though there is then a penalty to be paid in loss of lens speed. An 80–200-mm zoom would also be valuable. The reason I have recommended the zooms is that the search for some of the phenomena described in this chapter may take you on long journeys, and anything that cuts down the amount of equipment to be carried is worthwhile.

If your camera does not have a built-in exposure meter you will need to get a separate one, because a meter is used a great deal in calculating exposures for the sky and its contents. A polarizing filter used at approximately 90° to the direction of the Sun darkens the blue sky and is a valuable accessory. Finally, you must "be prepared." While weather conditions will help in anticipating some phenomena, others occur unexpectedly and unless you have a camera ready to fire, you will miss them.

Rainbows

Primary rainbows are caused by water droplets refracting light. A rainbow is an arc of a circle centered on the antisolar point, diametrically opposite the Sun on the celestial sphere, which is always below the horizon when the Sun is in the sky. Thus, if the Sun is high the rainbow will be low, and vice versa. If the Sun is out but there are plenty of heavy shower clouds around, then be prepared to see a rainbow in the sky opposite the Sun. Fainter secondary rainbows (outside the primary) and so-called supernumerary or interference rainbows (inside the primary) are not uncommon.

A polarizing filter will not help you in photographing rainbows because the Sun will be behind you and not to one side. Take a general reading with your meter. If you are facing an extensive rainbow seen against the backdrop of a large mass of dark cloud, the meter will give a reading which will tend to overexpose the rainbow. Take a reading of the foreground for a more accurate estimate, and in any case take at least one picture with the aperture stopped down by one half-stop. Slight underexposure when using transparency film can help to accentuate the saturation of colors in the rainbow. Of course, if there is a secondary rainbow it is usually much dimmer, so that it is possible the underexposure will substantially lose it. The answer is to make sure that you bracket exposures (see Figure 10.2), and I

Figure 10.2 *Successful rainbow images require skill and application. This picture was exposed on ISO 100 color transparency film to maximize contrast and sky quality as far as possible. Exposures were made through a 35–105-mm zoom lens with the focal length being varied as an aid to composition: exposures were bracketed but center-weighted metering was applied in automatic mode. Elements within a frame can result in more powerful rainbow records. Here the foreground is not dramatic but the positioning of the hedge relative to the bow and to a gibbous waning Moon results in somewhat more impact than an "empty" image of a rainbow would have had.*

would recommend two half-stops on either side of the exposure indicated by the meter.

If you have an automatic camera you can still achieve underexposure by dialing in a higher film speed than you are actually using. (But remember to change the speed back afterward.) Your camera may appear to read only the DX coding on the film cassette, but check that this is definitely so. Some cameras enable you to overcome this problem by a manual override, or by dialing in an exposure compensation value.

Usually, a rainbow is at its most intense for only a matter of seconds. You may be able to obtain a reasonable picture in the few minutes either side of maximum intensity, but you need to be alert to get the best possible result. Foreground interest too is important: a rainbow pictured suspended in the sky is "empty." Ideally the foreground should be an attractive one, but I am tempted to say that anything is better than nothing.

Halos

Like rainbows, halos around the Sun result from the refraction of light, but by ice crystals at high altitude rather than by water droplets. They usually occur in cirrus cloud. Figure 10.3 shows the appearance of the 22° halo and the less frequent 46° halo, together with other features associated with them (these values are the halos' radii).

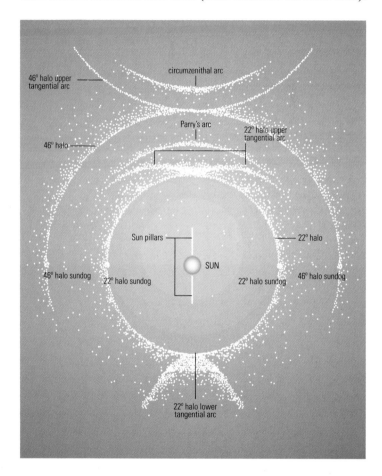

Figure 10.3 *Some of the commonest solar halo features, many of which can be seen together in the sky at the same time. The appearance and location of these effects vary with the Sun's altitude. For example, the two 22° halo sundogs are on the halo itself when the Sun is on the horizon. But as the Sun climbs in the sky they move further out, fading and disappearing altogether when the Sun reaches an altitude of just over 60°.*

Halos also differ from rainbows in that once a halo (and any subsidiary features) has appeared it usually lasts a considerable length of time – sometimes for hours – so there is no need to rush the photography.

To photograph an entire halo requires a wide-angle lens, and I have tended to use a fisheye lens (see Figure 10.4). Ideally you should compose the picture so that the Sun is blocked out by a suitably positioned tree or some other feature. When there has been no convenient obstruction I have, with a *very* quick glance through the viewfinder, positioned the unadorned Sun at center frame and made my exposures. Since a lens of very short focal length is in use the Sun will move very slowly across the frame, so that even over a lengthy program of photography there will be no need for more than one or two

Figure 10.4 A 22° solar halo, photographed through a 12-mm f/8 fisheye lens. The lens distorts the foreground, but this is no disadvantage in a composition which is based on the circle. ISO 64 Kodachrome was used for a sequence of images in which the film's relatively high contrast and high resolution were valuable in recording in as much detail as possible what is a difficult subject. Extensive bracketing of exposures is advisable in situations such as this where an exposure based on the solar disk will lead to gross underexposure of the sky. In this frame the choice of shutter speed was based on an exposure meter reading of a sunlit hand.

Figure 10.5 *A parhelion (also known as a mock sun, false sun or sundog) in the afternoon sky over Houston, Texas. The phenomenon is associated with a 22° halo around the Sun produced by the refraction of sunlight by ice crystals. The bright white shaft of light extending to the right of the parhelion (that is, away from the Sun) is produced by light rays being refracted through ice crystals or at angles other than the minimum deviation of 22°, which causes the separate colors to overlap and thus create white light. Kodak Ektar 125 film was used in a Nikon F301 camera set to an aperture of f/8. This is the best of several bracketed exposures made on either side of the indicated meter reading.*

quick glances through the viewfinder. During a long session of solar photography, place a lens cap on the lens between shots or, better still, cover the camera with a light-colored cloth in order to keep it as cool as possible.

Subsidiary features of the halo phenomenon such as *parhelia* (see Figure 10.5) can be photographed with a moderate telephoto lens, and a zoom provides the flexibility to achieve the most striking cropping. The use of the longer lens also removes the Sun from the field of view. The exposure can be based either on a standard center-weighted exposure meter reading, or read by one of the more sophisticated matrix systems that sample all areas of the frame. Exposures should be bracketed, and I normally shoot at least two half-stops on either side. If the Sun is in the field of view, the meter system will tend to be overwhelmed by the intensity of its light and will heavily underexpose the sky area. That being the case, you should open up by at least one stop, and the "bracketing" should all be on the side of (apparent) overexposure in terms of the meter's reading.

Coronas, light pillars and the green flash

There are many other attractive phenomena associated with sunlight or moonlight. A *corona* (not to be confused with the corona that is the outer atmosphere of the Sun) quite frequently occurs when the Moon passes behind light or broken cloud (see Figure 10.6). Much smaller than the 22° halo, the most common form of the lunar corona is a disk of light which is bluish at its inner edge, changing to white further out, and intensifying to a reddish-brown outer edge. This is called the aureole, which may well have a further colored ring or rings surrounding it (normally referred to as iridescence). The corona is caused by the diffraction of moonlight by water droplets or by ice crystals in the atmosphere. (Although it is there, we do not usually notice the corona around the Sun because the area of sky close to the Sun is just too bright for our eyes.)

Since it is created by clouds which can obviously be moving, the lunar corona can vary over short periods of time, but the typical weather pattern in which it is created means that photography is not limited to a few seconds. A tripod and cable release are clearly required with a moderately long focal length lens. An ISO 200 or 400 color film will give adequate quality for a delicate subject, and if the cloud is moving relatively fast it will be best to open the lens wide (the corona is an extended object) and keep the measured shutter speed as fast as possible. Try a center-weighted exposure as well as a full frame sampling if you have that type of meter with bracketing of exposures of at least two half-stops on the side of (apparent) overexposure.

Figure 10.6 *A lunar corona occurs when the Moon shines through certain types of cloud which cause diffraction of the moonlight. Photographically it is a testing subject because the corona is a relatively faint phenomenon whereas the lunar disk is very bright by comparison. Once again bracketing of exposures is essential. A Nikon 801S tripod-mounted camera fitted with an 80–200-mm f/2.8 zoom lens was loaded with ISO 100 and afterward with ISO 400 transparency film. Automatic metering was used with reliance on the center-weighted mode. Use of the maximum aperture enabled the selection of the fastest possible shutter speeds to be made. This image was one of over 70 exposed. It effectively overexposed the Moon–corona combination – as can be seen – but yielded reasonable detail of the aureole. Dark room dodging (local holding back) and burning in (the opposite) can assist a subject like this, as can digital manipulation. The planets Jupiter (left) and Saturn were also recorded in the frame.*

The diffraction effects that give rise to coronas around the Moon (and Sun) are also responsible for more localized phenomena of a less astronomical nature. The *glory* can be seen from an aircraft whose shadow, cast on to clouds below it, is surrounded by colored rings. In the similar *specter of the Brocken* (named after a peak in Germany's Harz Mountains), seen when a climber casts an enormous, conical shadow on to mist or cloud below, the head part of the shadow is surrounded by halos.

Other impressive phenomena are caused by reflection, rather than refraction, by ice crystals or water droplets and water. A *Sun pillar* (or

10.7 This solar pillar is another effect created by the Sun shining through suitable types of cloud. (Any bright body can cause such a pillar, including the Moon and Venus.) Here the pillar is not so marked as it can be because the stratus cloud was becoming quite thick. Once again, a high-resolution ISO 100 transparency film was used to maximize quality and contrast. Since there was no concentrated source of light in the frame, a generalized meter reading of the sky was taken and the resulting exposures bracketed by half and one stop on either side. The lens used was a 35–105-mm zoom boosted by a teleconverter.

Moon pillar) is a normally vertical column of light above a Sun or Moon close to the horizon, caused by light reflected upward into the sky by ice crystals (see Figure 10.7). A similar downward reflection when the Sun is higher in the sky gives rise to a subsun, formed below the horizon. Aircraft passengers often see a *subsun* on cloud below them and it can flash with greater brilliance when its track passes over a body of water. A more common though no less dramatic sight in most people's experience is the *glitter path* extending across water toward the viewer from the Sun or Moon near rising or setting (see Figure 10.8).

If a low Sun is in the field of view when you are photographing a pillar, there is again the danger that a general meter reading will be biased by the solar disk, resulting in severe underexposure. To compensate, overexpose by at least one or two stops. Such a measure should not be necessary when you are photographing a subsun and the Sun is out of the field of view. For a glitter path the exposure is a matter of choice: exposing for the Sun and the (frequently) brilliant path can isolate them and create a powerful effect. Allowing one or two stops more creates a more mellow scene of the kind that may bring back warm memories of summers past.

Another refraction effect seen at sunset is the flattening of the disk and its separation into segments (see the inset on Figure 10.8). This is caused by temperature differences between non-uniform layers of the atmosphere, and can frequently take the form of a mirage. The most important photographic requirement is again to base the exposure on the Sun itself.

The *green flash* is a quite famous but very elusive phenomenon. In the final seconds of sunset on a clear horizon, out across the sea or on a distant mountain horizon, just before the Sun disappears the last visible segment of its disk may be seen to break off and momentarily flash green. The theory is that, as the Sun sinks and sunlight passes through the greatest possible thickness of atmosphere, yellow-orange light is absorbed by water vapor, and violet and some blue light are dispersed by atmospheric scattering. This leaves red light, which is refracted less (and therefore is seen lower down), and green light, which is seen last of all. While this theory is generally agreed upon, it is not understood why the green flash is so unpredictable.

Its elusiveness is what makes it a good photographic challenge, and I must confess to having hunted the flash but never to have captured it. The technique, however, is straightforward. The camera with the longest focal length lens available is placed on a tripod with a moderately fast color film, ISO 200 or 400. The green flash appears in the last few seconds before the image of the Sun disappears entirely below the horizon, and it is such a delicate emerald color that overexposure must

be avoided at all costs. It is best to expose on the basis of the solar disk itself. If your camera has a spot meter, which measures an extremely small area at the center of the frame, so much the better; if not, expose with center weighting and stop down a further half-stop as you wait with finger poised for that (hopefully successful) last picture.

The greatest care must always be taken when photographing the Sun. The usual advice is to use the correct filters, and never look at the Sun directly or through any optical instrument. However, when the Sun is *very* close to the horizon I do not use filters, and certainly never when trying to catch the green flash. I do not look through the viewfinder for more than a split second on any one occasion, and experience has taught me when I can do this and when I cannot. The rule remains: if in doubt, *don't*.

Dawn, twilight and moonlight

There is great beauty in dawn and twilight skies. The subjects for the photographer are almost endless: *crepuscular rays* ("crepusculum" is Latin for twilight) fanning out from clouds beyond the far horizon (Figure 10.9); the shadow of the Earth cast by the setting Sun visible toward the eastern horizon; twilight layering (Figure 10.10); and cloudscapes illuminated by the Sun in limitless profusion (Figure 10.11). I take such pictures with just as much enthusiasm as I have for "straight" astronomical subjects, and I make no excuse for repeating that we exist on a dynamic, living planet. Little more is required than basic photographic equipment loaded with good-quality color film. Correct exposure is the biggest test, but bracketing eases many of the problems. Given the variety and beauty of so many sky subjects, I think it is a tragedy to economize on effort, or on film.

And don't forget moonlit scenes: pictorial images both including and excluding the Moon, and particularly with broken cloud in frame, are just as attractive as sunsets, if very different in mood. Again, exposure is the prime challenge. Moonlight is nothing more than reflected sunlight, and I have seen one estimate that a moonlit scene is 2 million times (or 21 photographic stops) dimmer than sunlight. Be that as it may, if you set your camera up on a tripod, compose the picture and let the meter take command you will end up with a daylight rendering because the meter is again aiming for an 18 percent grey. You will need to give between 25 and 50 percent less exposure to get a well-exposed moonlit scene. Making sure that the Moon is behind a convenient cloud will save you having to worry about the exposure differences between the Moon itself and the scene. Incidentally, film manufactured for use with artificial (tungsten) lighting is more sensitive to blue, so this color will be emphasized in your moonlit scenes if you decide to try such a film.

Figure 10.8 A solar glitter path, photographed as part of a series of tests undertaken in advance of the annular solar eclipse seen from California on 1992 January 4. The eclipse took place in the late evening, and exposures with and without filters needed to be worked out beforehand for that time of day. Ektachrome 50HC transparency film was used, loaded in a Nikon F4S camera. A 300-mm focal length f/4 Nikkor lens boosted by a TC16A AF teleconverter was fitted, and the MF23 data back was programmed for a sequence of auto-bracketed exposures over five frames. In this case spot metering on the Sun itself was chosen, and the exposure of 1/500 of a second created the intended color saturation in both the Sun and glitter path. A degree of flattening of the solar disk is noticeable, caused by refraction as the Sun nears the horizon. The phenomenon is even more marked in the inset image. Once again the exposure was based on a spot meter reading of the solar disk.

135

10.9 Sunlight can frequently be seen broken up into isolated beams by openings in cloud sheets. These go under the general name of crepuscular rays. The beams can spread downward or upward, with the latter occurring most dramatically at dawn before the Sun comes up over the horizon. In this wintertime view, a general meter reading of the sky (with no Sun yet in view to create difficulties) was adequate to record good detail of clouds and rays while severely and deliberately underexposing the foreground tree. Notice that the vapor trail of an airliner returning overnight from the US is sharply delineated immediately above the tree.

Figure 10.10 Twilight layering is a frequent subject for astronaut photography but the effect can also be seen very well in any high flying passenger airliner traveling, for example, back to Europe overnight from the US. (It is also a mark of dedicated insomniac photographers!) The blue toward the top of the frame results from Rayleigh scattering where the upper atmosphere is already illuminated by sunlight. This becomes whiter lower down because of additional aerosol scattering. The lowest layers appear red for the same reasons as we see red skies at dawn and dusk on the surface: aerosols and atmospheric gases scatter blue light more strongly than red so that the red light from the Sun penetrates strongly to our eyes whereas blue is "lost." The dark band at mid frame is a layer of thick cloud. Other than it was exposed on Fuji ISO 400 transparency film, no data is available for this image, which was one of a series shot hand-held with an automatic camera through an aircraft window.

Lightning

We have all seen magnificent photographs of lightning, but they are not easily won. A few ground rules will help to increase your chances, even though you will probably face a high film consumption. Photographing a storm at night provides the best opportunities. Typically, the camera is loaded with film in the range ISO 100 to 400, set up on a tripod, and operated by cable release. The ideal conditions are a slow-moving storm some distance away with a moderate amount of foreground detail (for example, a few house or city lights) to provide a human context (see Figure 10.12).

Set the aperture at $f/5.6$ or $f/8$, fire the shutter, and hold it open for perhaps 20 seconds or so (although earlier tests might have shown that

Figure 10.11 *A scene on the border between astronomy and atmospheric physics but which, despite its beauty, is all too often ignored by astrophotographers. Once again, it is important to bracket a series of exposures because, as the Sun sets, large expanses of foreground cloud become very dark. With the Sun partly obscured by distant clouds a single, general meter reading would be biased in favor of greater exposure to yield more detail in the nearby clouds. This exposure of a sunset off the island of Madeira was deliberately underexposed by one stop to hold the color saturation in the sky around the Sun and to emphasize the contrast between the rays of light and shade above it. Kodak Ektar 125 negative color film was used in a Nikon F301 camera.*

a longer exposure can be given before foreground lights become too intrusive). If a lightning stroke occurs, close the shutter immediately. Should a storm be concentrated in one location for any length of time, you could try securing multiple images on one frame of film. Cloud-to-cloud lightning will usually fog your exposure, so it is best to wind the film on immediately afterward in the hope of a more dramatic stroke between surface and clouds.

Attempting to capture lightning on film in daytime is difficult. The shutter cannot be kept open, as during the night, because overexposure would quickly take place. It has been claimed that lightning strokes frequently take place in pairs and that the second one can be anticipated. There is some evidence to support this, but there must be a large element of luck – or dedication – involved. It is better to concentrate on night storms where the practical difficulties are some-

what less. It is a platitude that lightning is dangerous. Considerations of safety should be paramount: a mountain would provide an excellent vantage point for photography, but (as a one-time climber who experienced storms in the mountains) I would never dream of attempting it!

Protecting your equipment from rain is also important. An ideal place for protecting your person and your equipment while attempting to photograph lightning is a roofed balcony or patio facing the storm. If you decide to venture out during a storm, don't stray far from the car, and build a protective cage for the camera – or take plenty of clean dry rags with which to mop up!

Figure 10.12 *An awe-inspiring photograph obtained by Willem Hollenbach during a storm over the Cederberg Mountains north of Cape Town in South Africa. His Ricoh KR5 Super camera with its 50-mm f/4 lens was loaded with Agfa ISO 100 color transparency film, and he made a series of 30-second exposures as the storm approached. The strokes here were obviously very close; anyone endeavoring to secure dramatic pictures of lightning must not ignore their own safety. Although inevitably very dark, the trees in the foreground of the photograph aid the composition.*

Comets and the zodiacal light

Comets

Most of the comets that are discovered or return to the inner Solar System each year are detected by inveterate and mostly amateur comet-hunters using binoculars, or by researchers studying photographic plates. These usually very dim comets will receive considerable attention from cometary scientists and keen amateurs and virtually none from the public. But, while nowhere near so frequent, an occasional new comet becomes a bright, even naked-eye object of great beauty and impact, and well within the grasp of the amateur's fixed camera. Comets Ikeya–Seki (most comets are named after their discoverers) in 1965, Bennett in 1970 and West in 1976 were good examples some years back. There was then something of a pause with the return of Halley's Comet in 1985–86 being a big disappointment for the general public – at least in the northern hemisphere. However, the 1990s saw a resurgence of public interest. In July 1994, the fragments of Comet Shoemaker–Levy 9 collided with Jupiter. Closer to home, that event was followed by the appearance of Comet Hyakutake in 1996, Comet Hale–Bopp in 1997 and Comet Ikeya–Zhang in the spring of 2002.

Throughout history, comets have been popularly associated with death, destruction, plague and other horrors. The folklore is interesting and entertaining, but comets have a much more serious place in astronomy. They are usually regarded as being the most primitive members of the Solar System, believed to have undergone relatively little change since it came into being about 5 billion years ago. Therefore, although comets vary greatly in their characteristics, the more that can be learned about them, the greater the insight that can be gained into the evolution of the Solar System. This is why comets have received so much attention since the beginning of the space era, and why Halley's Comet in particular was studied by a flotilla of space probes from various countries.

Spaceborne research continues apace and over the next decade a number of spacecraft will conduct cometary missions. NASA's Stardust vehicle is already in space and in January 2004 will fly through the halo of dust around the nucleus of Comet Wild 2 and bring back samples of that dust to Earth. If all goes well, it will make a soft landing in January 2006. CONTOUR (Comet Nucleus Tour), another NASA mission, was launched on 2002 July 3, with planned flybys of two comets, but contact with it was unfortunately lost several weeks later. In January 2003, ESA (the European Space Agency) will launch its long planned Rosetta mission to Comet Wirtanen, which it will reach

in 2011 after "gravity assist" flybys of Mars and Earth (twice). NASA plans yet another cometary mission, scheduled to launch in January 2004. Graphically called Deep Impact, the spacecraft to be sent to Comet Tempel 1 will consist of two elements – a flyby vehicle and an impactor. In July 2005 the latter will strike the comet's surface at a speed of 10 km/s (6 miles/s) to provide new information on its subsurface structure. The crater it makes will be seven storeys in depth.

When a comet is in deep space it consists essentially of just a small *nucleus* a few kilometers across. According to current theory (largely confirmed by the results from the Halley missions, even if more recent research suggests the ice may exist beneath a hot and dry surface), the nucleus is a "dirty snowball:" a mixture of frozen gases – mostly water

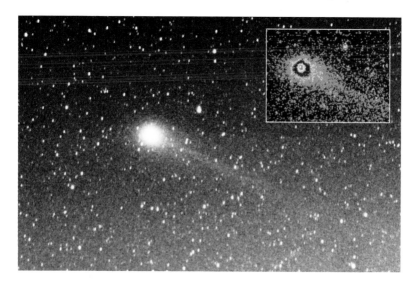

Figure 11.1 Comet Levy (1990c to give it its formal designation) had a tenuous tail some 2° long when photographed from southern England in August of that year in an 8-minute exposure on hypersensitized 2415 film. The camera was a Nikon F3 fitted with a Nikkor 180-mm f/2.8 lens and mounted on a GOTO Optical Mark X camera platform programmed to track the comet. Comet Levy was in Pegasus at the time, and the bright object to its upper right is the double star 33 Pegasi. This image may be regarded as fairly typical of those recording a relatively faint comet which does not arouse the interest of the media and therefore of the general public. Inset is the result of the image being density sliced in the computer after scanning. While the eye has difficulty in discriminating different levels of density in the area of the comet's coma this is no problem for a computer. Such procedures can aid analysis of a comet's structure.

ice – and dust particles. As the comet comes into the inner Solar System, a *coma* (Latin for "hair") develops. This very tenuous halo, extending sometimes hundreds of thousands of kilometers into space, is composed of a mixture of dust and gases released by the warming effect of the Sun. Later, there develops a tail of two components: a *dust tail* and an *ion tail*, the latter consisting of molecules released by the nucleus that have been ionized by solar ultraviolet and X-radiation. Electrically charged particles from the Sun (the solar wind) and solar radiation pressure cause both tails to point away from the Sun. Hence the tails follow the head of the comet as it approaches the Sun but, perhaps paradoxically at first sight, precede it on its journey away from the Sun. It is, of course, the tails of comets that can be so spectacular and cover such a large area of the sky, presenting a marvelous subject for the photographer.

How bright and extensive a comet appears to observers on the Earth depends upon many factors, not all of which are understood. One which is readily apparent, however, concerns the relative positions of the comet and the Earth as the comet rounds the Sun. The reason why the 1985–86 visit of Halley's Comet was not one of the best was that for some time around perihelion (the point of its closest approach to the Sun, and when it is at its most active), it was on the opposite side of the Sun from the Earth and therefore lost in the Sun's glare. The distance between comet and Earth on the incoming and outgoing passages is also important.

So comets vary in brightness from extremely dim, and visible only in telescopes, to very bright, sometimes bright enough to be seen in broad daylight. The last occasion on which this happened was early in 1910, when the Great Daylight Comet upstaged that year's apparition of Halley's Comet which followed some weeks later. In the face of such differences it is difficult to give valid guidance to the newcomer to comet photography, but one generalization may be proffered: if a comet is a naked-eye object, then any attempt to photograph it with a fixed camera on a tripod is well worthwhile. There is one feature of comets that works in the photographer's favor, but which frequently causes some confusion. While a comet usually will be moving at high speed in absolute terms, when viewed from Earth it will not be speeding across the sky "like a shooting star:" it will be moving gradually against the backdrop of stars, and in many cases a few hours will need to elapse for the movement to become clearly discernible. Over the course of several nights, however, this movement will become readily apparent.

Comets are extended objects so, as with everyday objects, the measure of the speed of a lens is focal ratio. Because comets typically brighten around perihelion, when they are at their best they will often

be located in the western sky during evening twilight, or in the eastern sky near dawn. The sky behind them will therefore be relatively bright, so lengthy exposures are not possible. There is an advantage in these conditions, mentioned in an earlier chapter: while the eye may see little color, film often records delightful hues which result in a most attractive pictorial image. If the comet is still up some time after the Sun has set, light pollution may become a problem near towns, but this is something the individual must resolve in the best available way. Should a naked-eye comet appear it is almost certain that it will be well covered in the media, with newspapers giving details of when and where in the sky it will be visible – weather permitting, of course. Estimates of the length of the tails may well be given in advance, and from them the most likely suitable lens's focal length can be worked out (as on page 93). Alternatively, direct observation can establish the most suitable focal length (see Figure 11.2). If the tail structure devel-

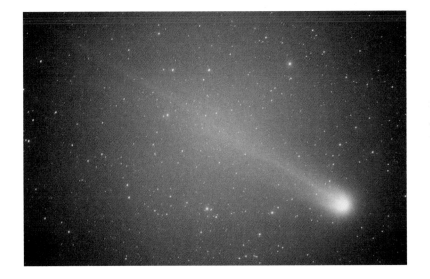

Figure 11.2 *Early in 1996 a new comet was discovered that became a spectacular feature of the sky as it traveled at high speed past the Earth in the late winter. It had an estimated 0 magnitude and its tail extended for perhaps 50°. Comet Hyakutake (named after its discoverer who sadly died quite young early in 2002) proved tantalizing to inhabitants of the* UK *because for many of the best nights of its apparition the weather was poor. This picture was taken on 1996 March 26 just after the comet had passed its nearest point to Earth. The camera was a Nikon F3HP with a 180-mm f/2.8 Nikkor lens fitted. The exposure was for 3 minutes on Ektachrome Panther 1600 transparency film.*

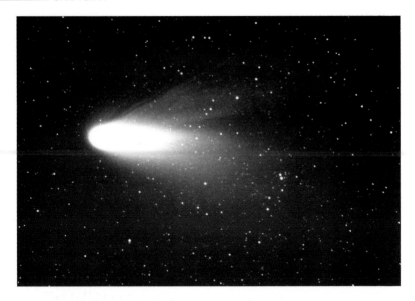

Figure 11.3 Comet Hale–Bopp followed a relatively few months after Hyakutake. It was another bright comet (magnitude −1) although its tails were not so long. This image, however, shows well the different appearance of the dust tail (yellow) and the ion tail (blue). The picture was taken on 1997 March 6. A Nikon F4S was loaded with Fuji Provia 1600 Professional film and fitted with a 300-mm f/4 Nikkor whose focal length was further boosted by the attachment of a 14B teleconverter. The exposure was for 2 minutes 30 seconds in the early morning. The variation in the color of the sky background color when compared with that of Figure 11.2 is partly accounted for by different film material but also by the images having been taken from separate locations.

ops well it is probable that a 50-mm focal length lens will be required. With the prospect of a light, colorful sky, as opposed to the full darkness of a nighttime image, quality is important, and I would recommend a compromise on film speed with the use of an ISO 400 film and nothing faster.

Set the lens at its fastest focal ratio, observe the basic photographic drill (sturdy tripod, black card, and so on), and make a series of exposures from around 5 seconds up to perhaps 1 minute in 5-second increments. Some star trailing will take place in the longer exposures, but this is perfectly acceptable since it is the comet that is the prime target. If the weather is good and the comet is visible on a number of days or nights, modifications to the bracketing sequence can be introduced if the first results are not satisfactory. If the comet

becomes very bright and the first results suggest the possibility, it would be worthwhile trying a slower film of ISO 200 in the interests of even better quality.

Should the comet be a bright object at dusk or dawn, this again would be an occasion when an aperture priority automatic exposure system would prove its worth (careful notes being made of the shutter speeds selected by the camera), and today's versatile and high quality color negative film could be used. The image size of the comet (according to focal length selected) would affect the metering mode chosen if more than one mode is available. With a very bright comet, a keen black-and-white photographer could experiment with recording the ion and dust tails. Since the dust tail is yellowish (because of the backscattering of sunlight toward the observer) and emission from the ion tail is at the blue end of the spectrum, a yellow or orange filter in the one case and a blue filter in the other could be used to enhance detail. Kodak Wratten filters, types 21 and 47 respectively, would be suitable. Clearly, to stand any chance of success with the use of filters (which attenuate the light transmitted) on a camera which is fixed and not on an equatorial mount, the comet would have to be extremely bright. In that event, ISO 400 black-and-white film rated perhaps at ISO 800 would seem a suitable choice for such a filter experiment.

It has to be admitted that the procedures suggested here will not work with the vast bulk of comets. However, the evidence of events in the later 1990s and on into the new millennium gives at least a promise of better things. It could certainly be argued that we are due a daylight comet. Capturing your first comet on film is a prize indeed and the appearance of such a bright visitor from the depths of the Solar System would make the task all the easier.

The zodiacal light

Comets can be bright, but are all too frequently dim. A genuine dim light phenomenon which nonetheless makes an intriguing picture is the zodiacal light. Quite probably it has been seen by many people, particularly those fortunate enough to take cruises to the tropics and the equator, but confused with the twilight.

The name "zodiacal light" stems quite logically from the fact that it stretches along the imaginary belt of constellations through which pass the paths of the Sun, Moon and planets. It may be seen after astronomical twilight ends during evenings (that is, when the Sun is more than 18° below the horizon) and for some time before the Sun reaches that position at dawn. The phenomenon is caused by sunlight scattered by the *zodiacal dust cloud*, a sheet of dust particles in the inner Solar System. It appears as a luminous wedge or pyramid of light,

approximately as bright as the Milky Way, and its widest and brightest part is on the horizon – that is, closest to the Sun. It has been suggested that, because of interaction between particle streams emanating from the Sun and the zodiacal dust cloud, the zodiacal light is more intense at times of sunspot minimum.

If the zodiacal light is to be seen, a dark sky is a necessity, and moonlight is certainly to be avoided. It is seen to best advantage from the tropics, where, following the line of the ecliptic, it rises up steeply from

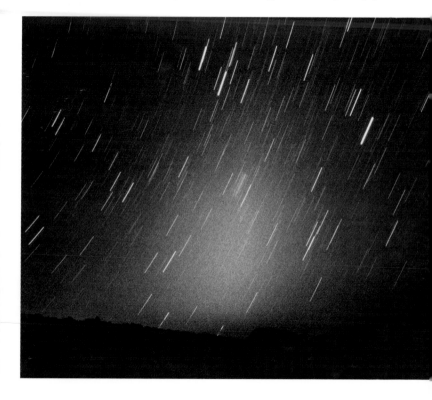

Figure 11.4 The zodiacal light seen in an autumn morning sky from Tenerife in the Canary Islands. The star trails at the top of the picture include Castor and Pollux in Gemini. Procyon in Canis Minor is the bright trail on the right, and plainly seen as a broad bluish band in the upper center of the zodiacal light cone is the open star cluster Praesepe (M44) in the constellation Cancer. The wedge shape and inclination of the zodiacal light are well demonstrated here, but the light appears a good deal less bright to the eye than it does in lengthy time exposures. The exposure through a 24-mm f/2.8 Nikkor lens attached to a tripod-mounted camera was for 15 minutes on Agfachrome 1000RS Professional transparency film.

the horizon throughout the year. However, it is still clearly visible in a dark sky outside the tropics. It is best seen (being at its steepest to the horizon) in the west after sunset in the spring, and in the east before sunrise in the autumn. The evening zodiacal light inclines to the left, and in the early morning to the right (that is, to the south in both cases), and under the optimum conditions of a very dark sky it can be seen stretching almost to the zenith.

As with other astronomical objects, locating or recognizing the phenomenon may well be a little more difficult for newcomers than actually photographing it. Since the zodiacal light can last for an hour or so after astronomical twilight ends, there is no rush. Given its extent, a 50-mm or (under very dark skies when its height will be the greater) a 35-mm wide-angle lens is required, and the camera needs to be loaded with at least ISO 400 film. Like comets, the zodiacal light is an extended object so a fast focal ratio is essential, and a sequence of time exposures (1, 2, 4, 8 and 12 minutes) is suggested. Although the zodiacal light is essentially monochromatic, color film gives a pleasing picture since star trails will be recorded (see Figure 11.4). Greater accentuation of the phenomenon itself can be achieved by using an ISO 400 black-and-white film, overdeveloping it by about 25 percent, and printing the resulting, contrasty negative on a hard grade of paper.

As with comets, but even more so, dark and unpolluted skies are essential if you are to see and photograph the zodiacal light well. The urban astronomer will have to be prepared to travel near or far to find such skies, for which there is no substitute: the use of filters, as described in Chapter 8, and other technical measures are unlikely to bring much reward to the beginner seeking to capture this faint, elusive phenomenon.

— *Meteors, satellites, aircraft and UFOs* —

Meteors

Everybody has at some time or other seen a "shooting star" or "falling star" – a brief trail of light in the night sky usually lasting a fraction of a second. The flash is caused by a particle of interplanetary dust impacting the upper atmosphere of the Earth. The heat generated by its passage usually vaporizes the particle completely, but a complex inter-action results in the ionization of air molecules around and behind the particle, and this is the light trail that we see in the sky. The name *mete-or* is given to this phenomenon; the actual particle of dust is called a *meteoroid*. Larger, more robust objects that survive their passage through the Earth's atmosphere and reach the surface are known as *meteorites*.

Meteors occur at altitudes from 80 to 120 km (50 to 75 miles). Their entry speeds vary greatly, with an upper limit of around 70 km/s (45 mile/s). Brightness levels, too, vary widely, with an effective lower limit for the photographer of magnitude 2, rising to the brightness of the planet Venus at maximum (magnitude -4.7) and beyond. Meteors that outshine Venus are called *fireballs*, and the brightest of them can be seen in daylight.

On any night, meteors can be seen at a rate of maybe five or so an hour. But greater numbers are seen at times of the year when the Earth encounters what are called *meteor streams*. These streams are generally believed to originate from periodic comets losing material as their orbit brings them into the inner Solar System. In time, this material becomes distributed around the comet's orbit. When the Earth's orbit about the Sun takes it through or near the orbit of a comet, a surge in the num-ber of observed meteors takes place in what is called a *meteor shower*. Meteors from a particular shower seem to radiate from the same point in the night sky on the same dates each year. The particles are in fact moving on parallel paths, and the appearance of radiating from a point is an effect of perspective. In much the same way, if we stand on a bridge over a long straight road and look toward the horizon, the parallel lanes of the road appear to converge and meet in the distance, although we know they do no such thing. Nonetheless, the term *radiant* is still used for the apparent point of origin of meteors from a particular shower, and a shower is named after the constellation in which its radiant lies.

The major annual meteor showers are listed in Table 12.1. There are in addition many minor showers with lower hourly rates. The dates given in the table indicate when the shower is active; activity rises to a maximum, then fades away. Individual observers will see fewer meteors than indicated by the hourly rates given here, which are all-sky figures calculated as if the radiant were at the zenith. January's Quadrantid

shower is named after the now defunct constellation Quadrans Muralis, and its radiant is in the constellation Boötes. The Eta Aquarids and Delta Aquarids have their radiants near two different stars in the constellation Aquarius. Perhaps the best-known shower is the Perseids, peaking on a warm mid-August evening that should not deter even the most casual observer. The Leonids are a *periodic shower*: less than 10 an hour are visible in most years, but about every 33 years comes the possibility of something much more dramatic – a *meteor storm*. The reason for this behavior is that the cometary debris is not evenly spread around the orbit, but concentrated in a swarm which the Earth approaches closely every 33 years. Thus, in 1966, for 40 minutes, the hourly rate of Leonids in the skies above Arizona in the US was estimated at over 60,000. The Leonid cycle has been repeated over recent years but November 1999 nowhere near matched 1966, and 2000 was even poorer. But there was something of a resurgence in 2001 when several peaks of estimated hourly rates close to 4000 occurred over the Pacific. There are hopes of a good performance in November 2002.

The dates and, in particular, the hourly rates of meteor showers show slight changes from year to year. But although a particular shower's performance in any one year cannot be predicted, the time demanded of the less than devoted specialist is kept within bounds by the existence of a recognized date for the likely maximum. Even the more elusive *sporadic* meteors (those not associated with any shower) have a diurnal peak – in the hours before dawn. This is because, as the Earth moves in its orbit about the Sun, an observer in the early hours of the morning is on the leading side. Meteoroids that are encountered enter the atmosphere head-on, generating higher energies and therefore producing brighter meteors. In the evening hours the observer is on the trailing side of the Earth, where incoming meteoroids have to "catch up;" those entering the atmosphere come in at a lower relative speed, so generate less energy and produce fainter meteors. Even with the major meteor streams just a few hours can make an enormous difference to the numbers of meteors observed.

TABLE 12.1 MAJOR METEOR SHOWERS			
Shower	Dates	Maximum	Hourly rate at maximum
Quadrantids	Jan 1–6	Jan 3	100
Eta Aquarids	Apr 24–May 20	May 5	35
Delta Aquarids	Jul 15–Aug 20	Jul 29	20–25
Perseids	Jul 25–Aug 20	Aug 12	80
Orionids	Oct 15–Nov 2	Oct 21	30
Leonids	Nov 15–20	Nov 17	variable (see text)
Geminids	Dec 7–15	Dec 13	100

So, although we have an indication of the nights of the year on which there is the best chance of observing meteors, skill and luck are obviously going to be important. The task facing the astrophotographer is intriguing. When we photograph the stars with a fixed camera (and we are not deliberately trying to record star trails), their apparent movement is very slight, and in effect for the duration of the exposure their light falls on the same area of film. Meteors, like stars, are point sources, but ones that move across the film in a period of time between about 0.1 and 1 second! It may sound quite encoraging to talk about meteor trails of, for example, magnitude $+1$, but photographically this is very different from a star of magnitude 1 that steadily builds up an image on film over a period of 20 seconds or more.

As we have seen, the diameter of the lens is the most crucial factor in the photography of point sources, so the natural inclination might be to opt for the long, large-diameter lenses discussed in earlier chapters. Their drawback is their relatively small field of view, which makes the chances of capturing meteors all the slimmer. At the opposite extreme, a wide-angle lens gives a far greater chance of including a meteor in its field of view, but because it has a relatively small diameter a meteor might appear very faint or not be recorded at all on the film. The best solution is compromise, in the shape of the faithful 50-mm focal length lens, particularly if it is $f/1.8$ or faster. This has a very reasonable $27° \times 40°$ field of view and a diameter of 28 mm (or more with faster lenses). For more on the subject of lenses for meteor photography, see *Sky & Telescope*, August 1993, pages 97–8, and February 1994, pages 85–7.

As in star photography, high-speed films may appear attractive, but you must bear in mind the quality of your sky. Remember that, used wide open, the lens will be doing its best with point sources, but at the same time the fast focal ratio will be causing any light pollution (or airglow) to build up rapidly on the film. If the sky is dark and of good quality there is every reason to select one of the high-speed films in the ISO 1000 range. With meteors there are no worries about reciprocity failure over lengthy exposures, and films capable of maximizing the very brief light burst are at a premium. Most meteor photography specialists use black-and-white film, and there is little to be gained in using color, which in any case is more expensive.

Although it may seem surprising, it is not advisable to center the radiant in the camera's field of view. If it is in the center, then any meteors captured will be seen head-on or nearly so, as points of light or very short trails. Based on observations over some years, meteor specialists advise pointing the camera at an elevation of 50° to the horizon and from 30 to 45° to one side of the radiant. It is claimed that an elevation of 30° is likely to produce a higher yield of fireballs.

Meteor photography is a type of what might be called patrol photography. Since it is obviously impossible to react fast enough to photograph meteors as they occur, a series of time exposures must be made of a duration and over a period that are decided upon beforehand. It is difficult to give general advice on this, but the length of each exposure depends most importantly on the darkness of the sky. If the sky is good, then exposures of 10 minutes or more should be possible with little risk of sky fog – particularly if a medium-fast ISO 400 film is being used. If you have not done so before, a sensible thing to do in advance of a meteor shower is to make some test exposures lasting for, say, 1, 5, 10 and 15 minutes on the type of film and from the site to be used. This will establish the quality of the sky and the tactics that must be pursued. Meteor

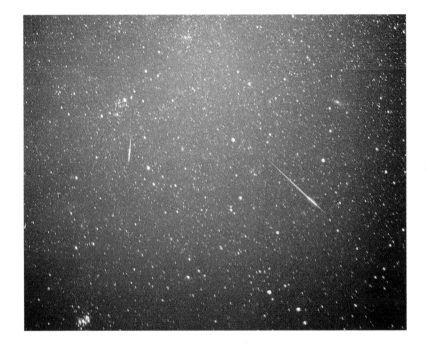

Figure 12.1 This time exposure by Akira Fujii captured two Perseid meteors, and gives a classic demonstration of how meteors radiate from the area of the sky after which they are named, in this case the constellation Perseus. The shorter of the two trails is in fact still within the boundaries of Perseus, and the radiant itself can be traced back to just outside the top of the frame. At the bottom left are the Pleiades, and toward the top right is the Andromeda Galaxy (M31). The original picture was exposed on Fujichrome ISO 400 film in a Canon F1 camera with an f/1.4, 24-mm wide-angle lens fitted.

photography and light pollution do not go well together, so if your tests reveal sky fog quickly developing in the images, a move to a darker site is indicated. My local sky is very bad, and when I cannot travel I restrict exposures on ISO 400 film to no more than 2 minutes. This is far from ideal, and is very heavy on film, particularly when using a battery of cameras set to fire automatically! But sometimes we have to decide on something rather than nothing. The general advice given in Chapter 5 also applies, and since meteor photography tends by definition to be a somewhat protracted business if tackled at all seriously, a method of dealing with the formation of dew on lenses should be available (see page 58). Specialists use a rotating shutter spinning at nearly 1000 revolutions per minute in front of the lens to "chop" meteor trails into segments, from which the velocity of the incoming meteoroid may be calculated. These devices also enable meteor trails to be distinguished from the otherwise similar trails left by artificial satellites and aircraft.

In the past the Earth, like most other bodies in the Solar System, has been subjected to meteoritic bombardment of great intensity. Relatively few large bodies have impacted the surface during recorded history, but this has not prevented the evolution of generally accepted theories about the role of such impacts in the Earth's more distant past, for example in the extinction of the dinosaurs. Often no bigger than specks of dust, the particles that burn up to produce meteors are at the opposite end of the size scale, but occasionally we are reminded of what might be. On 1972 August 10, for example, a fireball was seen over a large area of the US and Canada in broad daylight. Because of the oblique angle and high velocity of its approach, it cut through the Earth's atmosphere and went back into space without striking the surface. Its weight was estimated to be 1000 tons, and, had it impacted, the energy released would have been the equivalent of a thermonuclear explosion. More prosaically, a lesson of its appearance was the wisdom of carrying a camera at all times (see Figure 12.2). On 1994 February 1 a body estimated to have weighed 400 tons exploded 20 km (12 miles) above the Pacific Ocean, producing a fireball with a magnitude of -23, almost as bright as the Sun. Although the only eyewitnesses seem to have been the crews of fishing boats, the fireball was picked up by at least six surveillance satellites.

The potential danger to Earth from large bodies has received increasing attention in recent years both amongst the general public (reflected in the appearance of at least two large-budget motion picture films) and the scientific community. It is a question of when not if our planet will be struck by such a body. Internationally, scientists have concentrated on greatly improving the surveillance machinery so that what are now generally called dangerous Near Earth Objects (NEOs) can be discovered and tracked. Data on these objects' orbits can then be refined such

Figure 12.2 The Teton fireball of 1972 August 10. According to Lanny Ream, who took this photograph from the Idaho/Montana border, the object was in sight for about 20 seconds and left a trail like a jet plane's, but thicker, that remained visible for half an hour. The exposure was on Kodachrome-X film loaded in a Nikkormat camera fitted with a 50-mm lens.

that any potential danger in the future can be established. This is a subject which for obvious reasons generates enormous public interest (to put it mildly), and a major element in the scientific work that is being done is to establish a system for the dissemination of timely and accurate information about future near-Earth passes. In the absence of such information, scare stories are easily generated, as happened with two asteroids in 1997 and 2001. NASA has established a web-based information system on this subject (called, appropriately, Sentry) which seems to be improving matters. In the spring of 2002, it was announced that the Earth would have a close encounter ("most likely a miss") with asteroid 1950DA on 2880 March 16 – a forecast that speaks volumes for the improving sophistication of the surveillance machinery but one that should not concern readers of these pages too much!

However, such levity might be misplaced. As these pages were being prepared for press in the early summer of 2002, it was announced that an asteroid some 120 meters (400 feet) in length had passed the Earth on June 14 at a distance of a mere 120,000 km (75,000 miles) – that is, inside the orbit of the Moon – and had been totally undetected until three days *later*. Although small by cosmic standards, if Asteroid 2002MN had impacted the Earth the energy released would have been equivalent to a 10-megaton explosion. The resulting devastation would have been on the scale of the famous Tunguska event of 1908 in Siberia.

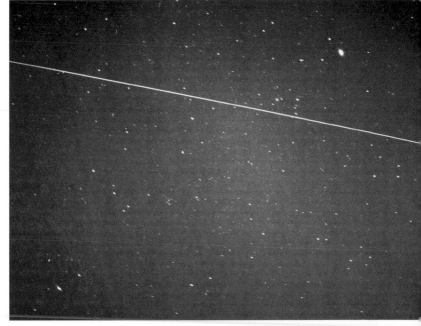

Artificial satellites

A rtificial satellites in orbit about the Earth are much more predictable than meteors, although natural forces acting on them may cause them to be a little later or earlier than predicted. Military radars are currently tracking over 7000 objects in space (many of which are defunct spacecraft and the remnants of numerous launch vehicles, well deserving the description *space junk*) and at any one time 500 or more may be above the horizon. They are so numerous that an experienced binocular observer can spend the entire night tracking satellites as they cross the sky, a new one appearing every few minutes.

Earth-orbiting satellites shine by reflected sunlight, so it follows that the best times to see them are after sunset and before sunrise against the darkness of the sky above. Depending on how far the Sun is beneath the horizon and on the altitude of a satellite, it will either remain lit by sunlight for its entire passage overhead, or enter the Earth's shadow (in the evening) or come out of it (in the early morning) part way through its traverse of the sky. Not infrequently the surface of a satellite catches sunlight at a critical angle and a brief flash is seen – doubtless the cause of some UFO reports.

Satellites seen by the naked eye or through binoculars fall into two broad categories. Weather and earth-resources satellites (as well as many military spacecraft) are usually in what are called *polar orbits*, in which they travel in a north–south/south–north direction and cross the equator

Figure 12.3 Almost 20 years separate these two images. In the top image the space shuttle Columbia flies over southern England during the early evening of 1983 November 28. The vehicle was carrying the European Space Agency's Spacelab module on its first flight, and this was also the first occasion upon which the inclination of a shuttle's orbit had brought it sufficiently far north to be seen from the UK. The exposure was for 45 seconds on Tri-X film, and an f/2.8, 24-mm Nikkor wide-angle lens was used. Columbia was already in the field of view to the west when the exposure was begun, and it moved into eclipse almost at the zenith. Vega in Lyra is the bright star toward top left, and the "handle" of Ursa Major can be seen over the poplar tree at bottom right. The light on

the horizon is a mixture of twilight and light pollution. Vega also figures in the lower image, taken on 2001 October 18 as the International Space Station (ISS) passed over southern England. Vega is at top right while Altair in the constellation Aquila is at bottom left. The trail of the ISS is across the Summer Triangle, although Deneb in Cygnus is out of frame at the top. A Nikon F3HP was used for this exposure which was made on ISO 400 TMax black-and-white film. Having noted the area of sky covered by the 35-mm f/1.4 lens fitted, the exposure was begun as the spacecraft entered the frame and was terminated as it exited. The lens was used wide open at f/1.4, which accounts for the typical coma (off-axis distortion) seen in the bright disks of both Vega and Altair.

more or less at right angles. This orbit is selected because over a given period of time all of the Earth's surface passes beneath the satellite's cameras or other sensors. Many other satellites are in orbits that do not take them so far to the north and south of the equator: thus one which is said to be in a 50° inclination orbit will never pass beyond 50° north or south latitude. Most communications satellites and some meteorological satellites are placed in what is called a *geosynchronous orbit*, at an average altitude of just under 36,000 km (over 22,000 miles), where their period of revolution matches the rotation of the Earth below them. A satellite in such an orbit which is circular and in the plane of the Earth's equator appears from the Earth's surface not to move, and is said to be *geostationary*. These satellites are extremely difficult to photograph, but it can be done (see *Sky & Telescope*, June 1986, pages 557, 563–7 and 606–7).

Depending upon their purpose, satellites differ too in their altitude, and thus in the time they take to complete an orbit and in how rapidly they move across the sky. The lower they are, the faster they travel. Thus a satellite at an altitude of about 200 km (125 miles) will take around 90 minutes to complete an orbit of the Earth, and will move across the sky in one observer's field of view in perhaps 2 minutes. Another at an altitude of around 5000 km (3000 miles) or more could easily take 3 hours to circle the Earth, and 10–15 minutes at least to pass across the sky as seen from one vantage point.

Brightness also varies enormously, depending on such features as the size and shape of the vehicle as well as its altitude and the angle at which it is illuminated by the Sun. Many satellites require binoculars to be seen, while others – such as the US space shuttles and the ISS or International Space Station (see Figure 12.3), as well as the Russian space station Mir before its demise – can be at least as bright as Sirius, the brightest star in the sky. Similarly, whereas satellites usually move in their orbits with apparent ease and grace, there can be occasions of great drama, as when a spacecraft or rocket stage re-enters the Earth's lower atmosphere in a brilliant firework display, or a shuttle approaches the ISS prior to docking. Not infrequently, parts of rockets used to launch spacecraft can be seen periodically flashing as they tumble end over end in orbit overhead.

During any period of observing it is very likely that a satellite of some kind will be seen. In pre-Internet days securing prediction data for satellite passes over a specific area was a little involved. Now, however, it is available free of charge at the cost of just a few clicks on the computer keyboard. An excellent service is operated at *http://www.heavens-above.com*. You can enter the geographical coordinates of your location, choose any category of satellites that you want to observe and you will be supplied with ten-day forecasts of passes which will be visible to you between the hours of evening and dawn twilight. A copy of the data

Visible Pass Details

| Home | Info. | Orbit | Help |

Ground Track
Click here for a view of the ISS ground track during the pass, centred on your location.
Graphics courtesy of our partner DLR.

Whole Sky Chart
This chart show the path of the satellite across the sky. Please note that East and West are **NOT** the "wrong way round" if you hold the chart over your head to correspond to the view of the sky.

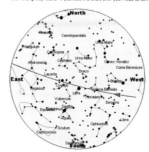

Pass Details

Date: Friday, 17 May, 2002
Satellite: ISS
Observer's Location: HAVANT (51.0000°N, 1.0000°W)
Local Time: British Summer Time (GMT + 1:00)
Orbit: 384 x 395 km, 51.6° (Epoch 09 May)
Sun altitude at time of maximum pass altitude: -8.2°

Event	Time	Altitude	Azimuth	Distance (km)
Reaches 10° altitude	04:08:29	10°	253° (WSW)	1,411
Leaves shadow	04:08:25	10°	253° (WSW)	1,437
Maximum altitude	04:11:38	81°	169° (SSE)	395
Drops below 10° altitude	04:14:48	10°	79° (E)	1,415
Sets	04:16:51	0°	78° (ENE)	2,267

Detailed Star Chart

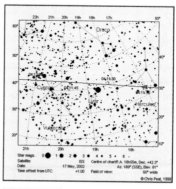

Change chart size 500 (500 to 1600 pixels)

Click anywhere within the inner chart to zoom in on that region.
Click in the border region to get a new chart at the same resolution, but with the centre point moved in that direction.
The chart is oriented such that the local zenith is towards the top.
Click here for more info and help on using the charts.

Developed and maintained by Chris Peat, Heavens-Above GmbH
Please read the updated FAQ before sending e-mail.

Figure 12.4 An example of the extremely helpful information about specific satellite orbits available from the Heavens Above website, tailored to one's own location. While star backgrounds for a pass of the ISS are shown here, a chart of a satellite's pass relative to the Earth below can also be selected. Much information about other astronomical and spaceflight subjects is available from the site.

provided for a pass of the International Space Station over my location (edited for clarity) is included here as Figure 12.4. With a little practice, the track of a satellite against the stars is easily read but you can download a diagram showing a satellite's track across the Earth's surface if you prefer. With information about the track and time of the pass available, of course, basic photography is quite straightforward. There is a considerable amount of astronomical and other information at this address which is a most valuable resource. I have to confess that years ago I regularly obtained satellite orbital elements from NASA and then entered them into a special prediction program that I had purchased. Now all of my requirements are met by "Heavens Above."

Satellites are point sources which are sometimes brighter, and invariably moving much more slowly, than meteors. Moreover, the advance information about their orbits means that, while there may be some small discrepancies, the photographer can await the appearance of satellites without the need to adopt the patrol approach necessary with meteors. Once again, the standard 50-mm lens at maximum aperture provides both reasonable speed and large sky coverage, which will be welcome news for the novice. (Later, when experience has been gained and the passage of a satellite can be predicted with greater accuracy, longer focal length and faster lenses can be used.) Because the shutter is rarely held open for more than half a minute or a minute at most, there is little fear of light pollution having too much effect on the image, particularly as there is no need to use a very high-speed film: one of ISO 400 (whether color or black and white) is entirely satisfactory.

The normal basic procedures described in Chapter 5 should be adopted. Once the camera has been aimed, it helps to memorize quite accurately the area of the sky covered by the lens's field of view, or even to draw a rough sketch-map. When the satellite has been spotted, you can open the shutter on the B setting using the black card technique, wait until the satellite is just a short way from the edge of the field of view, withdraw the card, and then cover the lens again once the satellite has moved out of the target area. Of course, there is no reason at all why an exposure should not be begun or ended with a satellite in the middle of the field of view, but this is more likely to be by accident than design, when the satellite has been spotted at the last moment or has moved unseen and unexpectedly into an exposure being made for other reasons.

Your notes should include not only details of the lens and exposure, but also timings for the entry and (if possible) exit of a satellite from the camera's field of view, together with information about the location's longitude and latitude, and the starfield in the image. If there is then any subsequent query about the identity of the satellite, the image and notes should together be enough to provide the answer (see Figure 12.6).

When a satellite's passage is across the entire sky and is picked up very early, there is a temptation to try a series of pictures. With a single camera in use this should be attempted only after having practiced smooth and efficient readjustment of the tripod/camera pointing angle between exposures. It is better to get one excellent image of a satellite (as near the zenith as possible) than risk knocking the tripod over or some similar mishap. If maximum coverage is required, it is sensible to arrange two cameras on two tripods pointing at different parts of the sky.

Since satellites were first put into orbit around forty years ago, professional and amateur observers have conducted an intensive study of the effects of gravity, variations in the upper atmosphere, and other factors on orbiting spacecraft, and much new knowledge has been gained.

Figure 12.5 These two images were recorded during an automated camera patrol. The aircraft in the image at right passed directly above the camera, and its full complement of strobe and fixed lights was recorded. The aircraft in the image at left was probably banking, so few lights were recorded, but at least one of them was a flashing strobe. At critical angles and without visible strobes aircraft can resemble satellites in the trail they leave on film. On those relatively rare occasions careful analysis is required to identify them accurately. An aircraft trail also appears in the colorful inset which shows Jupiter at center and a Gatwick-bound aircraft trail above. Perhaps this trail gives an idea of how one of the massive orbiting advertising billboards, with which the world – and astronomers in particular – are threatened from time to time, would look.

By devoting a great amount of time and developing observational skills of a high order, amateurs have played an important role in this work, and for the newcomer to satellite photography there is the prospect of eventually becoming part of this effort. Then the simple enjoyments of locating and photographing satellites will give way to the need for highly precise timings of the passage. Specialists use a rotating shutter that "chops" the trail of the satellite recorded on the film into several segments, corresponding to equal time periods, from which detailed information about the satellite's orbit may be derived. The use of computer programs, together with updated information about satellite orbits supplied in the first instance by NASA, greatly facilitates such studies by providing a wealth of data.

Aircraft – and UFOs

Many images of meteors and satellites are quite unmistakable. Meteors range from faint and delicate needle-like traces to the far more robust and denser trail of a fireball. Satellite trails are often of uniform density, although where they enter or leave eclipse there may well be a "feathering" effect before the reflections from the spacecraft are extinguished (as in Figure 12.3). Sometimes, however, the trail may be broken into segments as a satellite rotates or tumbles, while somewhat less dramatic perturbations of this kind may introduce a pulsing of the trail that is discernible only under a magnifier. Under less than perfect sky conditions (and if visual observations were not taking place at the same time) it can be difficult to decide on the likely cause of some trails, and this situation is compounded by aircraft lights.

Civilian airliners display a whole battery of lights. A constant red light is located at the end of the port wing, and a constant green light on the starboard. A constant white light is usually fixed to the tail, and flashing anticollision beacons, usually orange in color, are located both above and below the fuselage. Finally, very bright landing lights on the inner leading edges of the wings are often switched on at night as a further collision-avoidance measure once an aircraft has descended below 3000 m (10,000 feet).

When seen (or photographed) from directly below at night, an aircraft cannot be mistaken for anything else. However, as angles get more oblique an image can become less easy to interpret, and the presence of light cirrus cloud can complicate the problem. The two photographs in Figure 12.5 were taken during an automated camera patrol. One shows a trail from beneath an aircraft, and the other shows the trail of an aircraft at an angle to the camera. Both interpretations are indisputable, but it only needs the flashing strobe lights to be hidden from the camera for a teaser to be set for the newcomer to astrophotogra-

Figure 12.6 An IFO (identified flying object). These two images are of the Corvus/Crater/Hydra region of the sky, centered at declination 20° S, and were obtained in 1987 during a program of fixed-camera constellation photography. Two 20-second exposures were made: the upper image first and then the lower, using an f/1.4 35-mm Nikkor lens and Agfachrome 1000RS Professional film. During the photography no movement in the sky was observed, but when the film was processed two short trails were revealed quite clearly. These indicated a bright object at considerable altitude and moving quite slowly in a southerly direction. The object was subsequently identified by Russell Eberst as the largest remnant of the Pageos balloon satellite, which was launched in 1966 and which disintegrated in 1975. At the time the pictures were taken, the remnant took about 180 minutes to orbit the Earth in a near-polar orbit, but it subsequently re-entered the Earth's atmosphere.

phy, and sometimes for the more experienced too. Often other evidence, such as knowledge of satellite passes or aircraft movements, will provide the answer, but not always.

This leads to the occasional need for detective work to solve a mystery. I live about 60 km (35 miles) southwest of London's Gatwick Airport, under one of the main approach paths. Years ago, shortly after taking up astrophotography, I became puzzled by bright, seemingly stationary lights to the southwest of the camera site. Thorough observation over a short period revealed these to be landing lights on aircraft making a head-on approach a considerable distance away. No engine noise was audible, lateral movement was minimal, and over a period of a few minutes there was no apparent movement of the light source. If the lights were watched for long enough the eventual movement of the aircraft was clearly revealed. This type of sighting may well be the origin of some UFO reports.

Sometimes, even for the knowledgeable, celestial objects can provide a brief puzzle. During an evening's photography one spring I saw a bright point of light in which green and red elements were discernible. It was to the northeast, in the general direction of Gatwick Airport. My first thought was that this was an aircraft that had just taken off, and that I should not let it intrude into a picture. A few minutes later the light was still in the same position, and I thought a helicopter might be operating in that area. After a few minutes more, with the light still in approximately the same position, the truth dawned: the beautiful star Vega was rising and displaying some of the classic features of twinkling (or scintillation), when atmospheric turbulence refracts the light from a star and causes flashes of different colors.

If you ever see an object in the sky that puzzles you, endeavor to make full notes of place, time, direction, elevation and any other relevant details. If at all possible, photograph the object in a series of time exposures (say 5, 10, 20 and 30 seconds on ISO 400 film or faster) that hopefully will record background stars if the sky is clear. If time allows, use lenses of different focal length and change the position of the object in the field of view (see below). In at least some of the pictures include a foreground object, even if it is a totally dark hedge, tree or house. Note as accurately as you can the time at which each exposure was commenced. It will be surprising if any mystery remains after subsequent analysis of notes and pictures (see Figure 12.6).

However, I have to report one astrophotography experience where later research and analysis failed to identify an object convincingly. A sequence of four different time exposures I took in November 1988 included the Hyades and Pleiades in Taurus and a very bright Jupiter. On later examination, an uncharted, star-like object appeared in all

four frames (see Figure 12.7). Because it was in all the frames, the object could not be the result of a processing fault. Neither did it possess the typical characteristics of a ghost image, even under microscopic examination. Subsequent tests of the same camera/lens/filter/film combination were inconclusive, and in the absence of any positive, corroborating evidence from other sources I concluded (perhaps too easily) that the object was probably an unknown artifact of the photographic system. In retrospect, of course, a simple test would have provided the answer. If, using the same equipment, the camera had been moved between frames so that Jupiter occupied different positions in the field of view, then on the film a ghost image would have moved too. But this was being wise after the event, because I was not aware of the mystery object when taking the pictures.

If you do find an uncharted object in a photograph you have taken, do research it thoroughly. You may have (unknowingly) recorded an asteroid, a nova or a comet – who knows, you may even have *discovered* one.

Figure 12.7 *A mystery object (see the text). One of the original color transparencies, exposed on 1988 November 2. Jupiter is the major object, with the Pleiades above and the Hyades with Aldebaran below. The small unidentified object is arrowed. Under microscopic examination the image of the object did not have the typical characteristics of a "ghost," and subsequent tests with Jupiter in the field of view failed to recreate anything like it. The object appeared on four consecutive exposures, from 30 seconds to 2 minutes, on Agfachrome 1000RS film loaded in a Nikon F3 camera mounted on a driven platform. The lens was a 58-mm f/1.2 Noct-Nikkor stopped down to f/2.8 and fitted with a Lumicon Deep-Sky FilterTM.*

Processing

For many photographers "home processing," whether for black and white or for color, is half the fun. This chapter is directed not to them but at newly enlisted astrophotographers who have not hitherto processed their own films. Why should they now contemplate doing so? Putting aside the increased enjoyment to be had from the hobby and the question of safeguarding one's efforts (discussed in Chapter 4), the main attraction is the convenience. We have to take advantage of periods of good weather when we may be able to devote consecutive nights to astrophotography, and it is advantageous to be able to see the results of one night's work before the following night. If there is a good, fast processing laboratory in the neighborhood then all is well, but many of us will not have access to such a service. Even if we do, a laboratory might well be shut for a lengthy period over a holiday – exactly when the astrophotographer might have the time and therefore a greater inclination to take advantage of clear nights. It is also easy for the home processor to take a compact kit away on foreign travels so that results can be checked between photo sessions, and also to ensure that no damage results from X-ray screening of unprocessed film at airports (see Chapter 16).

It is quite natural to wonder how the costs of commercial and home processing compare (both vary somewhat according to locality and, of course, country). Although it is possible that over a comparatively short period of time somebody who exposes and processes a considerable number of films might save money, I would not recommend home processing on that account. Another important consideration is quality. If you are prepared to follow a small number of detailed instructions carefully (and can read a thermometer accurately), the quality you can achieve by using a home processing kit will leave nothing to be desired. Moreover, it will not entail a great expenditure of time.

The guidance that follows cannot be as lengthy or as detailed as that found in a specialized book on processing or in manufacturers' instruction leaflets (which are usually first class). It is, however, intended to be sufficient for you to decide whether to go ahead and purchase the few items of equipment that are needed and to try home processing for yourself.

Preparatory stage

This may be described as the dry stage. The exposed film has to be removed from its cassette in total darkness and placed in a light-tight container before processing. You can do this in a photographic darkroom – but if you have access to one, you will not be reading this

chapter. One step up from such primitive methods as unloading film under the bedclothes is to use a dark cupboard. The problem is that cupboards are very rarely dark, as will become clear if you shut yourself inside one and allow time for your eyes to get dark adapted. Making a cupboard dark enough for handling films (particularly fast films) is a laborious business. The simple and very modestly priced answer to the problem is the *changing-bag*. This is made of a black fabric and looks rather like a cushion cover. It has a large zipped flap in an inner lining, and a flap in an outer cover which is closed by several press-studs. In two corners of the bag are shaped cuffs through which you insert your hands, and which are kept light-tight by elasticized bands. (The bag is an excellent purchase for it serves also, for example, as a means of tackling such problems as opening the back of a camera in which a film has apparently jammed, and unjamming it without losing any frames through exposure to light.)

The large flap of the bag admits a daylight *developing tank*. This consists of four main parts: a two-sided, grooved plastic reel on to which the film is wound; a hollow spindle that passes through the middle of the reel; a cylindrical tank that accepts the spindle and reel; and a tank lid molded in such a way that a central spout (into which processing liquids are poured) fits down inside the spindle, thereby rendering the inside of the tank light-tight (see Figure 13.1). A rod for agitating the reel is supplied with some tanks, and all have a tightly fitting cap for the lid.

These tanks have improved steadily over the years, and some current models have rather strangely shaped lids through which processing liquids can be poured in no more than a second or two – an important factor in securing an optimum result. Into the changing-bag with the film cassette and tank go an opener for extracting the film from the 35-mm cassette (this need be no more than an ordinary hook-type bottle opener) and a small pair of sharp but preferably blunt-nosed scissors.

The two ends of the reel can be set at different distances from each other to take various sizes of film. The tanks themselves come in a number of sizes, and some will take more than one reel at a time, which is an obvious advantage when several films of the same type are to be processed. As a reminder to the user, the tanks normally have molded somewhere on the outside details of the volume of processing liquids required by different sizes of film.

Before inserting the film into the reel, the leader has to be cut off in between the perforations across the full width of the film. (If the cut runs through one or both of the perforations it is likely that the film will not enter the reel without difficulty.) This is why the habit of winding the film completely back into the cassette after the final exposure is not recommended. With a film not fully wound back it is an easy matter to

Figure 13.1 *A modern, highly efficient daylight developing tank. The main shell of the tank is at center left. To the right is the light-tight inner lid shaped for fast pouring of developing solutions; at the far right is the reel on to which the film is wound, with a hollow spindle inserted through the reel core. In the foreground is an agitating rod, and at far left is the outer lid which seals the tank completely so that it can be inverted without solutions leaking.*

extract all of the leader and cut carefully and at right angles across the full width of the film. If the film has been wound in fully then the operation has to be done within the changing-bag when the cassette has been opened (and then there is a very good chance of cutting across the perforations because we obviously cannot see precisely what we are doing) – either that or an attempt must be made to extract the leader.

One way of extracting the leader is to cut a piece of acetate or very thin but stiff plastic into a strip measuring about 10 × 2.5 cm (4 × 1 inches). The corners of one end are rounded off so that the film is not scratched when inserting the strip through the lips of the cassette, and a piece of double-sided adhesive tape roughly 2 cm (0.8 inch) square is fixed on one side of that end. About half the length of the strip is pushed through the lips of the cassette with the adhesive tape toward the film core. The core is turned clockwise, which presses the film against the tape, to which it will hopefully stick so that it can be withdrawn, though several attempts may have to be made. The moral for home processors is not to wind the film fully back – although a camera with auto-rewind will usually put the matter beyond their control.

Extracting the film from its cassette and loading it on to the reel requires practice. The changing-bag is somewhat restricting to the inexperienced, so it is a good idea to practice the technique first of all in ordinary light on a table, and then in the dark on the table, before attempting to use the changing-bag. This requires the expenditure of two or three films (perhaps outdated ones which have been around for a long time, or a particular brand you have come to dislike), but this should not be regarded as a waste.

Gather together the film cassette, the tank (with lid lightly on, but reel and spindle separate – this saves a needless extraction of the reel from the tank once it is inside the bag), the opener and the scissors. Pull the leader out from the cassette and cut it off at the point where the film becomes full width. Clipping and chamfering the corners of the film makes it less likely to jam when it is being fed into the reel. Place the hook of the opener under the edge of the cassette cap opposite the long end of the spool, and remove it. Take out the film (still on its spool) and discard the empty can. Put the film down for a moment – it will not unravel if you take care – and take up the reel. Align the two entry points (which have ball-bearing ratchets to facilitate the entry of the film) and take the reel in one hand with the entry points facing you. Take up the free end of the film between the thumb and first finger of your other hand, and draw it gently between the entry points until several inches of it are through and it is secure (see Figure 13.2, upper image).

Place the fingers of each hand along the edges of the reel with the thumbs acting as guides to the film at the entry points, and rotate the two sides back and forth in opposite directions until almost all of the film has been loaded (see Figure 13.2, lower image). If the two little fingers of each hand are kept extended underneath the reel while the film is being wound, they can be used as sensors to check that the film end is close with the spool still attached. (If you cannot feel this, you risk damaging the film if the spool jams into the reel ends.) Hold the reel in one hand, pick up the scissors, and cut off the spool. Rotate the sides of the reel again until the film is completely loaded. Taking care not to touch the surface of the film, insert the spindle through the center of the reel. Put the reel and spindle down for a moment and remove the lid from the tank. Place the reel and spindle (reel first) into the tank, and snap the lid in place. If the lid is kept on the tank until the last moment, it should prevent the empty cassette and loose end-cap from finding their way into the tank, and causing confusion when the operation is taking place in the changing-bag.

If several films are being processed in quick succession in a single film tank, it is essential to ensure that the reel and tank are completely dried between films. If there is any water in the spiral grooves of the

Figure 13.2 (above) In the darkroom or in a changing-bag, this is the way the film is drawn past the entry points or ball-bearing ratchets of the reel. The leader of the film is cut neatly at right angles to facilitate entry. (below) Once the film has been taken up by the reels, it is wound in by counterrotation of the reels.

reel, the film will swell and become sticky, making loading virtually impossible. Occasionally, for no apparent reason, the film may not load smoothly. On no account should it be forced once resistance has been felt, since this can result in damage to the film and possibly in light flashes on the developed photographs caused by physical deformation. Try tapping the reel with your knuckles. If this has no effect, flex the end of the film that is still free by pushing the edges together slightly, and pull the film free with the reel rotating in the other hand. (If much of the film is on the reel, it should be pulled very slowly so that, as it comes away, the film coils up on itself loosely, and does not hang free, vulnerable to damage.)

In daylight and with a reasonable working space, this first practice session should go quite smoothly. Before the second practice, place all the items close to hand before cutting off the leader and then switching off the light. The main difference between the practice in the dark

and the third practice in the changing-bag is the greater restriction on space. I find it best to work on a table-top so that the various items in the bag are supported, and I can take the weight on my elbows.

The tank, with the lid lightly in position, and the spindle are placed to one side of the bag; the reel is positioned in the center; and the cassette, scissors and opener are put in the opposite corner. The bag is then closed. Once the cassette has been opened, the film is placed carefully by the reel for a moment, and the end-cap, together with the empty cassette and opener, are replaced in their corner of the bag. This is important because there is then no risk of the objects touching and scratching the film as it hangs beneath the reel during the loading operation. Once this is completed and the film spool is cut off (and placed in the right-hand "refuse corner" of the changing-bag), the spindle is inserted into the reel with its base at the bottom. Both are placed in the tank and the lid is fixed firmly in place. The bag can then be opened, all objects can be removed, and processing can commence.

With a little practice you will be able to carry out this procedure with few if any problems. The main difficulty will be the occasion when, with hands within the bag, you sneeze or get an itchy nose!

Processing black-and-white film

A brief description of what happens when an image on black-and-white film is developed will help make clear the practical requirements. When film is exposed in the camera, light affects silver halide crystals in the emulsion and forms what are called *development centers* in the crystals. These make up the latent image. If we could see the film at this stage, no image would be visible: a developer is needed to act on the development centers where the silver halides are reduced to black metallic silver, the extent of this action being broadly proportional to the amount of light striking the film in the original exposure. The silver halides not affected by the light have no development centers, so none should develop, but when this does happen for a variety of reasons it causes a chemical fog that degrades the image.

When enough silver has been produced to give the desired result, the action of the *developer* (which is alkaline) must be stopped. This is done by removing the film from the developer solution and placing it in a mild acid solution known appropriately as a *stop bath*. The remaining silver halides, which are still sensitive to light, must be removed, and this is accomplished by the *fixer*. This is a selective solvent which reacts with the halides to form soluble silver salts that dissolve into the fixer solution. Finally, once removed from the fixer, the film has to be washed to remove residual fixer chemicals, dissolved silver salts and other by-products of the various stages.

This is a very simple outline of what is a complex process. The ultimate result depends on an enormous number of variables including the properties of the film, the nature of the original exposure, the characteristics of the developer, and the manner of the development. Fortunately for the newcomer, the manufacturers of film and processing chemicals usually issue excellent instruction leaflets with their products.

Although the exact details of the processing steps vary somewhat according to the particular film and chemicals, the basics are very similar. The film is developed for a period of time (roughly 4 to 10 minutes) that is determined to a considerable degree by the temperature of the developer solution. The film is then placed in the stop bath for up to 30 seconds, and then in the fixer for several minutes. The traditional working temperature for black-and-white film development is 20°C (68°F), although processing at higher temperatures has become more popular in recent years. Holding to the chosen temperature of the developer is critical to the result, but the acid bath, fixer and washing water may be a degree or two either side without any ill-effects to the image. If water from the tap cannot be held to approximately the desired temperature while the film is being washed, it is safer to fill a bowl with water at this temperature and to wash the film by repeated changes of water from the bowl. After washing, the film is given a final rinse in a wetting agent (which helps prevent the formation of drying marks on the film) and hung up to dry. The drying place must be dust-free, and preferably warm and well-ventilated. Detailed guidance on, for example, the type and amount of agitation of processing liquids required in the different sorts of development tank will be found in the manufacturers' instructions, but it is pertinent here to indicate the items of equipment (as distinct from chemicals) required by the newcomer.

The developing tank has been discussed in detail already. The next most important item is the *thermometer*. Various types are available, the differences largely concerning accuracy and ease of reading, and therefore cost. Spirit and mercury versions are popular, usually accurate to about 1°C (0.5°F) and 0.4°C (0.2°F) respectively, although I must confess to having had difficulty over the years in reading mercury thermometers. Dial thermometers are very easy to read but are somewhat unreliable in accuracy. Digital LCD display thermometers are accurate to about a tenth of a degree and are easy to read, but are about three times as expensive as a mercury thermometer. Contamination is a problem during the preparation of processing solutions, and care must be taken to wash the thermometer thoroughly in cool (not hot) water.

Working solutions of acid bath and fixer can be used repeatedly until they near exhaustion. With many developers you need to make up a working solution from a powder or liquid concentrate. Therefore at least

three appropriately sized and dedicated containers or bottles will need to be purchased, with most people seeming to prefer glass containers. A small graduated vessel or measuring cylinder with a capacity of at least 300 ml and marked graduations down to 25 ml is needed for measuring out the solutions, although again thorough and frequent washing is essential in order to avoid contamination. (In general, a little developer will have no detrimental effect on acid bath or fixer, but a small amount of acid bath or fixer will have a potentially severe effect on developer.) A mixing jug and a mixer or mixing paddle facilitate the preparation of the processing solutions, the mixer particularly if the developer concentrate is in powder form, which dissolves with greater reluctance than a liquid concentrate. Again, take care to avoid contamination.

If tap water can be mixed to the desired washing temperature, use a *film washer*. This is a simply a tube that fits into the developing tank at one end, to ensure maximum washing efficiency, and over the tap at the other. It costs very little. Holding processing liquids and washing water at steady temperatures can be accomplished by using a *water jacket*, which can be as elaborate as a thermostatically controlled tank designed specially for the job, or as simple as an adequately sized kitchen bowl containing water a few degrees warmer than the solutions. Pairs of *film clips* (one of which is weighted) are used to hang the film up for drying. They are inexpensive and are more efficient than drawing pins/thumbtacks at the top and clothes pegs/clothespins at the bottom! Some people recommend using a film squeegee with soft rubber blades to drastically reduce the amount of water left on the film after putting it through the wetting agent. I do not use one because, however much care is taken, it is a potential source of scratches on the film. While some of us have skins which are far less sensitive to chemicals than others have, it is sensible to wear a pair of ordinary household rubber gloves during all processing operations. Finally, a countdown timer with a very clear display is essential, particularly at those stages in the process where the processing liquids need to be agitated at specified intervals so as to optimize development.

Processing color film

Despite the additional complexity of color transparency or negative films, processing them is only a little more involved than for black and white. Leaving aside Kodachrome film (which requires complex processing that can be carried out only in major laboratories), the industry standard for transparency films is based on Kodak's E-6 process, which is well suited to home processing and which can be used for virtually all other manufacturers' films of this type. Similarly, C-41, another industry-wide process established by Kodak, relates to color negative films.

Whereas black-and-white film is composed basically of one sensitive layer, color film has essentially three layers, one sensitive to each of the primary colors of blue, green and red. In transparency films, after exposure, a first developer produces a black metallic silver image that, as with black-and-white film, represents the highlight areas of the original. Unlike black-and-white film, however, this silver is developed in the three basic layers according to the colors in the original scene. Since the film is intended to yield transparencies (or positives) and not negatives, the negative images have to be turned into positive images by reversal processing. This is accomplished by the use of a color developer that fogs the hitherto unexposed and undeveloped silver halides in the positive areas of the image, and then creates in them dye images of the correct hue in each color-sensitive layer. Since the positive and negative silver images now serve no purpose, they are bleached out of the film, and the film is fixed by a combined bleach fix solution to leave only the color dye images. It is then usually passed through a stabilizing bath. Processing color negative films is simpler because no reversal step is involved. Thus the transparency film home-processing kits now available comprise three processing baths (plus stabilizer), whereas the C-41 kits have only two baths plus stabilizer.

One major difference from black-and-white processing is the high temperature that is regarded as optimum for color processing – typically around 38°C (100°F). Obviously this makes it more demanding to keep the solutions at their required temperatures. An equally important difference is the need to maintain the critical balance between the images formed in the three color-sensitive layers, and this is accomplished by strict adherence to the required solution temperatures and processing times.

Kodak's own processing kits are now limited to sizes suitable only for professionals and laboratories but fortunately a number of conveniently sized kits for amateurs are available from a number of companies. Those made by the German based but international company Tetenal under its Colortec brand name are available widely (including in both the UK and US), while Fotospeed and Photocolor are two other brand names of both E-6 and C-41 kits. As indicated above, the processes differ only in details and the following summary of the processing steps for an E-6 film, while based on the Colortec instructions, is very similar for all kits.

1. Bring the processing solutions up to 38°C (100°F) by standing the containers in a bowl of water at about 40°C (104°F). Preheat the developing tank to 38°C in the bowl.

2. Pour in the first developer. Agitate (see below), and stand the tank in the water (it is kept there as much as possible throughout the pro-

cess). Develop for 6 minutes at 38ºC, including the time taken (around 10 seconds) to pour out the developer, which is kept for re-use up to the stated maximum number of films.

3. Wash the film for 2 minutes – in running water if available at a constant 38°C (plus or minus 1°) or with changes of water every 30 seconds.

4. Pour in the color developer at 38°C plus or minus 1°. Agitate. Replace the tank in the water bath. Develop for 4 minutes at 38°C, including the pouring out time. The developer is retained for re-use.

5. Wash the film for 1 minute in running water – say three or four changes of water if running water is not available. Temperatures now become a little less critical: this wash is at a temperature optimum of 36°C (97°F) plus or minus 3°.

6. Pour in the bleach fix. The temperature is at the same 36°C, with a leeway of 3° either side, for a period of 4 minutes. The bleach fix is retained.

7. Wash the film for 3 minutes at the same temperature as the last two steps.

8. Soak the film in a stabilizing bath at 20–25°C (68–77°F).

9. Hang the film up to dry in a warm, dust free area. It may be heat dried but the temperature must not exceed 60°C (140°F). If a hair dryer is used, great care must be taken to avoid local overheating. The transparent parts of the film will have a milky appearance when wet but will clear on drying.

NB: The times given for the three principal processing steps are for the first two films of a six film maximum capacity for this size of kit – times lengthen for later films. Agitation during those three steps (whether by inverting the tank a number of times or, in tanks having an agitating rod, by rotating the spiral reel) should be constant for the first 15 seconds of immersion and then just once every 15 seconds. Processing must be in total darkness during the first development and subsequent wash but the tank lid can be removed if desired once the film is in the color developer.

Copying slides

If you want a good-quality, accurate copy of one of your slides, it is probably cheapest to go to one of the film manufacturers or one of the independent photo labs that cater for the amateur photographer. Getting sufficient accuracy is very difficult, but accuracy may not be what you are after. You may want to increase the contrast of the original to bring out more detail, or adjust the color balance to give a more faithful rendition of the original scene as you remember it, or as you

wish it had appeared. These objectives are not so difficult to achieve, and are well worth trying for yourself as you get more deeply involved in astrophotography.

The main requirement is for a duplicator assembly that will reproduce the original slide at least at the same size. The simplest such system consists of a tube in which is mounted a dedicated, fixed-aperture lens. At one end of the tube is a slide-holder, and at the other an adapter for mounting a camera. Daylight may be used as the light source for illuminating the original slide during copying, and for reliable calculation of exposures you cannot beat an SLR camera with its through-the-lens metering. At the other end of the scale are bellows copying units made by the major camera manufacturers for their own models, employing lenses specially designed for close-up work, although a standard 50-mm lens can be used if it is reversed when fitted to the bellows. These dedicated units are usually versatile and come with a host of features, but they are expensive. While it is possible to make use of daylight as the light source, greater control can be exercised by using an electronic flash or a tungsten light positioned behind the original slide.

The film used will depend on the light source. If it is daylight or electronic flash, then a slow (say ISO 25 or 50), high-resolution, high-contrast slide film balanced for daylight is the best choice. A tungsten light source will require a film balanced for that type of light. In your choice of film, however, you will in another aspect depart from the usual photographic practice. Dedicated copying films are intended to limit the contrast that builds up when an original is copied. However, you will almost certainly be wanting to increase the contrast, and so will choose a conventional (non-copying) film balanced for daylight or tungsten light. Experience will teach you whether you need to modify the exposures indicated by the SLR's through-the-lens system. For example, you may have a dense transparency which, when illuminated by a strong light source, shows considerable detail. One or two stops of overexposure in terms of the meter reading might well be required to bring this detail out.

If you are attempting to correct a color cast in the original, then you will need to understand a little about filters and the nature of color. A particular filter passes its own color, but blocks others. Thus a red filter will pass red light, but absorb the other primary colors, green and blue. Much use is made in photography of the so-called subtractive primary colors (sometimes called secondary colors) of cyan, magenta and yellow. In terms of their filtering properties, cyan is composed of blue and green, and so passes them, but absorbs red; yellow is composed of red and green (yes!), and so passes them, but absorbs blue; and magenta is composed of red and blue, so passes them, but absorbs green. If you need to get rid of an unattractive greenish cast in a slide,

then give a light red or magenta filter a try. If there is a red bias in the slide, a cyan filter could well improve things.

Various manufacturers make a range of color-compensating filters that are available in gelatine and are reasonably priced. Duplicating is a technique with a special significance for the astrophotographer because it can help correct some of the deficiencies in an original, and it offers a few of the opportunities open to the user of CCDs and computers (see Chapter 15), but admittedly it is something to be tackled further along the learning curve.

I have not attempted to give any guidance on black-and-white or color printing. I have recommended home processing principally as a means of checking easily and quickly that all photographic systems are working well. Printing and darkroom work represent a further stage, one best left to specialized books and guides or tutorial courses. The information given in this chapter should be sufficient to help the newcomer decide whether to start home processing. Home processing has many advantages and, with attention to detail, good quality can be achieved. Moreover, even for those who have lost count of the number of films (black-and-white or color) they have processed, the thrill of "seeing the image come out" rarely dies.

Figure 13.3 "Home" color processing packs are very compact. Shown here are the Tetenal 0.5 litre E-6 kit with the concentrated solutions contained in sachets (left); the Fotospeed C-41 two liquid concentrates for making 0.9 litres of working solutions (center); and the Tetenal 12 film C-41 "Phototabs" kit (right). The last is a new development in that the concentrates are in tablet form which are made up as required into appropriate working solutions that are thrown away after use, ensuring the use of fresh solutions each time. The tablet preparation also removes any potential health hazard arising from chemicals in powder form being inhaled during the preparatory stages of processing.

Project photography

When we first start astrophotography, we are pleased if we manage to secure sharp and well-exposed images of targets such as the Moon or the constellations. Once we have gained experience and the number of failures has decreased, we may find as time goes by that getting individual pictures of reasonable quality is not enough to hold our interest. Motivation is important in any chosen field of activity, and what we might call project photography can provide it in astrophotography. By project photography I mean the study of an astronomical event or phenomenon using photography that is somewhat more involved or demanding than is required to obtain a single image, no matter how competently that image may have been obtained. The purpose of an advanced project might be to contribute to original research, but it is more likely to be of an educational or informational nature: to obtain, for example, a photographic record of a phenomenon which is of particular significance or which extends over a period of time and which our eyes cannot therefore encompass. Project photography does not necessarily require complex or expensive equipment, although that can expand the scope in some circumstances. Most of the examples in this chapter use little more than basic photographic equipment. Some projects can be attempted at any time, while others have to do with astronomical events that must be recorded at precisely the right time.

The slender crescent Moon

The first sighting of the new Moon has considerable religious importance for Muslims. Spotting a very young new Moon (or a very old one just before new) has long been a challenge for amateur astronomers, and photography of the event is a good test of technique. Properly documented sightings of a Moon less than 20 hours from new are rare, and what may be the record was established on the evening of 1989 May 5 when a Moon just under $13\frac{1}{2}$ hours old was seen with binoculars (and also possibly by the naked eye) from the US. Witnessing the event is more than just having the luck to be in a location where the Moon reveals the thinnest of crescents in a twilight sky. Very important too are the steepness of the ecliptic to the horizon and the Moon's position relative to the ecliptic, which must be such that its angular separation from the Sun is as great as possible. Moreover, the Moon must be close to perigee (the closest position to Earth in its orbit) because then it is traveling at its fastest, and that increases its angular separation from the Sun more quickly than at any other time. These conditions were favorable when the record sighting was made in May 1989, and the new Moon was spotted from a location which was

close to ideal because from there the Moon was standing directly above the Sun as the sky darkened sufficiently for it to be seen. For more on the subject, see *Sky & Telescope*, July 1994, page 14.

There is sufficient interest in such sightings for astronomy magazines to publish information about forthcoming opportunities and the best vantage points in advance, so the need for detailed knowledge of the event itself is not a problem. Computer programs (see Chapter 15) are a considerable help, too. Photographically it is demanding because by definition the thin crescent Moon will be relatively low on the horizon where it can easily be obscured by cloud, haze and atmospheric pollution. In addition, the slender crescent will be seen against a comparatively bright twilight sky in middle and higher latitudes, although this is less of a problem the closer the photographer is to the equator.

Figure 14.1 The Moon was just over one day old, and could easily have been missed in the bright twilight. The difficulty with photographing a very young Moon is not one of exposure – a general reading of the sky will suffice. Rather, the problem is to obtain sufficient discrimination and contrast between sky and crescent by using a long lens and a high-resolution, high-contrast film. This picture (which also includes Venus) was taken on 1989 June 4 using a 300-mm f/4 Nikkor lens at maximum aperture and an exposure of 1/15 of a second on Fujichrome ISO 400 transparency film. A slower film would have offered somewhat more contrast and also higher quality, particularly as there is such a large expanse of clear sky in the scene.

The exposure may confidently be based on a meter reading since the crescent Moon and sky do not present a severe lighting contrast, and a general reading should suffice; although I always bracket at least two half-stops each side of the indicated exposure. With such a large expanse of sky the film chosen should be no faster than ISO 400, otherwise grain will become too intrusive. The lens should be a telephoto of at least moderate focal length. One of around 200 mm would provide a pictorial type of image, particularly with an attractive foreground, whereas longer focal lengths of up to 2000 mm will direct attention to the Moon only. For optimum results, observe closely the advice on procedures given in Chapter 5, such as use of tripod and cable release, and especially of mirror lock-up and shutter-release delay if available in the camera. Figure 14.1 shows a photograph of my earliest Moon: it was taken in England on 1989 June 4 (the lunation following that of the record sighting) when the Moon was a little over 25 hours old.

Earthshine

This phenomenon, referred to in Chapter 6, could be developed as a project for both observation and photography. Earthshine could be photographed at regular intervals from the earliest possible occasion after new Moon until the time when the growing daylit crescent of around three days begins to swamp it. Alternatively, a similar study could be made of the waning crescent Moon. Since the phase of the Moon as seen from the Earth is the reverse of that of the Earth as seen from the Moon, earthshine would be expected to be at its brightest immediately after new Moon. Atmospheric conditions would almost certainly vary over the two or three evenings for which earthshine remained visible, as it would from one lunation to the next. Nonetheless, it is quite possible that careful observation and recording of the atmospheric conditions over the period of the study could lead to meaningful conclusions about variations in the nature of earthshine. For example, might the different levels of earthshine resulting from a cloudy or less cloudy Earth, or from more of the Antarctic as distinct from the Arctic being seen from the Moon, be recorded convincingly? The extent of the difference would be revealed by gains or losses in the detail discernible among the recognizable surface features on the lunar night side (see Figure 14.2).

Although I have photographed earthshine quite frequently, I have not attempted a study of this kind, but it is an attractive proposition. The photography is not difficult; the salient points were made in Chapter 6. For optimum results a long focal length lens of 1000 mm (or more) should be used, and the camera mounted on a platform (or telescope) tracking at the lunar rate. Extensive note-making will be essential.

The size of the Sun – and the Moon

The Earth travels round the Sun in an elliptical orbit, and is at its closest to the Sun (at perihelion) early in January each year and its furthest (at aphelion) early in July. At these times its distances from the Sun are 147 million km (91.5 million miles) and 152 million km (94.5 million miles), respectively. The difference has a small but discernible effect on the size of the solar disk (plus or minus $1\frac{1}{2}$ percent) as seen from the Earth, and this can be demonstrated in a simple photographic experiment.

The Sun is photographed on black-and-white film or high-resolution color film through suitable white-light filters (see Chapters 7 and 15) early in January, and again early in July using exactly the same equipment. The lens should be of at least 500-mm focal length, the longer the better. The resulting negatives or slides are then enlarged by exactly the

Figure 14.2 Earthshine is recorded clearly in this picture of a two-day-old Moon. A 1000-mm f/11 Nikkor mirror-reflex lens was boosted to 2000-mm by the use of a ×2 teleconverter, and the camera was mounted on a platform tracking at the lunar rate. The original exposure was 8 seconds on Fujichrome ISO 1600 transparency film. While the daylit crescent is overexposed, the exposure is generally satisfactory in that there is limited flare. Flare does, however, become apparent in the long exposures required for earthshine once the Moon is about three days old.

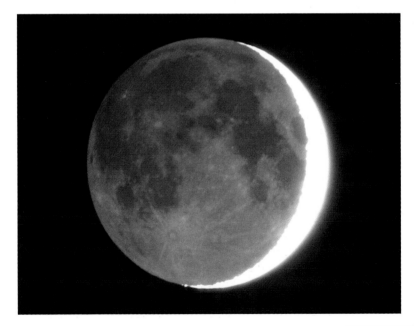

same amount, and printed. One quite dramatic (and practical) way of demonstrating the difference in the size of the two disks is to carefully cut each print in half, and then mount the left half of one facing the right half of the other on a black background, leaving just a thin gap between them. Alternatively, the two comparative images can be scanned and, using a simple procedure in one of the imaging manipulating programs, the smaller disk can be dropped on the larger to demonstrate the difference in diameter. An example of this method is reproduced as Figure 14.3.

The fact that Earth is closer to the Sun during the northern winter can puzzle those with scant astronomical knowledge. The fact is, of

Figure 14.3 It is a relatively simple photographic exercise to demonstrate how the apparent size of the Sun varies during the course of a year. The main constraint is that the same focal length of lens be used to obtain the winter and the summer image, and that the means of presenting them be strictly comparable – for example, giving the transparencies or negatives exactly the same degree of enlargement, as here. These images were obtained using an Inconel white-light solar filter and, although a long focal length lens and a film camera using high-resolution film would have performed well, on this occasion a Nikon D1 digital camera and a 1600-mm Starfire refractor telescope were used. The larger image was taken on 2001 January 3 almost exactly at the time of perihelion and the superimposed, smaller one on 2000 July 14 – some ten days after aphelion, the delay being caused by inclement weather. The difference in apparent size is only 3.5% but can nonetheless be discerned clearly, as can a number of sunspot clusters.

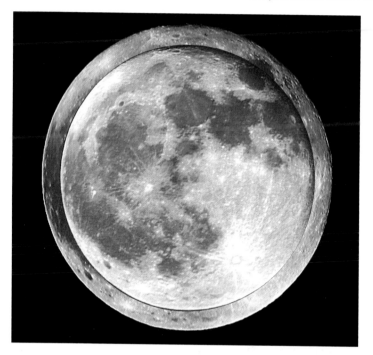

Figure 14.4 The variation in the apparent size of the Moon over the course of a year can be demonstrated by a directly comparable method to that adopted in the case of the Sun in 14.3. In this composite image, the Moon at perigee (its largest) was photographed on 1999 December 23 and at apogee on 2000 July 17. On both occasions the exposures were made on Fuji Velvia ISO 50 high-resolution color transparency film loaded in a Nikon F4S camera. The exposures were 1/60 of a second in each case at a focal ratio of f/9. The comparison images were obtained using exactly the same procedures in each case – a vital necessity. Following processing, the transparencies were scanned and combined using the computer. Color balance in different images can vary normally but in this case each disk was given a different hue to emphasize the comparative sizes.

course, that both the northern and southern winters occur at those times of the year when the $23\frac{1}{2}°$ tilt of the Earth's axis causes those parts of the world to receive less solar energy – the Sun totally disappearing for some time within the Arctic or Antarctic Circles.

The Moon's orbit about the Earth is in the form of an ellipse, so it too varies in apparent size. When the comparison in size is made it can be seen immediately that there is a considerably greater disparity than

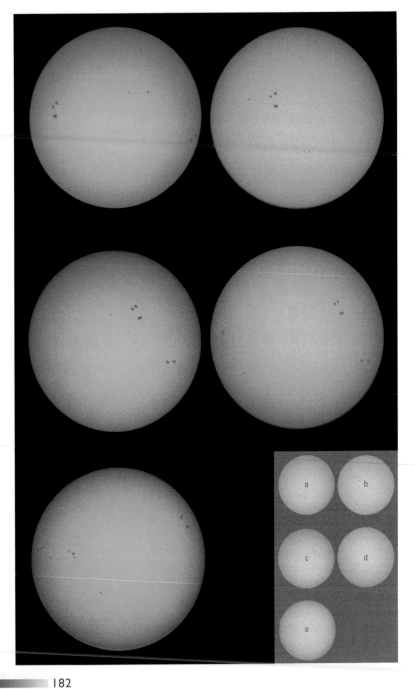

in the case of the Sun. At perigee the Moon spans almost 34' (minutes of arc) but this falls to just under 30' at apogee – a difference of around 12 percent. Figure 14.4 illustrates this phenomenon.

Solar activity

With the same equipment described above for photographing the Sun, we can demonstrate the rotation of the Sun, using sunspots as markers. The Sun completes one rotation as measured at its equator in just under 27 days, although the rate slows progressively toward its poles. Movements of sunspots across the visible disk can therefore be seen for a little less than two weeks, weather permitting.

Using a neutral density filter (or a special solar filter – see below) and as long a lens as possible to achieve maximum detail, the Sun is photographed on as many days as possible. The film can be high-resolution Technical Pan 2415 black-and-white film, or one of the high-resolution color transparency films such as Kodak Ektachrome E100S. Given favorable weather and sufficient sunspot activity, an impressive multi-image display consisting of five or six prints can be produced. If of good enough quality, as in Figure 14.5, a sequence of this kind can also demonstrate how individual sunspots or clusters of spots themselves change with the passage of time. It is important in displaying the images to ensure that the orientation of the Sun's axis is consistent so that the sunspots' tracks across the disk can be followed.

A hydrogen-alpha filter will reveal active regions and other details of the solar chromosphere – but it is expensive. Its use is dealt with in Chapter 15, but it is appropriate to mention here that with such a filter it is possible to obtain a sequence of images of the Sun recording changes over minutes rather than days. The images in Figure 14.6 show the development of solar prominences – plasma shooting up for sometimes tens of thousands of kilometers into space – over the course of almost $2\frac{1}{2}$ hours.

Figure 14.5 Pictures of sunspot activity can be used to demonstrate the rotation of the solar disk. This sequence of photographs charts the movement from east to west (left to right) of a large group of spots across the face of the Sun's northern hemisphere on (a) day 3, (b) day 5, (c) day 8, (d) day 9 and (e) day 11. All five images were originally recorded on ISO 100 Ektachrome transparency film through an Inconel type solar filter placed over the full aperture of a Celestron C8 telescope. The camera was a Nikon F3, and the exposures varied from 1/125 to 1/500 of a second. A full sequence of images covering a complete rotation of the Sun could be turned into an even more striking demonstration by using a video camera to copy the individual images and then presenting them as a time-lapse movie.

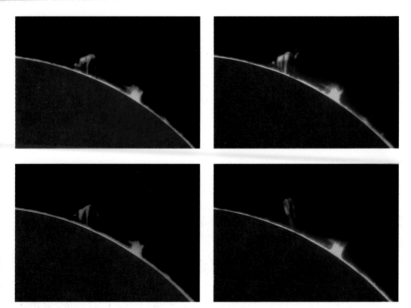

Figure 14.6 *Solar prominences. The picture at top left was taken at 12.17 UT on 1996 August 22. That at top right was exposed 10 minutes later and the image at bottom left after a further 10 minutes (at 12.37 UT). The final image was recorded almost 2 hours later at 14.40 UT. The relatively compact prominence at right altered little over the period but that on the left developed significantly. The images were taken through a DayStar 0.7-Å bandpass hydrogen-alpha filter attached to a Starfire 178-mm f/9 refractor telescope. Each exposure was for 1/2 of a second on Technical Pan film and was subsequently colored. An exposure of this length is necessary to record prominences but totally overexposes the solar disk, which can be occulted as in this example with pre-cut black paper disks (this could now be accomplished digitally).*

Libration

The manner in which the Moon wobbles on its axis so that over a period of time we can see some 59% of the Earth-facing disk was discussed fully in Chapter 6. This too makes for a very straightforward project in which images of the Moon taken over the course of perhaps a year are retrospectively compared so that differences at the leading or trailing limbs can be discerned. Such differences can be seen elsewhere on the lunar disk but I find that they can most graphically be demonstrated by locating major features close to the limbs. The two images reproduced as Figure 14.7 were separated by nine months and show marked examples of both libration in longitude and latitude.

Figure 14.7 *These two images show lunar libration in action very clearly. That at left was taken on 2001 March 1 and that on the right on 2000 June 8. The phase of the Moon was approximately 6½ days in both cases. Compare the areas of the lunar surface numbered on the right with the features in the later image. The roughly circular, dark Mare Crisium (1) is clearly much further away from the trailing limb in the numbered image than it is at left. Similarly, the Mare Nectaris (2), with the major craters Theophilus, Cyrillus and Catharina on its western edge, is both further to the north and to the west than in the March 2001 image. Perhaps the clearest demonstration of libration in latitude (3) occurs at the top (north) of the disk along the terminator, where the craters Aristoteles and Eudoxus, rim lit by the early morning Sun, are markedly closer to the lunar north pole region in the June 2000 image than in that obtained in March of 2001.*

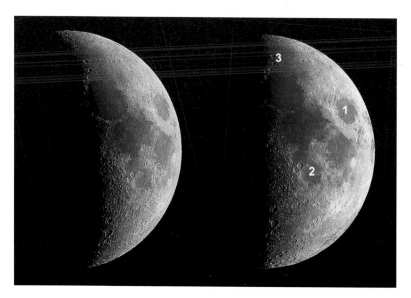

Mars – a retrograde loop

At certain times in their orbits, the normal eastward movement of planets against the background stars as seen from Earth appears to halt. They then appear to move in a westward direction for some time before again halting and resuming their movement eastward. This apparent westward movement is called retrograde motion. It is a line-of-sight effect which (for planets from Mars outward) occurs when the Earth is at its closest to a planet and in effect performs an overtaking maneuver as it speeds by between the planet and the Sun. The inner planets, Mercury and Venus, can also display retrograde motion but this is not usually seen as clearly as in the case of Mars, for example,

because they are so frequently in a twilight sky without stars to reveal the apparent retrograde movement.

Because the planets' orbital planes are all slightly different from the Earth's (see Table 1.1 on page 17), the path of a planet's retrograde motion shows intriguing variations of shape that depend on the planet's distance from the Earth and its location above or below the ecliptic. Thus Mars can perform "S" or "Z" shaped zigzags or loops. Mars performed such a loop between September/October 1992 and early May 1993, and I decided to record it (see Figure 14.8). Publicity about the event indicated that the retrograde movement of the planet would be about 19° in the constellation Gemini, so the field of view of a normal 50-mm lens would be more than adequate to record the entire loop. There were, however, two possible ways of accomplishing the task. Given a satisfactory location, a camera could be dedicated to the project for the entire period, multiple images being exposed on a single frame of film. I was aware of one previous attempt of this kind, but while an exact timing of the exposures could doubtless be arranged (for example, fixing a telescope of some kind which would be sighted on a target star) there were two objections. Multiple exposures of a night sky – even if fairly dark, which I could not guarantee – would eventually build up a fog level, and since Castor and Pollux would be in the field of view a series of images of them would quickly lead to gross overexposure.

As a result I decided to make separate exposures of the Gemini area over the period of retrograde motion and to combine them in the darkroom. This decided, I chose Ektachrome ISO 400 film as the standard with the $f/1.4$ 50-mm lens stopped down to $f/2.8$ on every occasion to limit off-axis coma as much as possible. The individual pictures were taken from a variety of locations, some of which (abroad) had excellent dark skies, while others (such as at my home) suffered badly from light pollution. Exposures of up to 10 minutes were given in the former case, and as little as 1 minute or 30 seconds in the latter. These shutter speeds required the use of a camera mount tracking at the sidereal rate. The cameras used were a Nikon F3 and a Nikon F4S. The area photographed did not need to be exactly the same during each exposure, provided Mars and some target stars which ensured correct vertical and horizontal coverage were in view. Several images of different exposure lengths were taken on every occasion to ensure that there was at least one usable frame.

By May 1993 images had been obtained on 57 different dates. Sequences where images would be almost on top of one another were thinned out, leaving 31 for the composite. One 5×7 inch color print was made from each to exactly the same degree of enlargement, and each print was duplicated under copying lights on to one frame of Ektachrome

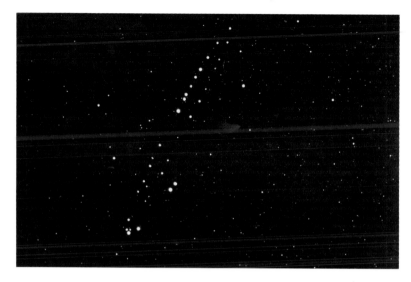

Figure 14.8 The progress of Mars as it performed a retrograde loop as seen from Earth in 1992–93 was the subject of another multi-image photograph, but this one was largely a darkroom project. An in-camera solution (as for the analemma) was ruled out by the risk of fog building up as a result of many exposures on the same frame of film and of gross (and unsightly) overexposure of Castor and Pollux, two of the stars which would be in the field of view during the course of the loop. Instead, a series of individual frames taken at different times were accurately combined and set against a starscape of Gemini in the darkroom. The different angular diameters of Mars were a result of the different exposures in the individual frames dictated by sky conditions (especially light pollution) from various different locations. The ideal would have been an identical exposure on each occasion with Mars at a predetermined altitude, but this was not possible. The track of the loop, however, is demonstrated well.

160 film balanced for tungsten lighting. This was loaded into my Nikon F2AS copying camera with the *f*/3.5 Micro-Nikkor lens fitted.

There were two major requirements in this operation. First, the starfields appearing in the individual frames clearly had to be exactly in register. This was accomplished by marking up an acetate overlay with target stars. Before copying, each print was carefully placed underneath the overlay in register, and taped down before the overlay was removed from the field of view. The second requirement concerned Mars itself. One of the best frames would be used for copying the entire background starscape, but in all the others only Mars was to be copied. At first I thought that a sheet of matt black paper with a very small hole

perhaps 2 or 3 mm in diameter would suffice. But more than thirty exposures of a black sheet under bright copying lights produced a very washed-out sky. A little thought produced the solution. I made a rough-and-ready cone, the broad end of which fitted up and around the lens barrel of the Nikon, and the tip of which just cleared the surface of each print. A small hole cut in the tip enabled Mars to be located in each print and permitted the copying lights to illuminate just that small area, with the rest of the print excluded.

In a few of the frames it was not possible to match all the stars to the overlay because of differential refraction through the atmosphere, and for these a "best fit" policy was adopted. Also, because of the different exposures given, as well as distended images resulting from the proximity of Mars to the horizon in some frames, the apparent diameter of the planet varied. Because of this one can draw no quantitative information about Mars's magnitude or diameter from the composite, which is simply a record of the planet's changing location tracing out a retrograde loop. A more aesthetic balancing of the individual images would have been pleasing, but that, and a more desirable consistency in length of exposures, would be possible only if the project were carried out in a very favorable climate.

Once again it can be stressed that this was a purely photographic exercise and that now at least some aspects of the multi-image assembly of the single record of the loop could be more easily executed using digital techniques.

The analemma

Figure 14.9(b) records the passage of a year from January 14 to the following January 11. On a single frame of film in a 35-mm camera, I recorded the passage of the Sun from winter into summer and back again by making one exposure at precisely 08:30 UT regularly on one day each week (weather permitting). The resulting shape (called an analemma, from the Greek for "lofty structure") has a characteristic figure-of-eight outline, which was frequently included on globes of the Earth many years ago. This exquisite celestial phenomenon – which only the time-lapse camera can record – results from the combined effects of the tilt of the Earth's axis and the elliptical nature of its orbit about the Sun.

The $23\frac{1}{2}°$ tilt of the Earth on its axis is well known, and is represented in Figure 14.9(a) by the long axis of the analemma. Understanding this presents no great problem, but the spread of the solar track along the short axis, which is graduated in minutes (of time), is a little more complex. If the Earth's orbit about the Sun were circular and its axis not tilted, the Sun would appear to move eastward

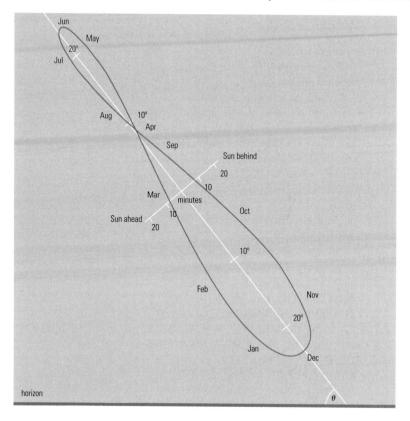

Figure 14.9(a) The analemma – the figure obtained by plotting the position of the Sun in the sky, at the same time of day, at regular intervals for a whole year. The long axis, graduated in degrees of arc, represents the effect on the Sun's position of the Earth's axial tilt. The short axis represents the effect of the Earth's elliptical orbit, and for reasons explained in the text is graduated in minutes of time. The angle (θ) that the long axis makes with the horizon is equal to the observer's latitude.

throughout the year at a constant rate and it would constitute a perfect clock. This *mean Sun* is what our clocks are designed to emulate, and they keep what is called *mean solar time*. But actual or true solar time is less perfect. At the solstices, the real Sun's effective eastward motion is faster than the mean Sun's. Therefore, at those times (twice a year), the Sun arrives at a location's meridian later and later – that is, it runs slow. Around the time of the equinoxes, its motion is slower than the mean Sun's, so at those times it arrives earlier and earlier – that is, it runs fast. Actual solar time can be ahead of, or behind, mean solar time by as

much as 16 minutes, and the difference between the two is called the equation of time. It is this difference that produces the east–west spread of the analemma as shown in Figure 14.9(a).

The lower loop of the analemma is larger than the upper one because the Earth's elliptical orbit brings it closest to the Sun (to perihelion) in January. During the northern winter months, therefore, celestial mechanics causes the Earth to move faster, and this in turn causes the Sun's apparent motion along the ecliptic to be faster than at other times of the year; hence the greater size of the lower loop. (The same effect is seen when a comet orbits close to the Sun.)

Equipment and procedure

The camera used for the photograph in Figure 14.9(b) was positioned so that it framed the view from an "up and over" sloping loft window facing due east, with a clear horizon. Any jarring would disturb the smooth outline of the analemma, so it was essential to eliminate even the slightest movement of the camera body. This would be most likely to happen when the window was opened and closed for an exposure. So a strong platform fixed to the window frame was specially constructed. The camera was placed on wooden supports shaped so as to orient it at the correct angle to the horizon, and bolted to the platform. Window stops were also screwed to each side of the window frame to prevent the back of the camera from being struck when the window was opened for photography.

A motor-driven Nikon F3 was selected. Its readily accessible multiple-exposure lever was a valuable feature in this project, and the use of a motor drive reduced the possibility of slight camera movement on the platform resulting from the operation of a lever wind by hand. Critical to the choice of lens was the angular movement of the Sun's position between the winter and summer solstices. Information supplied by the Royal Greenwich Observatory for my latitude indicated that between December 21 and June 21 there was a movement of 40° in altitude and 30° in azimuth. Some additional margin in altitude was necessary to allow for a foreground in the (hoped for) final picture, as well as for peace of mind. My eventual choice was a 24-mm Nikkor wide-angle lens with a 55° vertical and 80° horizontal field of view. The latter was much more than necessary, but the vertical angle of view was the critical factor. The solar disk would be very small, but I had always envisaged enlarging a successful image at the darkroom stage of the project.

With the first exposure due to take place in mid-January, the camera was fixed to the platform so that the solar disk was located in the lower right corner of the field of view with the reasonable expectation that the Sun's image would not run out of frame in June. Come June, I was

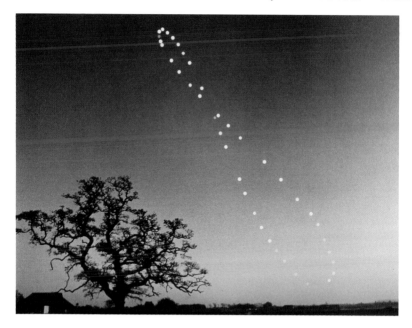

Figure 14.9(b) *The analemma. Recording it is another project involving multiple images on one frame of film, but it differs from the others described in this chapter in the time encompassed – an entire year. The azimuth and altitude of the Sun at the summer and winter solstices dictated the focal length of lens chosen for the camera, which needed to be bolted into position for an entire year so that the track of the solar analemma on the single film frame would be accurate. A white-light solar filter was in place for every image. A successful outcome to the project stemmed largely from precise accuracy in the time of day that each of the weekly exposures was made, and good fortune in the sky being clear at that time. At the conclusion of the project the series of solar images was combined with an image of a sunlit scene to make the final result more pleasing.*

(thankfully) able to confirm this visually, thanks to the choice of an SLR camera. Before the first exposure was made the camera was fully checked, new batteries were installed, and the lens was taped to a focus setting of infinity and an aperture setting of $f/11$. These and other settings and arrangements were checked for accuracy throughout the year.

The camera unit would be subjected to considerable extremes of temperature in the loft over the course of the year (despite the provision of a thermal blanket). For this reason I selected an amateur color negative film, as such films are less likely to be affected by temperature variations than the professional transparency films I normally use.

Exposures were to be made through an ND5 gelatine filter pack, which does not require a fast film when photographing the Sun, and I eventually chose the then Kodacolor Gold 100. Previous tests with the proposed equipment/filter/film combination indicated an exposure of 1/250 of a second at *f*/11.

The day chosen for each weekly exposure throughout the year was Saturday, but such is the English weather that one day either side was regarded as acceptable. Far more critical was the precise time of day, 08:30 UT, which had to be accurate to the split second. Also important was remembering to keep to UT throughout the year, making allowance for when daylight saving time was in operation.

The procedure on a morning when an exposure was scheduled was first of all to set a countdown electronic timer accurately according to a radio time check. Then a regular drill – removing the lens cap, moving the motor drive control from L (lock) to S (single firing), and so on – was observed. This drill was written down for those occasions when I could not be present personally to make an exposure. It was rather difficult to look through the camera's viewfinder while holding the window fully open, so whenever broken or cirrus-type cloud made me wonder

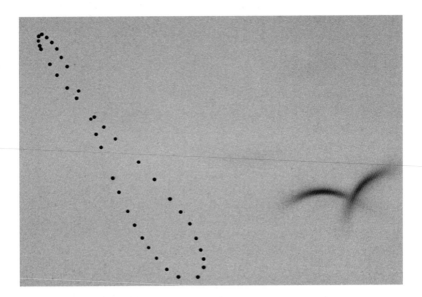

Figure 14.9(c) *How it almost went wrong! A reproduction of the single frame negative on which the year's analemma track of the Sun was recorded. The stress flash resulting from the difficulty encountered in loading the film into the developing tank occurred perilously close to the hard won images of the solar disk.*

whether an exposure should be made, I looked through a second, hand-held filter. Doing that, holding the window open and firing the shutter all at the same time required some dexterity, but it could be done.

Since the view from the loft was somewhat boring pictorially (an open field), a more interesting scene was selected for a single daylight exposure with which the analemma could be combined carefully. Over the course of the year 40 solar images were obtained out of a possible 51, and light cloud cover caused a few other images to be fainter than optimum. I considered this quite acceptable for a location in the UK. If I were to undertake the project again, I would modify at least two photographic elements. First, the density of the solar images exposed during winter was less than expected, obviously because of the attenuation of light resulting from the Sun shining through a greater thickness of atmosphere when close to the horizon. A half-stop increase in exposure would have solved the problem. A second problem arose when the film was processed. Having been wound round the take-up spool in a fixed position for a year, the color negative film had "taken set" – it had become kinked. The direction of the set was the opposite of what was needed for smooth entry into the small developing tank reel, and I failed to get it to take up on the reel despite several attempts. Loading the film from the other end was successful, but not before the failed attempts had caused stress "flashes" to appear on the film perilously close to the single image (see Figure 14.9(c)). Clearly, any film left in a camera in a fixed position for a long time should be unrolled and loaded trailing end first into the developing tank.

Nonetheless, the relief and pleasure when I processed the film and saw the result can be imagined! Afterward, it was a relatively simple matter to combine the single frame containing the image of the analemma with a suitable background picture to produce the final composite. One final comment on the theme of the analemma: it demands some dedication over the course of a year and those successfully accomplishing it tend to communicate the fact to *Sky & Telescope* magazine. At the last count, somebody acutely observed that more men had walked on the Moon than had photographed the analemma!

The attraction of project photography is that if successful it can provide a great sense of satisfaction and achievement. As time goes on, you may develop special interests which can form the basis of a project or projects. For example, you might like to make a record of Jupiter's four Galilean moons at various points in their orbits, or photograph selected constellations so that differences in star colors are brought out as clearly as possible. One objective I have is to make a comprehensive photographic record of halo phenomena. It is just a question of the weather – and finding the time.

The way ahead

Part one: Telescopes and new horizons

Some readers may have reached this point after sampling previous chapters, and decided that observing rather than photography holds the main attraction for them. Others may have worked through the book in a determined manner, steadily gaining knowledge about the sky and the photographic skills used in recording its greatly varied treasures. Hopefully the hard work will have been rewarded and photographs produced that at least show promise when compared with those published in the astronomy magazines. The primary purpose of this book has been to bring readers to this stage. Now the obvious question is, where do we go from here? This chapter points the way.

Camera drives

As we turn to photographing more difficult celestial objects requiring exposures of many minutes, the performance of even

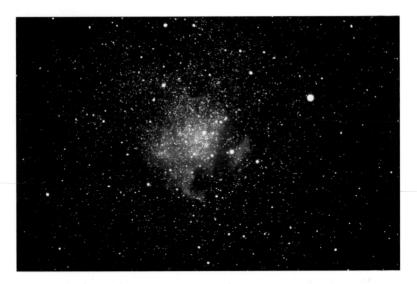

Figure 15.1 The North America Nebula in Cygnus (NGC 7000) with Alpha Cygni (Deneb) to the right was recorded in a 5-minute exposure on hypersensitized Technical Pan 2415 film. A Nikon F3 camera was mounted on an equatorial, driven camera platform and fitted with a 180-mm f/2.8 Nikkor lens. This lens is made from extra-low-dispersion (ED) glass, which limits the chromatic aberration inherent in telephoto lenses, and yields "tight" stellar images and improved contrast.

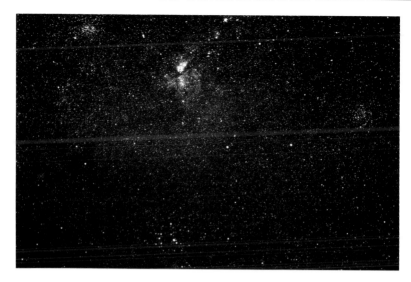

Figure 15.2 The Eta Carinae nebula photographed on ISO 400 color transparency film loaded in a Nikon F3HP. The lens was again the 180-mm f/2.8 Nikkor (shown on the mount in Figure 15.3) and the exposure was 10 minutes. Several attractive star clusters are in the frame. The star after which the nebula is named has been likened to an "orange blob" and although dimmed by the nebulosity is calculated to be possibly six million times more luminous than our Sun.

the fastest films used in a fixed camera is outpaced, and we must look to equipment that will enable us to track the stars. A first step in this direction, the simple Haig mount, was discussed in Chapter 8. Cameras with standard photographic lenses fitted still have an important role to play in photographing astronomical objects that, for example, cover large areas of the sky (see Figures 15.1 and 15.2). The means of enabling them to track the stars lies in two directions: dedicated camera drives, and telescopes upon which cameras ride "piggyback" (see Figure 15.6).

The number of such dedicated drives, normally powered by conventional batteries, on the market has declined in recent years. They were useful, relatively cheap and highly portable. If the beginner locates a used one for sale it is a worthwhile investment because it not only performs a valuable function in itself, but also is a valuable learning tool. For example, it is important for the newcomer to realize that, no matter what any advertising may say, even when a camera mount or telescope (other than the very sophisticated) is correctly aligned on the north or south celestial pole and the equipment is performing to spec-

ification, the gears and other mechanical components of the system cannot of themselves track a chosen celestial object with absolute accuracy. This is of no great significance when wide-angle and normal focal length lenses are in use, but once a focal length of around 100 mm is reached a control unit is required which allows the photographer to make small adjustments to the speed of the motor while monitoring the target's position. This is known as *guiding*.

The dedicated mounts often have two-arm booms or platforms that are driven by the motor. A camera can be placed at each end, but often one end is used for a guidescope. This is focused on the target object, and used by the photographer to track it throughout the exposure, making adjustments as necessary with a hand-controller. The more expensive models have better provision for accurate alignment on the celestial pole, and a mount with guidescope is comparable in essentials to a small telescope. Figure 15.3 shows a current, popular mount

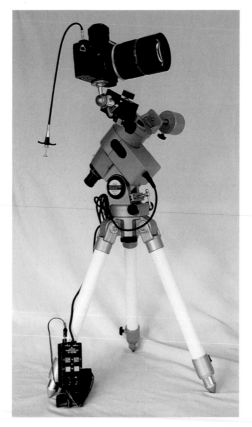

Figure 15.3 *A Vixen GP Polaris driven mount for astrophotography. The power pack for driving the motors and the hand control unit are seen against one leg. The polar alignment eyepiece points downward on the left hand side and a small counterweight balances the camera. Although relatively small, the mount is extremely sturdy and can easily bear the weight of a small telescope: it always accompanies me on trips abroad, particularly for solar eclipses.*

which is primarily intended as a telescope mount but which I use pure-ly for astrophotography with a mounted camera – for example, at solar eclipses. Basic, lower-priced mounts are suitable for taking good-qual-ity constellation images in a matter of minutes with cameras fitted with wide-angle and normal focal length lenses. More expensive, dedicated mounts can deliver good performance with lenses of up to 200- or 300-mm focal length, but in my view that should be regarded as the limit: we have now reached the province of the telescope proper.

Using the telescope

For the general public, the telescope is the instrument that epitomizes astronomy and which (for the reasons stated at the beginning of the book) we have so far been largely ignoring. The various types (see Figures 15.4 and 15.5) all have their protagonists. If you decide to pro-ceed further with your astrophotography you will find the pros and cons of different telescopes well analysed in the various magazines, and knowledgeable staff at retail outlets as well as astronomy club members should be able to help. Here we identify three broad categories. The Newtonian reflector (which uses mirrors to form the image, with the eyepiece the only lens) is relatively cheap, has a fast focal ratio, and is a popular choice for studying planets and deep-sky objects. The refrac-tor (and particularly the apochromatic type) yields superbly sharp and contrasty images, and is well suited for imaging the Sun, Moon and planets, but is relatively slow and, aperture for aperture, is the most expensive type of telescope. It is undoubtedly the third type – the *Schmidt–Cassegrain* – that has done more than anything else to bring astronomy, and in particular astrophotography, to a wider, participat-ing audience. The catadioptric optical system embraces both lenses and mirrors (not unlike the mirror-reflex photo lenses discussed in Chapter 3) and the Schmidt–Cassegrain name is in honor of the two pioneers whose optical researches (greatly separated in time) led to the development of this instrument.

These telescopes (the bulk of which are manufactured by two US corporations – Celestron International and Meade Instruments) have become steadily more advanced over the years. When I purchased my first Celestron some time in the early 1980s I was delighted at having a "state-of-the-art" system boasting an aperture of just over 200 mm (8 inches) and a focal ratio of $f/10$, yielding a focal length of 2000 mm. Not only that, it came with a dual-axis drive corrector with which to make corrections to the electric motors in both declination and right ascension, and a number of eyepieces of various powers. It made astrophotography relatively easy but you were required to make sure the assembly was level and you had to align it carefully on the north celes-

Figure 15.4 Two current telescopes. At left is a Celestron Nexstar 5 – a 5-inch f/10 Schmidt–Cassegrain telescope of 1250-mm focal length. It is easily transportable and offers extensive "GO TO" functions. The hand control unit can be seen "parked" on the arm supporting the telescope. Below is a fast (f/3.5) 8-inch Newtonian reflector produced by Parks Optical. It is particularly suited for deep-sky observing and imaging. The telescope is in the company's Nitelight series and this model has a 3° field of view. Parks' products may be described as "high end:" the 16-inch version of this telescope with accessories costs well into five figures at the present time.

tial pole for accurate tracking. This size of telescope is still very popular but the application of electronics has greatly increased its versatility and user friendliness. Just a few years ago a sophisticated hand controller was introduced, which had a large memory of astronomical objects. Once you had leveled and aligned the telescope, entered your latitude and longitude, date and time into the controller, and then identified two "target" stars so that the telescope was calibrated, you could require it to point itself at as many objects as there were in the hand controller's memory. Appropriately, this became known as a GO TO function.

Now even that has been superseded. The latest Schmidt–Cassegrains bear the designation GPS (for Global Positioning Satellite). You simply switch it on and the electronics automatically enter your position and the date/time by communicating with GPS satellites (see Figure 15.5). Moreover, an electronic compass finds north, and another subsystem levels the telescope. Inevitably these aids come at a price and it might be argued that more important are the quality of the telescope's optics and the accuracy with which it tracks celestial objects. Be that as it may, in terms of astrophotography we will consider using a basic 8-inch Schmidt–Cassegrain to establish what it offers.

Figure 15.5 This telescope, introduced in 2002, features the GPS "state-of-the-art" system described in the text. It is a Meade LX200GPS model, which is available in various sizes from 7 inch up to 12 inch. This is the 8-inch model. The base of the equatorial mount houses the electronics, and the hand control can be seen in a retaining clip beneath the eyepiece. Amateur astronomers are offered a great variety of features with telescopes of this kind: it is claimed, for example, that the "GO TO" memory contains the location of 145,000 celestial objects.

Piggybacking

The telescope makes an admirable mount on which to piggyback our camera fitted with its own lenses. Many popular astronomical objects are too large to fit within the film frame of a 35-mm camera when photographed through, say, a 2000-mm focal length instrument. The solution is to purchase or make a special fitting that permanently attaches to the telescope and to which the camera can be threaded or clamped. The camera is then fitted with a convenient focal length lens to record a target object, which is sighted along the top of the telescope barrel with the normal viewfinder being used to frame the body (see Figures 15.6 and 15.7).

The telescope, of course, plays a vital role. Aligned correctly on the celestial pole, it will be tracking in right ascension quite well. It may be that the focal length of the lens being used will be such as to reveal few

Figure 15.6 A camera and 180-mm focal length lens mounted piggy-back on a 6-foot long refractor telescope. The disks seen below the camera are counterweights which are moved forward or backward on rods to balance the telescope (and its drive system) when cameras and other objects of varying weight are in use.

signs of the minor fluctuations in the rate at which the telescope is being driven by its motor, but most photographers will usually guide nonetheless. A *star diagonal* is fitted at the rear cell of the telescope to direct the light rays upward at right angles, and in it is placed an *illuminated reticle*. This is a high-power eyepiece with single or double cross-hairs that are illuminated by a red light whose brightness can be controlled. The telescope is aimed at the area to be photographed, and when the correct field of view for the camera lens has been confirmed, a target star is focused in the telescope's eyepiece. Then, throughout the exposure, a hand-control is used to make slight adjustments in right ascension (and less likely in declination) so that the target star remains on the illuminated cross-hair. This is an admirable means of guiding for moderate focal length photography because, obviously, if a 2000-mm telescope is being used for the guiding and is holding steady on a target star, the results produced by a lens of only 300- or 400-mm focal length should be excellent

The telescope can be used for photography in a much more direct fashion. If the camera lens is removed, the camera itself may be attached by means of an adapter and a T-ring (designed for the particular camera) to the rear end of the telescope. Now the skies are

viewed through the *f*/10 optics of 2000-mm focal length (or whatever the size of the telescope is). This is normally (if not too accurately) referred to as *prime focus photography*. The focal length is such that the Moon and Sun fit conveniently into the 35-mm film frame: when other objects are too large a tele-compressor lens can be fitted which reduces the telescope to an effective *f*/5 1000-mm system – which is faster, of course.

Direct photography and eyepiece projection

Since the photography is taking place through the main optics of the telescope, the problem arises of how to guide during lengthy time exposures of deep-sky objects. This is usually accomplished by a technique known as *off-axis guiding*. A hollow T-shaped accessory screws directly into the rear cell of the telescope, and the camera is fitted to the other end to receive the light down the tube. Part way down the guider tube is a small prism which reflects light from the edge of the field of view and directs it up at right angles to an illuminated reticle

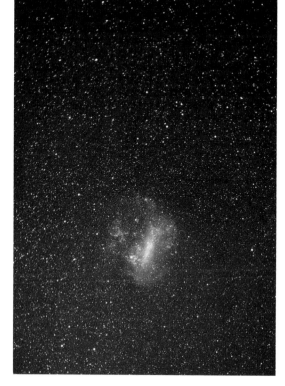

Figure 15.7 *The end result of piggybacking – the Large Magellanic Cloud, one of the neighboring galaxies to our own Milky Way, located in the southern constellation of Dorado. The image was exposed on ISO 400 transparency film loaded in a Nikon F3HP camera with a 58-mm f/2 Noct-Nikkor lens fitted. The exposure was for 10 minutes.*

which is fitted at the top of the long stem of the T accessory. A suitable star is selected as the target, and, once the exposure is under way, any drift is revealed by the star beginning to move off the cross-hairs. Such movement is corrected (as in piggyback photography) by using the drive corrector control unit. The technique sounds very straightforward, but is in fact demanding and can become very tiring. It is not surprising, therefore, that the introduction of extensive electronics and CCDs has led to the development of autoguiders that take over this function from the astrophotographer.

One more stage remains with the telescope as far as mainstream photography is concerned. A focal length of 2000 mm is insufficient for some purposes, such as detailed photography of the planets or "close-ups" of the Moon. At this stage the eyepieces used for visual observing are pressed into use. An eyepiece is screwed into the back of the telescope. A tele-extender, which is a projection tube, screws over the eyepiece and the camera fits at the other end of the tube. This arrangement is known as *eyepiece projection photography*, or EPP.

Expressed in this way it may sound straightforward, but it most certainly is not, and EPP may be regarded as the toughest test for an astrophotographer. There is a wide range of eyepieces to master, typically from 40-mm focal length (low power/magnification) to 4-mm (very high power). Eyepieces come in a number of different designs, but I think most experienced workers would agree that orthoscopics are the most suitable for astrophotography as distinct from observing. Having made a choice, which might begin with, say, 25- and 12-mm eyepieces to give a spread of magnification from moderate to reasonably high, and fitted the chosen eyepiece to the telescope, some of the problems will become quickly apparent. To start with, the tele-extender with the camera fitted to the end of the telescope will probably unbalance it. In that case, counterweights, which may have to be specially purchased, will have to be added toward the front of the telescope.

So we fit an eyepiece and magnify the image of part of the Moon (see Figure 15.10) or of the disk of Jupiter. But while magnification is the whole object of the exercise, we have to pay for it: higher magnification spreads a fixed amount of light over a larger area, so the image becomes dimmer. A normal SLR focusing screen is quite inadequate when the camera is being used for EPP, and in my view one of the special screens (see Chapter 3) is essential if good results are to be achieved. The dimness of the image (which in addition may of course be intrinsic to the celestial object) calls for long exposures. For dim deep-sky objects such as galaxies or nebulae, exposures can be an hour or more, and the main challenge then is guiding accuracy and endurance. With lunar or planetary photography, in which exposures often fall into the difficult "no-

man's land" region of around a second or so (see Chapter 5), operating procedures need to be at their best.

There is something else about EPP that needs to be stressed. As astrophotographers we may have improved and gained considerable experience, and we may be fortunate enough to own good-quality equipment, but if the seeing (the state of the atmosphere) is not good, then no amount of skill or hard work is going to lead to a happy outcome. Experience is also knowing when to stay indoors. Finally, although I have pointed out the difficulties, my intention has certainly not been to discourage anyone, because it is with the move to EPP that the astrophotographer comes of age, beginning to use focal lengths and ratios that would astonish the ordinary photographer – for example 28,000 mm at $f/140$!

Film

Reference to such a low focal ratio inevitably raises the issue of film, particularly as the specter of reciprocity failure affecting exposures of more than a few minutes has risen on a number of occasions in previous chapters. Deep-sky photography is the realm of the professional observatories and of many devoted amateurs. Over the years, Eastman Kodak evolved a number of astronomical film products for the observatories which were designed with specific sensitivities and to reduce reciprocity failure to a minimum. With the coming of CCDs and electronic systems, these films and plates have almost entirely disappeared. But where film is still used – particularly by keen amateurs – a technique developed quite some years ago is of help. This technique is known as *hypersensitization*, or *hypering* for short.

Film is hypersensitized by baking it in a special vessel containing a "forming gas" mixture of nitrogen and hydrogen for several days at around 30°C. A small amount of fog occurs, but reciprocity failure is greatly reduced and certain films exhibit what can only be described as astonishing speed gains. Kodak Technical Pan 2415 is one of the most successful of the hypersensitized films, and a tenfold speed gain has been claimed for it. The equipment for hypering films, as well as pretreated films themselves, are available from a small number of suppliers in the US and elsewhere. For many years, dedicated astrophotographers reduced reciprocity failure by using specially constructed *cold cameras* containing dry ice which chilled the emulsion. The technique was very demanding, but introduced little fog into the emulsion and color balance was scarcely affected. Now, however, one virtually never hears of anybody using the technique. Perhaps the days of film hypersensitization can also be judged to be numbered. The quality of unhypered films, particularly if allied with

digital scanning and manipulation in the computer after develop-
ment, has considerably improved. In addition and more important
still, the areas where film is at its weakest are where the CCD and
digital cameras come into their own. That will be discussed in the
second part of this chapter.

Specializing: Sun, Moon, planets and deep sky

Inevitably we tend to specialize as we progress. The following brief
comments on four particularly popular subjects are based on my
own experience.

The Sun is a fascinating subject, but the specialist filters needed for
serious work are expensive – as is the refractor, which, in my view, is
unmatched for solar photography. The best known of the broadband
(or "white light") filters are of the Inconel type, made of glass coated
with an alloy of cobalt, nickel and iron, and they reject 99.999 percent
of the Sun's radiation (see Figure 15.8). Specific solar features can be
studied in more detail by using special narrowband filters that pass
only a very small part of the spectrum. A hydrogen-alpha filter con-
centrates on the strong hydrogen line at 656.28 nm (6562.8 Å), and
reveals prominences, flares and other activity not visible through the
broadband filters (see Figure 15.9). Another filter concentrates on the
so-called K line of ionized calcium at 393.39 nm (3933.9 Å) and well
shows regions of magnetic activity (plages) in the solar chromosphere.
Eyepiece projection is normally used very little, and many serious solar
astrophotographers rely on the high-resolution, high-contrast, black-
and-white film Technical Pan 2415 almost exclusively. Some workers
have been successful with digital cameras but as yet I have not enjoyed
much success in that direction.

The Moon may seem at first sight an easy photographic subject, but
to get high-quality images of lunar surface features requires excellent
technique and much skill. Eyepiece projection is normally used (as for
Figure 15.10) and is essential, for example, if the photographer is a par-
ticipant in a group studying TLPs (transient lunar phenomena) – occa-
sional localized changes on the surface which might be caused by out-
gassing from the lunar interior. The telescope should be tracking at the
lunar rate. Depending on the Moon's phase, either high-contrast
(2415) or lower-contrast (T-Max type) black-and-white film is used,
and a variety of development techniques may be chosen for optimum
results. Color film can be used, but little is to be gained since the Moon
is essentially a monochromatic subject.

It is easy to obtain moderately satisfactory photographs of the
Moon, but excellent results require close attention to the procedures
outlined in Chapter 5. You also need the ability to recognize when

Figure 15.8 White light imaging of the Sun. The main image was taken on 2001 March 30 when the Sun exhibited signs of increased activity during a long drawn out maximum. An f/9 178-mm StarFire refractor was fitted with an Inconel type filter, and the exposure at prime focus was 1/125 of a second on high-resolution ISO 100 Ektachrome color transparency film. The framed disk of Earth is included for scale. The inset image shows the innermost planet, Mercury, in transit across the south-southwest limb of the Sun, giving an excellent demonstration of the difference in size of the two bodies. The transit took place on 1993

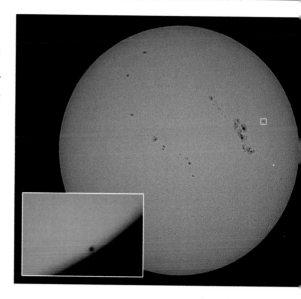

November 6, and was seen at midday in Australia. The original image was obtained using a 26-mm Plössl eyepiece fitted to a Celestron C8 telescope. Technical Pan 2415 film was loaded in a Nikon F4S camera and was exposed for 1/60 of a second through an Inconel solar filter. The image was subsequently copied on to color transparency film through an orange filter.

conditions will not permit good results. If you do not have an observatory then it is pointless trying to take pictures of the Moon (or anything else) if the tripod of your Schmidt–Cassegrain is being buffeted continually by a strong wind. The "seeing" is very important, and I feel that it is of far greater significance than any consideration of the different merits of various types of eyepiece. The altitude of the Moon, too, is critical in obtaining optimum results. A few serious lunar photographers in the UK argue that to photograph the Moon when its altitude is any less than 30° is a waste of time. This may be considered too severe an attitude, but it is certainly true that there are good times and bad times to try for high-quality images of the Moon. If you want to get the best results, then – all other things being equal – the first quarter Moon is best photographed in March, near the equinox; the full Moon near the winter solstice in December; and the last quarter Moon at the September equinox.

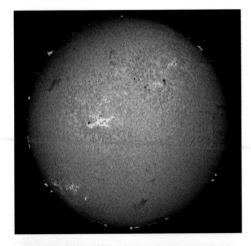

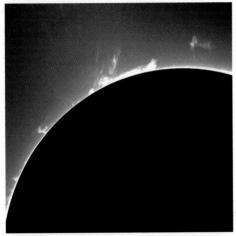

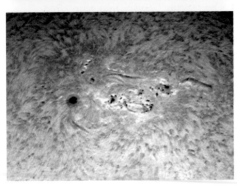

Figure 15.9 *The Sun photographed with a hydrogen-alpha filter. These three images were all taken on Kodak Technical Pan 2415 black-and-white film loaded in a Nikon F4S camera attached to an f/9 178-mm refractor telescope. The full disk image was exposed at prime focus but the other two were exposed through a 2 × Barlow lens. Using the 2415 film with my system, the typical exposure for obtaining disk detail usually varies from 1/30–1/60 of a second. Prominence detail requires exposures of around 1/4–1/8 of a second. Initially, the black-and-white images were converted into color by photocopying carefully registered black-and-white prints through an orange filter on to one frame of color transparency film; more recently, the color has been introduced by digital methods. The image at top was obtained on 1999 November 12 and well demonstrates sunspots, active regions, filaments and prominences. The middle image was obtained on 2000 August 11 and concentrates exclusively on prominence activity (with the overexposed disk occluded by a mask). The image at bottom is an enlarged view of a complex active region which was recorded on 1999 August 27.*

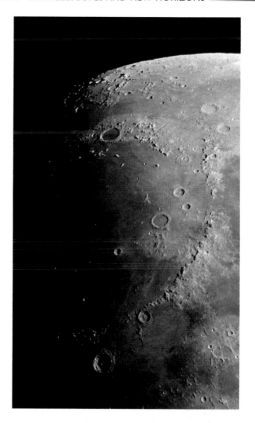

Figure 15.10 *Eyepiece projection through a 26-mm objective fitted to an Astro-Physics f/9 178-mm (7-inch) StarFire refractor tracking at the lunar rate was used to obtain this image of the eight-day-old Moon. The exposure was on Ektachrome ISO 100 Plus film for 1/2 of a second. Mare Imbrium is the major feature of the picture, together with a number of prominent craters. Toward the top is Plato, with the cleft of the Alpine Valley just to the right. At the bottom is the famous crater Copernicus, with one wall in shadow and the other brightly lit by the Sun. North of Copernicus is the smaller but clearly illuminated crater Eratosthenes, above which run the Apennine and Caucasus Mountains, which separate Mare Imbrium from Mare Serenitatis and Mare Vaporum. The large, partially filled crater within Mare Imbrium is Archimedes.*

Planets are arguably the most demanding subjects to photograph well. Eyepiece projection is essential, and all three of the major types of telescope have their protagonists. Filters are frequently used to emphasize color differences in the surface and atmosphere of planets such as Mars and Jupiter (respectively). Once again, good results come from attention to detail, application and experience. CCDs have much to offer the planetary specialist, since short exposures take advantage of momentary improvements in seeing, and subsequent computer processing will bring out detail that would remain hidden in a conventional photograph.

Deep-sky objects are probably what appeal most of all to beginners, inspired by images of exotically colored nebulae, of star clusters and of distant galaxies. (The Hubble Space telescope has a lot to answer for!) But this too is a very demanding area. The relatively fast focal ratios of Newtonian reflectors, the use of hypersensitized films, and a competence in off-axis guiding will all improve your chances of success.

Often, though, you are dealing with dim objects which to the eye can be lost in light-polluted urban skies and which (even when skies are good) require very long and demanding exposures. These factors are certain to strengthen the role of CCDs.

Into the darkroom?

Advanced darkroom work may seem a somewhat paradoxical theme in the light of the following sections about CCDs and digital methods, but it is very relevant. David Malin, at the Anglo-Australian Telescope in New South Wales, has a worldwide reputation for his magnificent color images that result largely from skilled darkroom techniques such as unsharp masking and photographic amplification which he uses to bring out detail not readily discernible in the original images. Malin's work has inspired some highly skilled amateur astrophotographers and darkroom workers. In the US it is by no means uncommon to see superlative deep-sky images resulting from dark-room skills in which color negatives are stacked in the enlarger as a means of producing color prints and transparencies with superior color, contrast and grain characteristics. For many years both profes-sional and dedicated amateur astrophotographers have overcome defi-ciencies in ordinary color film by taking separate pictures through red, green and blue filters on black-and-white film, and subsequently reconstituting a composite image on color film in the darkroom. A more recent development has been to take advantage of film's high res-

Figure 15.11 Two superlative images by Bill and Sally Fletcher of California. At top is the Seagull Nebula (IC2177) in Monoceros. They describe the large and colorful nebula – more than 2° along its major axis – as a wonderful target for wide-field photographic instruments. The photo was taken with an 8-inch, f/1.5 Schmidt camera in photographic tri-color. Three exposures were taken on hypersensitized Kodak Technical Pan film. Each was shot through one of the red, green and blue tri-color filters, the exposure times being 16, 55 and 65 minutes, respectively. The resulting black-and-white negatives were digitized, then assigned to the computer's corresponding red, green and blue channels. Finally the three channels were aligned, assembled and balanced to create the final color photograph. The image below is of the Pleiades – M45 in Taurus – one of the most popular photographic objects in the sky. Although the stars are very bright, a long exposure is the key to a successful image that includes the beautiful and intricate details in the surrounding nebulosity. This image was taken using an 8-inch, f/4.5 Newtonian telescope in photographic tri-color. The details of the photographic technique are basically the same as with the Seagull Nebula. However, the exposure times for this instrument and filters were: 65 minutes (red); 90 minutes (green); and 125 minutes (blue).

olution and spatial coverage in the initial capture of the image, but then to convert the color or black-and-white negatives into digital form with a scanner and use the computer to generate – and enhance – a color composite. Two excellent examples by American workers are reproduced as Figure 15.11. The best of both worlds, indeed!

It is to that other world of the pixel that we now turn.

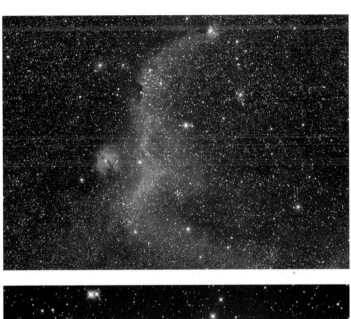

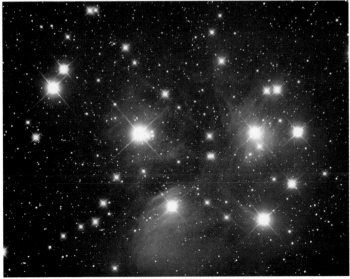

— *Part two: CCDs and the digital world* —

The CCD (charge-coupled device) is a solid-state imaging detector which has been used in professional astronomy for about a quarter of a century. The initial high costs have been reduced steadily and keen amateurs have been applying CCDs to their hobby with increasing enthusiasm over the past five years or so. If the crystals of silver salts are scattered randomly in a film, the "sensitized surface" of a CCD is quite the opposite – a rectangular array of many thousands of imaging elements called pixels (picture elements) in neat columns and rows. The basic function of the array is to convert incoming photons of light into electrons which are stored until they can be read out to a computer which displays the electrons as an image. An analogy for what happens when a CCD creates an image was described well by two imaging scientists at the Jet Propulsion Laboratory:

> Imagine an array of buckets covering a field. After a rainstorm, the buckets are sent by conveyor belts to a metering station where the amount of water in each bucket is measured. Then a computer would take these data and display a picture of how much rain fell on each part of the field. In a CCD, the "raindrops" are photons, the "buckets" are pixels, the "conveyor belts" the CCD shift registers and the "metering system" an on-chip amplifier.

A deep understanding of the physical processes by which the CCD creates images is not necessary to appreciate its advantages and disadvantages when compared with film. The former are impressive.

1. The CCD is very fast or sensitive compared with optimum type film. It is usually claimed that it takes one-tenth of the time to obtain a CCD image that it takes under comparable conditions with film. Films record about 3 percent of the light that falls on them whereas CCDs record between 50 and 80 percent depending on their design. Referred to as the quantum efficiency, it is this quality that gives the CCD a considerable advantage in imaging objects (and particularly dim objects) in heavily light-polluted skies.

2. Reference has already been made on several occasions to the reciprocity failure that film exhibits during long exposures. With film there is a rapid fall off in data gathering after an initial brief surge. The CCD does not suffer from this weakness: its response to light is constant or linear, meaning that a 20-minute exposure will give twice the amount of data (density if you like) as that captured during a 10-minute exposure. Under controlled conditions, this also makes the CCD an instrument suitable for scientific experiment – for example photometry.

3. CCDs record a broader spectral range than films.

4. CCDs have a greater dynamic range – a greater ability to show higher and lower light levels.

5. CCDs provide the facility of displaying a raw image on the computer monitor within seconds, allowing decisions as to suitability to be made by the operator. Images can be retaken if not suitable without the lengthy wait that would result from processing of film.

6. Images produced by CCDs are in a form ready for subsequent digital correction, enhancement and merging with other images: there is therefore a considerable degree of convenience. That convenience can be said to embrace the absence of the wet processing involved with the photographic process.

Film is not without advantages:

1. The 35-mm film frame is a relatively large 36 × 24 mm (to say nothing of the 60 × 60 mm of medium-format camera film). Although likely to increase further in size, CCDs are small – that in my camera being 4.7 × 3.6 mm. The CCD is thus too small for large scale images of the sky, where film still reigns supreme (see Figure 15.12).

2. Film yields one step color – that is, it is no different from black-and-white film in requiring just a single exposure. CCDs dedicated to astronomy – with one exception – have to take three separate black-and-white images through red, blue and green filters to create a color composite. (This limitation does not apply to general purpose digital cameras, which are discussed in a later section.)

3. The operation of a basic film camera does not require the provision of electric power, nor does it require a computer or digital printer to display astronomical images. This leads to a strong cost advantage in favor of film, although the quality of the end product must also be considered.

The debate on film versus the CCD is one in which many amateur astronomers love to indulge. I have been involved with both and it is perfectly fair to point out the greater complexity of taking a CCD image. The system generates its own "noise," particularly a dark current which degrades the signal coming from the astronomical object being imaged. The sky background to the object also generates a degree of noise. Both have to be countered by the provision of some form of cooling and the taking of a dark frame. The latter is an exposure that is made totally without light but which contains the same system noise; the noise is then subtracted from the astronomical image digitally.

Figure 15.12 A direct comparison of the area of a typical CCD (above) with that of a 35-mm film frame. The CCD shown here is the 8.7 × 6.7 mm chip incorporated in the Starlight Xpress monochrome MX916 unit. This unit is shown in Figure 15.13. The CCD surface is located inside and toward the top of the aluminum barrel with the name panel on it – the collar and the $1\frac{1}{4}$-inch telescope interface tube are detachable, thus allowing this comparison photograph to be taken!

Another similar requirement is the taking of a flat-field image. CCD images can be vignetted and additionally suffer from shadows caused by dust particles or variations in pixel sensitivity. Taking an image of a totally plain, evenly lit surface will record the same anomalies, which can then be subtracted digitally from an astronomical image taken immediately prior or after the flat-field frame. It takes practice and determination to follow the procedure for CCD imaging: locking a very small sensor on to a dim, very small object, having previously obtained focus on a brighter object such as a star; checking the focus at regular intervals by fast downloading of sample images; ensuring that the cooling levels are as required; and deciding in advance whether you are going to incorporate one of the methods that facilitate imaging – such as binning, whereby pixels are combined to form larger pixels which in turn boosts sensitivity. It is highly likely that those, no matter of what age, who have

been accustomed to the use of computers will accommodate themselves far faster to the demands of CCD imaging than those who have not. Similarly, they will be more confident using the numerous post-exposure routines for the improvement of images.

What must impress anybody who studies (and begins to use) CCDs and who has come from a film camera background is the enormous variety and versatility of the CCD cameras. Astroimaging using a camera loaded with film can only vary within relatively constrained limits which are set by the characteristics of the film and possibly the use of filters. Thus an exposure at the telescope made by a £100 camera loaded with film in most cases will not differ markedly from one made with a camera costing £4000. In the case of CCDs, however, a unit at the beginner's end of the market with an array of some 80,000 pixels and costing perhaps £500–600, while performing well, will be far less versatile than a camera at the top end with an array of 1.5m pixels and a current cost of around £5000 upward. The latter will not only have bigger, higher resolution chips but also will usually incorporate self-guiding systems, software enabling them to be operated remotely and – the current most desirable feature – adaptive optics, a technique previously limited to professional observatories which compensates for and corrects the effects of the turbulence of the atmosphere upon images.

But the versatility of CCDs does not necessarily equate to cost. For example, the pixels in one array may be small in size, say 7 microns (1 micron is one thousandth of a millimeter or 0.0004 inch), which implies high resolution, compared with a much larger 20 microns in another array, which means more light gathering capacity and therefore sensitivity. However, the configuration of a telescope system can be altered by adding a focal reducer to increase the speed of a small pixel CCD or by increasing the focal length of a telescope to improve the resolution of larger pixels. As another example of versatility, there is a long established technique in digital imaging whereby rather than taking one lengthy exposure (during which inadequate tracking by the telescope can cause star images to trail, or "overexposure" of pixels, whereby electrons spill over from a pixel into adjoining pixels, can cause bright stars to *bloom*) a whole series of shorter exposures are given which are subsequently co-added to yield an exposure that is almost as good as an optimum quality, single, longer exposure. Even a relatively low-priced CCD can offer the ability to take such a series of short exposures, automatically co-adding the images as it goes. Yet another indication of the versatility is that while the bulk of CCD images seen usually feature deep-sky objects such as galaxies and nebulae, nonetheless the cameras can produce impressive images of small regions of the lunar surface.

There are a number of CCD camera manufacturers worldwide and among the leading names are Santa Barbara Instrument Group, Meade Instruments, Apogee Instruments, Starlight Xpress and Finger Lakes Instrumentation. (Two typical examples are shown in Figure 15.13.) These manufacturers' web addresses are published in the appendix. The user guides which they issue with the various models that they offer for sale are usually comprehensive and extremely helpful. It is appropriate to record one caution here: while it is possible for somebody to operate a film camera at least after a fashion without reading an instruction manual, anybody attempting to do similarly with a CCD will encounter nothing but heartache! Reproduced here as Figures 15.14 and 15.15 are examples of deep space and planetary images, respectively, taken by two highly talented and experienced workers – but that talent does not develop overnight.

Digital cameras – the afocal method

When exposing images on film we generally use general purpose cameras with suitable modifications and accessories. While the CCD astro camera is a dedicated unit, there are now numerous digital cameras which may be regarded as similar to film cameras save for the recording medium. It is a natural question, therefore, to ask how well they perform at the telescope. These cameras have improved enormously in quality over the past year or so, with those in the medium-price range probably making the most significant advance. In examining their suitability and qualities, it is necessary to distinguish two broad categories: medium-priced cameras with usually a fixed zoom lens; and "high-end" single lens reflex cameras (SLRs) much used by professional photographers and talented, keen amateurs.

The first group, members of which now frequently boast 3 megapixel resolution and higher, takes us back to the pre-SLR days of astrophotography in one major sense. The SLR camera began its rise to popularity in the 1950s and 60s. Before that time, film cameras did not have the interchangeable lens function: like the new medium digital cameras, the lens was fixed to the camera. A telescope is of course a lens system in its own right so a way had to be found of using a camera with lens mounted with the telescope's optical system. By dint of many experiments a technique known as *afocal photography* was developed. In this, the camera was held (or fitted) to the eyepiece of the telescope, normally focused at infinity, and the exposure made. As will be realized, the camera was in fact photographing the image of an astronomical object in the eyepiece of the telescope. The technique involved considerable measurements and calculations, and of course establishing success or failure had to await the development of the (then almost always) black-and-white film.

Now advance forty years or so and again we have numerous very versatile digital cameras with fixed lenses. Afocal photography or imaging is again called for but with one very significant difference –

Figure 15.13 Two CCD cameras (not to scale). At top, an SBIG ST-237 is shown together with its central processor unit (CPU). This is a moderately priced, versatile camera with an array of 640 × 480 pixels, each of which is 7.4 microns in size. The optical head houses the CCD and preamplifier, while the CPU contains the readout and control electronics. The camera is a monochrome system into which a tri-color filter wheel can be fitted. Below, the Starlight Xpress MX916, which is a British product, is also a versatile unit. It offers an array of 376 × 290 pixels or 752 × 580 pixels according to the downloading method selected.

Figure 15.14 The power of the CCD in the hands of a master – Dr. Robert Gendler, from Connecticut in the US. The image below shows M51, the Whirlpool Galaxy, in the northern constellation Canes Venatici. The image was taken using a 12½-inch Ritchey–Chretien telescope at f/9 and an SBIG ST10E camera. The color information was secured by exposures of 20, 20 and 40 minutes, respectively, through separate red, green and blue filters. These color channels were blended together using the Maxim DL software package. A greyscale image to provide maximum detail ("luminance") took the form of a cumulative unfiltered exposure of 5 hours – composed of 15 separate subexposures each of 20 minutes'

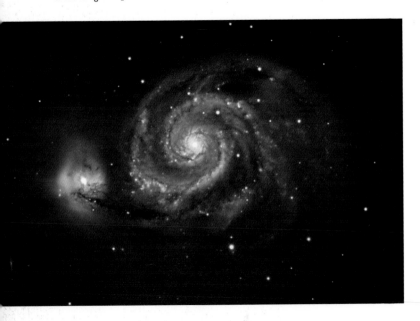

most of the mid- to high-range digital cameras will have an LCD screen (a viewing screen) so that the photographer can see exactly what the camera lens is seeing. (Bright ambient light may make that view far less perfect than in lower light conditions but it is better than no view at all.) And of course, even if there is no computer in the observatory or location where the imaging is taking place, it takes but a few minutes to remove the recording medium – typically a flash card – from the camera and to examine the quality of the images in a suitable viewing program.

The subjects suitable for the medium-range digital cameras are the Sun (with appropriate filters), the Moon and, with even more care, the planets (see Figure 15.16). The prime problem of the afocal procedure

duration. The final LRGB combined image was assembled in Photoshop. The exotic image at right shows the nebular objects M42 (the Great Nebula), M43 and NGC1977 in Orion. It is a three-frame mosaic taken with two different cameras – an IMG1014 camera made by Fingerlakes Instrumentation and an SBIG ST8. The telescope was again the $12\frac{1}{2}$-inch Ritchey–Chretien. M42/43 and NGC1977 were two separate RGB tri-color images, each with red, green and blue exposures lasting 20, 20 and 20 minutes respectively. The 20-minute exposures were the cumulative result of 30-second subexposures, a procedure often adopted to prevent stellar blooming. The subexposures were combined and the color channels blended using Maxim DL. All other manipulation, such as contrast, color brightness and sharpening, was applied in Photoshop. The stars of the Trapezium (a small group in the brightest part of M42) were the subject of a separate short exposure – RGB of 5, 5 and 5 minutes – and were layered into the image in Photoshop.

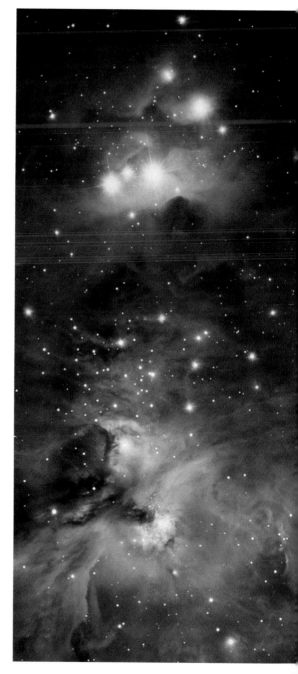

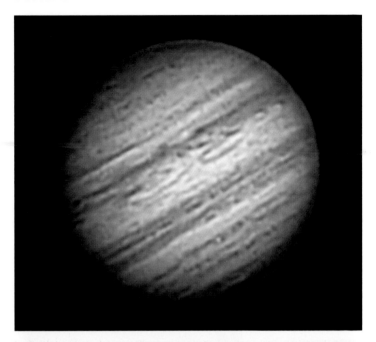

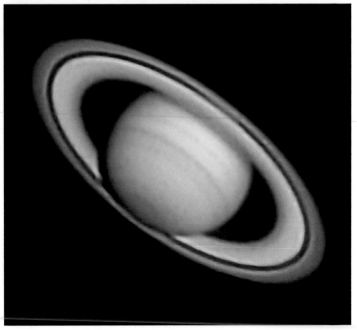

Figure 15.15 *The planets are tailor made for the CCD as is demonstrated here by two images taken by Damian Peach. Jupiter, above, was imaged on 2002 March 27 and Saturn, below, on 2002 February 15. The same technique was employed in both cases. An SBIG ST-5C camera was attached to a 30-cm Schmidt–Cassegrain telescope working at f/29. A series of exposures was made through Clear, Red, Green and Blue filters and these were composited to yield an LRGB image – "L" standing for "luminance," the detailed grey scale image. Unsharp masking was additionally used. Fine detail down to approximately 0.25 seconds of arc can be distinguished.*

is the same as it was decades ago – how to fit the camera to the telescope. The least satisfactory method is simply holding the camera to the eyepiece of the telescope. Quite apart from the danger of camera movement, it is very difficult to ensure that the camera lens is precisely centered over the eyepiece and that the optical axis of the camera lens is exactly perpendicular to that of the eyepiece. Fortunately, two solutions have now appeared. Adapters are being made which take the form of a mini-platform for the digital camera which is connected by several rods to the body of the telescope such that the camera is held rigidly in position. Such an adapter is inevitably tailor-made for specific telescopes, but the numbers will doubtless grow, and in any case the concept is one which anybody capable of working with metal should be able to translate into practice for themselves.

The other solution is the neatest but requires the digital camera to have a threaded lens barrel. In some of the units, an adapter fits the camera via the lens barrel directly on to an eyepiece, which is then inserted into the normal $1\frac{1}{4}$-inch orifice of the telescope. In others, the contact is not directly with an eyepiece but with a tube adapter (not unlike those used for eyepiece projection photography) into which the eyepiece is inserted before the entire assembly is fitted on to the telescope. One of the latter systems fits my Nikon Coolpix5000 camera and is shown in Figure 15.17. The system works well.

There are additional advantages to using these new digital units compared with the days of yore with film cameras. There is no mechanical shutter to cause any vibration when an exposure is made, and use of a self timer or a remote release makes a similar contribution to image quality. If manual settings can be selected, the camera's lens should be set to (manual) infinity focus but autofocus seems to present no problems if such an override is not possible. The optical zoom can be used to close in on the subject if it is relatively small in the eyepiece (like the planets) but vignetting can result if too extensive a use of the zoom is employed.

A very useful article on digital afocal imaging appeared in *Sky & Telescope*, August 2001, pages 128–34. Figure 15.16 shows the pleas-

Figure 15.16 The increasing numbers of good quality, conventional digital cameras with fixed lenses does not preclude their use at the telescope, the afocal method enabling the user to photograph the image created by the telescope (usually) in an eyepiece. Here are two examples taken with a Nikon Coolpix5000 digital camera mainly in automatic mode. For the image at left, an Inconel glass filter was fitted to my f/9 178-mm StarFire refractor and a 36-mm eyepiece was used to form the image of the Sun. Aperture priority was selected on the camera (f/5) and the meter set the shutter speed used to 1/500 of a second based on a speed rating equivalent to ISO 200. The camera's zoom was used to zero in on the disk. The same basic approach was followed for the image of the Moon at right, but a higher power eyepiece of 17 mm was used to isolate a segment of the lunar terminator (the boundary between lunar day and night) on 2002 May 18 when the Moon was slightly under $6\frac{1}{2}$ days old. The metered exposure was 1/2 of a second at f/5. The camera has recorded numerous, detailed craters well, but the most noticeable feature is the winding Rupes Altai lit by the morning Sun at extreme right. "Rupes" means "scarp."

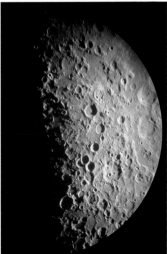

ing results that can be obtained with the method. Dedicated video cameras are also appearing and an article on one appears in the same issue of *Sky & Telescope*, pages 55–9. While I have no direct experience of their use, even webcams are now being pressed into service as astro cameras. An article on this application appeared in *Ciel et Espace*, April 2002, pages 72–5.

Afocal photography however is a compromise aimed at overcoming the presence of a fixed camera lens. How do high-end digital SLRs perform at the telescope? In my experience the answer is – excellently.

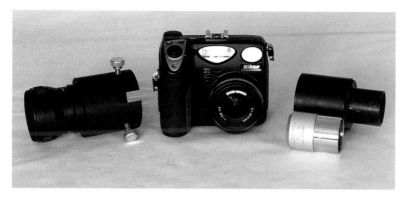

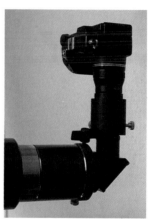

Figure 15.17 The equipment used to secure the afocal images in Figure 15.16. The Coolpix5000 camera is in the center of the image above. The adapter used to fit the camera to the telescope has been disassembled to show the constituent elements. In the foreground at right is the eyepiece which slots into the tube behind it. With eyepiece inserted, that tube is slotted into the sleeve on the left, the nuts being used to adjust the tube for focusing and to make sure it does not fall out. On the end of the sleeve is a Nikon adapter ring which screws into the lens barrel of the Coolpix5000 so that the unit is securely located. The image at right shows the assembly inserted into the telescope's diagonal.

Using top cameras

In some ways the CCDs in general purpose digital cameras do not differ greatly from the dedicated astronomical CCDs. There is one major difference however: whether at the cheaper or more expensive end of the price range, the general purpose cameras cannot replicate the lengthy exposures which are one of the hallmarks of their more specialized siblings. As we have seen, a cooling function is an integral part of those units and this does not exist in the general purpose cameras. Thus the latter cannot be used for lengthy exposure because "noise" becomes far too intrusive. But that difference admitted, the top digital cameras perform extremely well at the telescope. As SLRs they have the traditional feel of a high quality film camera but with significant advantages. Over the last year or so, the price of these cameras has come down from the metaphorical stratosphere to being merely expensive. A number of the top camera manufacturers' prod-

ucts come into this category but my experiences related here are based on prolonged use of the Nikon D1 and also of the D1X – the latter being a later and higher resolution development of the former.

As with dedicated CCDs, a major advantage of these digital cameras in the observatory, when imaging the Moon and Sun in particular, is that they can be operated from the computer keyboard. A Firewire connection is used to select most of the camera functions, trip the shutter and then transmit the image to the computer screen. This takes place in just a few seconds, and the image can be accepted or rejected on the basis of exposure, sharpness and other qualities. The Nikon "Capture" software package also offers a considerable degree of image manipulation capability. Figure 15.18 illustrates the general D1 setup in my observatory. Since atmospheric seeing varies so much and, at the other end of the telescope, it is so easy to forget important steps or make mistakes – all factors which may not be realized until a disappointing film is processed – this virtually instantaneous check is an enormous advantage. Various custom modifications can be selected when operating the cameras – for example, the introduction of a slight delay in the timing of an exposure so there is a pause after the mirror moves out of the way. The images are initially downloaded in a proprietary Nikon format (.nef) which contains information on the exposure – time, date, exposure used, shutter speed, any exposure compensation and so on. The need for notes has been stressed earlier, even when starting out in astrophotography, so this can save much time.

Considerable versatility is available depending on the subject matter. The D1 CCD sensitivity (I almost said "film speed!") can be selected from 200 to 1600 ISO equivalent and I always leave it on the equivalent of ISO 200. Image quality can be varied from a file size of almost 8 MB at the high end to one of 320 KB in basic mode. With a computer hard disk readily available I never change the setting from the highest. One can switch from color to black and white and back again with a click of the mouse. And whilst I thought initially that I would perform all image corrections and enhancements in Photoshop, Capture's Curves and Unsharp Masking functions are of such quality as to be valuable in making an early assessment of any images about which there is a slight doubt. And of course from the beginning, the image exists in digital form so there is no need for any scanning as there is with film originals.

In case this begins to sound as though I have shares in Nikon, I hasten to say there are features which are either mildly or more significantly unattractive. Like high-end film cameras with motor drives, the D1 is heavy (1.1 kgs or 2.5 lbs without batteries) and requires a change in the positions of the telescope's counterweights. The meter prism cannot be

removed, so that while an accessory right-angle viewer can be screwed into the eyepiece of the camera it cannot be a high magnification viewer. This therefore limits ease of focusing, although, to be fair, with an electric focuser control to hand a series of images can be quickly downloaded on to the computer screen to check focus, as with the dedicated CCDs. The CCD in the Nikon (like all of the cameras so far) is smaller than the traditional 35-mm frame (15.6 × 23.7 mm compared with 24 × 36 mm). This can be somewhat disadvantageous because if used together with a telescope of, say, 1600-mm or 2000-mm focal length a full disk Moon or Sun runs out of the image area and a focal reducer has to be installed. Then again, in the Capture software the ability to be

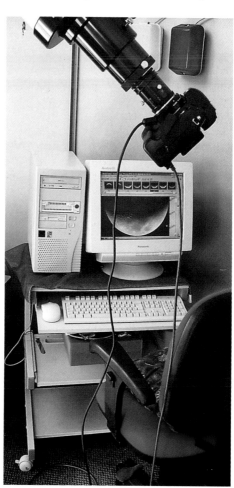

Figure 15.18 The Nikon D1 camera in action. Like a dedicated CCD astro camera, this high-end camera can be almost totally controlled from the computer keyboard when taking pictures. The two cables that can be seen attached to the camera are the Firewire connection to the computer and an AC power supply. Clearly seen on the monitor is an image of the crescent Moon which has just been downloaded from the camera. Notice the thumbnail views of exposures made earlier in the sequence.

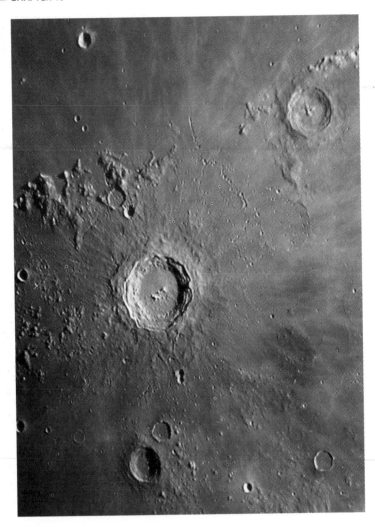

able to enter some notes over and above the functions that the system reports on automatically would be valuable.

Perhaps the most serious problem in using digital SLRs arises from dust on the CCD or, more accurately, on the low pass filter which fits in front of the CCD. This can be a problem with the dedicated CCDs, although in those units the CCD is normally deeply recessed within the body of the camera. In the case of the more moderately priced digital cameras, the problem does not arise because they are not SLRs and the CCD surface is never exposed. However, with the SLRs there is a

Figure 15.19. The end product from the D1 camera. The image at left shows the great lunar crater Copernicus at mid frame, with the crater Eratosthenes at top right. The black-and-white image was taken on 2000 March 15. A 17-mm eyepiece was used, and with aperture priority together with an ISO 200 speed rating selected the exposure was for 1/3 of a second. The image at right is a mosaic composed of images obtained on 2001 December 25 as part of a study of the lunar terminator. The Moon was 11 days old at this time. Eyepiece projection (EPP) employed a 26-mm ocular, and six separate images were subsequently assembled in the computer. Discrete unsharp masking was employed. The advantage of building up mosaics from EPP images is the far greater detail that is potentially available from the greater scale obtained. Even a top, general purpose digital camera cannot match dedicated CCDs when imaging the planets but the size of the Nikon D1's CCD enables Jupiter to be captured with all four of its moons in the same field of view. This image below is a composite of two shot on 2002 April 5. A 17-mm eyepiece was used at the end of the StarFire f/9 refractor. The camera was used in manual mode and the exposure for Jupiter was 1/3 of a second, and that for the moons was 10 seconds. The image of Jupiter was subsequently layered on to that of the moons (where the planet was grossly overexposed). The moons from left to right are Ganymede, Europa, Io and Callisto. The final image makes an interesting comparison with Figure 9.3, a film image of the same subject.

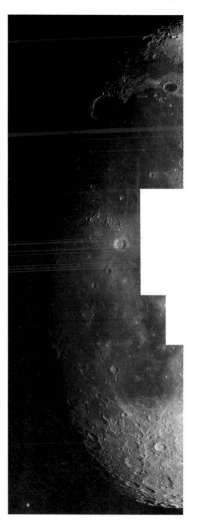

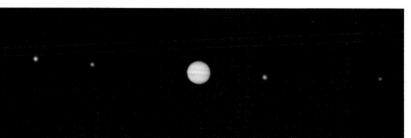

frequent changing of lenses and this greatly increases the chance of dust adhering to the surface of the CCD/filter. I am constantly aware of this danger and carefully use an airbrush on the surface before each imaging session. But even then I am constantly finding what appear to be new craters or other features on the surface of the Moon!

I have often written in this book that you never get something for nothing and high-end digital cameras are no exception. However, the advantages they offer are considerable and while I still use significant (if declining) quantities of film in imaging the Sun and Moon in particular (and under optimum conditions film gives higher quality enlargements beyond about 10×8 inches), the use of my Nikon D1 continues to increase both inside the observatory and outside it. Three examples of its output are reproduced here as Figure 15.19.

Modifying the image

One of the most attractive features of digital imaging is the capability it affords to correct, enhance and composite images. CCD cameras usually have their proprietary software for this although there are stand alone programs dedicated to astronomical imaging. However, I have always used Photoshop, which is perhaps the leading image manipulation package available, although it is not devoted to any particular or special theme. There are of course other similar programs – such as Paint Shop Pro – all of which have their keen adherents.

An introductory account of astronomical photography or imaging is not the place for an extensive account of image enhancement or manipulation but the examples given here show what can be done. Some of the changes effected could be done in the photographic darkroom but there is no disputing the ease and the resulting quality from work with the computer.

Correction The first example (Figure 15.20) demonstrates how one's mistakes or an equipment malfunction can be overcome. The original picture was of a crescent Moon and earthshine in a twilight sky. The exposure was a relatively long one and either mirror "bounce" or the fact that the camera was not securely seated on the tripod led to the double image of the crescent. The shot had been taken on color print film and the general tone of the sky was not as I remembered it. The image was scanned for computer manipulation. The second picture is the result of work in Photoshop. In a case like this the rubber stamp or clone tool – which samples areas of an image and can be used to replace artifacts or undesirable elements in other, similarly toned parts of the image – was the main tool used. The "false" crescent was removed, as was an intruding telephone cable at the bottom of the image which had not been noticed when the photo was exposed. The

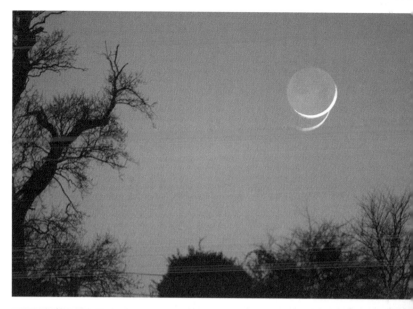

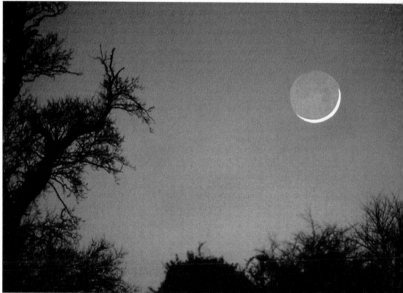

Figure 15.20 A before and after effect produced from digital manipulation. Such a correction would be difficult in the photographic darkroom but is relatively easy using the computer. Fuller detail is given in the text.

cropping out of unsightly, quite close vegetation at the extreme right could have been done as easily photographically as it was digitally. Finally, Photoshop's color balance function was employed to give the whole image a cast which was more consistent with my memory. Of course, this sort of change is purely subjective but in what is a purely pictorial image it is entirely acceptable.

Composites One of the major features of Photoshop and similar programs is the ability to add images to one another, a technique which is facilitated by each image being on its own layer. Figure 15.21 is a composite of ten such layers and shows a representation of the lunar eclipse of 1996 April 4. As we saw in a previous chapter, it would have been possible to make a time lapse record of the entire eclipse as it actually happened using purely photographic methods whereby images were exposed on one frame of film. But this would make use of a relatively wide-angle lens with little detail appearing on the disk of very small Moons. The method shown enabled me to take high resolution, individual images of the Moon on color film using a telescope and also to recreate an impression of the Moon actually moving through the umbra thrown by the Earth. The technique is quite simple. During the eclipse the Moon was in the constellation of Virgo. This was chosen

Figure 15.21 There have already been numerous references to composite images in which several different exposures either on film or on a CCD are combined to illustrate an event in which time is effectively frozen. This composite shows a lunar eclipse extending over several hours in one frame. As the text records, in this case individual exposures on film were scanned and then merged digitally. The assembled layers were then dropped on to a background of the constellation Virgo.

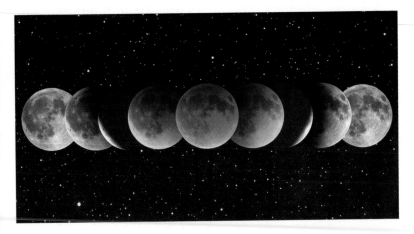

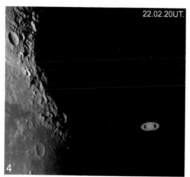

21.59.54UT.

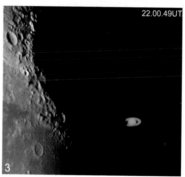

22.00.25UT.

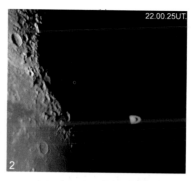

22.02.20UT.

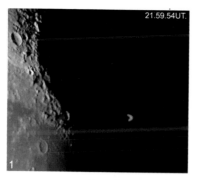

22.00.49UT

Figure 15.22 This is both a composite and a demonstration of the way in which digital manipulation can correct or replace elements in an exposure which are unsuitable as a result of over- or underexposure in the original – or some other fault. Here a series of digital images was exposed as Saturn emerged from behind the Moon. The planet was quite dim compared with the daylit area of the Moon so – using images of Saturn at optimum exposure as backdrops – one correctly exposed image of the Moon segment was overlaid on each. It was then a simple matter to arrange a number of images in a composite.

therefore as the background image and had been taken earlier, with the Moon out of frame; the star at lower left is Spica. Then individual images of the partial and totality phases of the eclipse, which had been taken on ISO 400 and 1600 Ektachrome transparency film respectively, were scanned. These digital records, each on its own layer, were then placed in sequence on the background.

Replacement On a number of occasions reference has been made to the problem of securing images where different elements differ greatly in brightness. This can be a problem in both photographic and digital exposures. One way of solving the problem is to combine such

elements taken by varying exposures into a reconstruction of a single image. Figure 15.22 shows a straightforward example of this applied to an occultation by the Moon of Saturn (at the time of the planet's emersion from behind the Moon) that took place on 2001 November 3. The image was shot digitally using the Nikon D1 and eyepiece projection at the telescope enlarged the immediate area of the emersion. The exposure for the Moon (which was just past full) varied between 1/25 and 1/10 of a second, whereas that for Saturn was between 1/4 and 1/2 of a second. To overcome the problem a previously taken, correct exposure of the Moon was superimposed over the overexposed disk on a series of images shot at the correct exposure for Saturn. The rough lunar terrain shown in the image is the edge of Mare Crisium and the prominent crater at top left is Macrobius.

Blending The technique demonstrated in Figure 15.23 is a far more versatile method than that of replacement for dealing with exposure difficulties that occur in a single frame. During a lunar eclipse the Moon rarely tracks through the center of the Earth's umbra or shadow so the part of the Moon's surface closest to the edge of the shadow is considerably lighter. The contrast between the lightest and darkest parts of the umbra can be quite extreme so again some way of combining exposures is advantageous. This picture shows the Moon during the eclipse of 2001 January 9 when individual frames were again exposed at the telescope on color transparency film.

The result of a 10-second exposure, the frame at top left – showing good detail in the main body of the Moon but overexposure at the limb – was scanned and imported into Photoshop. The frame at right – a 2-second exposure that shows much more detail at the limb – was similarly scanned and placed in Photoshop. Making sure there was accurate alignment between the two images, the shorter exposure was placed on top of the longer one, which at this stage disappears from view. However, a layer mask is placed over the top layer and filled with black. This causes the longer image underneath promptly to reappear. A brush tool is then selected and white chosen as the active color with which to paint the black mask. This has the effect of weakening the mask and allowing the darker image underneath the mask to show through. This painting away of the mask can be tightly controlled because the strength of the brush can be varied between 0 and 100 percent. In this case only the limb area was treated and the effect was built up by consecutive passes of the paint brush at no higher than 30 percent. The result is seen in the third image.

Most of my work is now devoted to the Moon and the Sun but a technique like this can be applied to any suitable subject. For example, there is a significant exposure problem with the famous Orion Nebula

(M42). Within the Nebula is a small grouping of stars called the Trapezium which cannot be seen in long exposures intended to reveal as much as possible of the Nebula. However a much shorter exposure to record these stars could be combined as above with a longer expo-

Figure 15.23 *Shown here is a technique known as blending. It is a form of replacement but one which requires more sophisticated handling. Certain desirable characteristics in specific areas of one image are "brought through" from underneath a similar image above it in order to replace over- or underexposure, undesirable artifacts or other blemishes in that top image. The procedure can be closely controlled by allocating a percentage power to the manipulation tool being used in programs like Photoshop: thus a high percentage will have a dramatic effect whereas a low percentage has a restrained effect.*

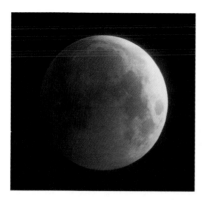

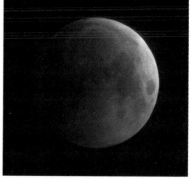

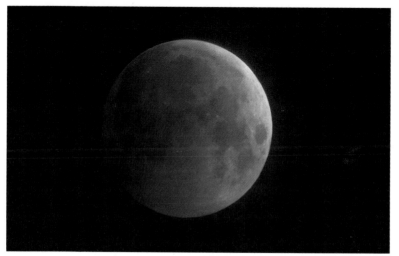

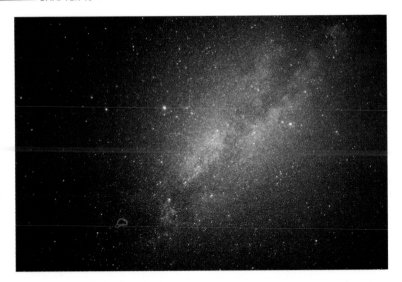

Figure 15.24 In the photographic darkroom it takes considerable experience and skill to take a negative and to "burn in" detail which would otherwise not be seen in a print or to "dodge"- to hold back too much light in the original negative from overwhelming a print. Negatives (or transparencies) can hold much more detail than first revealed in even a close study and this image is an example. Compare it with the last frame in Figure 8.5. That wide-angle picture of the Summer Triangle was an accurate representation of what appeared to have been recorded in the original transparency. It was scanned and then manipulated in Photoshop. This was the result of some relatively simple work using the program's Levels and Curves tools which broadly control the density and the contrast/brightness range of an image. This has resulted in the background of the Milky Way being far more prominent than in the straight image.

sure to show both features to advantage. (The problem of the Trapezium was referred to in the caption for Figure 15.14.) The use of a mask would also be a very straightforward way of adding images of Mars to the retrograde motion composite described as a purely photographic project in Chapter 14.

A straight application of some of the tools in Photoshop can bring out information in an image even without the use of masks as above. An example appears in Figure 15.24.

Apply Image It is fascinating how often the inability of imaging systems to cope with the great extremes of light encountered in astronomy becomes a problem for which we try to devise solutions. Totality during an eclipse of the Sun is a prime case. The accurate recording of

prominences at the limb of the Sun, whether with film or a digital camera, requires short exposures. Exposures of the red chromosphere and of the inner corona take a little longer. And if one tries to image the corona out to its visible edges the exposure can run into seconds. No single, straight record can encompass this. Scientists and serious students of solar eclipses overcome the problem to a considerable degree by fitting a gradient, radial filter to the front of the lens. Such a filter

Figure 15.25 The human eye is a remarkable tool with which to view the physical world. It can roam over an area and distinguish minute detail and can do so over a long period. But it cannot freeze time and space as still and movie cameras can. A solar eclipse is a case in point. The eye can study the bright inner corona and then switch to the dim, diffuse outer corona. Usually those eye "snapshots" will be of a swiftly changing situation. The brain must then hold the visual memory. A sequence of images can record the events as they happen and while problems of over- and underexposure can and do exist, the manipulation of those images can now result in a record of an eclipse which many would claim is as close as we may ever get to a permanent record of what the eye could see but could not physically record. This is a twelve image composite, produced by complex techniques within Photoshop, of the solar eclipse which occurred on 2001 June 21. The text has additional detail.

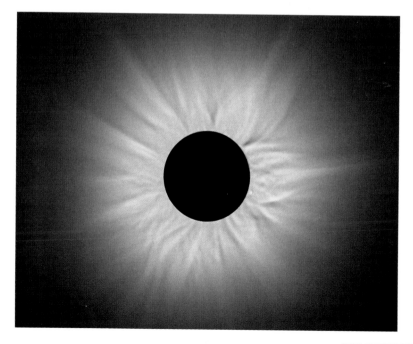

effectively has a nearly opaque mask where the limb of the Sun will be (and the light brightest) but thins to almost total transparency at the extremes of the corona. This technique works but is expensive because each filter has to be calibrated to suit a particular lens.

Over the last few years methods have been evolved of digitally combining considerable numbers of images of the corona. The images are exposed at different speeds so as to record the solar limb as well as the inner and outer areas of the corona accurately. In Photoshop, the images are combined using a complex procedure that makes use of a function called Apply Image. Its complexity precludes any detailed description here but it is worthwhile showing the sort of result that can be obtained. Figure 15.25 is a composite of twelve images exposed on

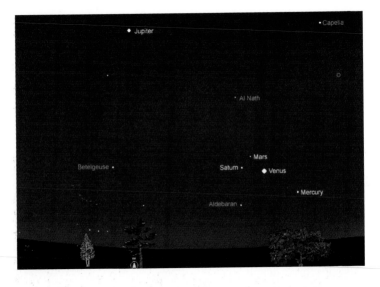

Figure 15.26 Astronomical computer programs can help greatly in portraying the sky and its contents at any particular time, which is a great aid to observers and photographers alike. Figure 9.1 recorded the conjunction of the five planets at 20.30 UT on 2002 May 4. The image above (a) is the scene as predicted for that time by Starry Night Pro. It was valuable to me because it forecast that I could take a sequence of images from my garden (and not have to travel further afield) despite the presence of surrounding trees blocking off the horizon in some directions. The programs also help in demonstrating aspects of astronomical phenomena that are not always obvious to those with little knowledge. The image at right (b) demonstrates the positions of the planets at the time the May 4 images were taken as seen from directly above the Sun; it graphically confirms that what we see from Earth is a line-of-sight effect.

film during the solar eclipse seen in parts of East Africa on 2001 June 21. Comparison with the perfectly acceptable single eclipse images in Chapter 7 underline the difference.

The computer and the sky

Before the coming of the personal computer, we learned our way around the sky by getting out on as many nights as possible with sky maps or the ingenious planisphere – which allowed us to rotate a timescale overlay disk over a fixed chart of the constellations – in one hand and a red-light torch in the other. Although there is no substitute for actual looking, the computer can be such a powerful learning aid that it was only to be expected that astronomy programs

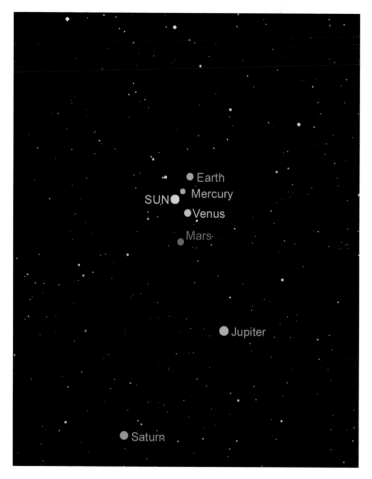

would be quickly added to the software. Many such programs are available, all with their quota of adherents. The Sky, MegaStar, RedShift4, Sky Map Pro and Starry Night are but five. For years I have used Starry Night, which comes in a number of forms – Beginner, Backyard and Pro. Here is the introduction to the User's Guide for Starry Night Pro:

> View the sky as it appears from any location in our Solar System ... see how the stars and planets will look tonight, tomorrow, or far into the past or future. You can view the stars as they appear from your own backyard, from a country on the other side of the world, or from another planet. You can witness a total eclipse of the Moon, watch the Sun set from the surface of Mars, or even ride a comet. Set time flowing at whatever pace you desire, backwards or forwards. You are limited only by your curiosity....

Such versatility is appealing but setting the field of view to one's own location and checking what is visible in the sky at a specific future time is most valuable, even if that is simply a more graphic, colorful and easily interpreted representation of what appears on a planisphere. The value of such programs is demonstrated by my use of Starry Night Pro at the time of the conjunction of five planets in 2002 April/May. I was able to run the program for each night and get detailed information about the azimuth and altitude of the planets for a specific time – which is important information for deciding on a suitable picture-taking location – and their position relative to one another. Figure 9.1 is a picture I took on May 4. Figure 15.26(a) is the guide picture I ran before that evening. For purposes of demonstrating how the appearance of the planets was a line-of-sight effect, running the view from directly above the Solar System was extremely helpful (see Figure 15.26(b)).

The graphic display of astronomical events beforehand is particularly valuable when giving advice to those whose astronomical knowledge is slender. I have participated as an "expert" in a number of solar eclipse tours and being able to show an audience precisely what will happen makes a valuable contribution to their understanding of the process and to their enjoyment. For example, in advance of the 2001 June 21 solar eclipse in East Africa I produced a series of images on the progress of the eclipse from our precise location. Figure 15.27(a) clearly showed my audience where on the (duly filtered) solar disk they should be looking to spot first contact. The following image showed them the solar limb remaining visible just prior to totality. Figure 15.27(c) presented a view of the sky during totality, with brighter stars and three planets that might be glimpsed clearly indicated.

We have come a long way from our first planisphere!

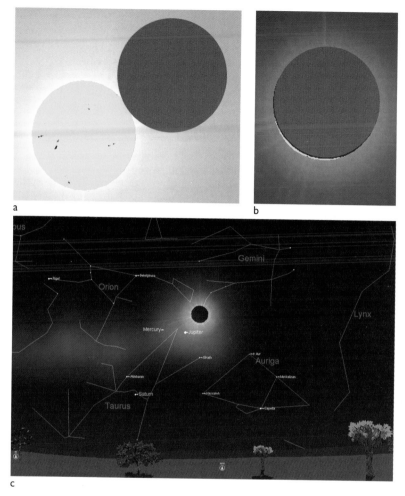

a

b

c

Figure 15.27 *Further examples in which a computer program such as Starry Night can show what happens in the sky during a particular event. The images relate to the solar eclipse seen in East Africa on 2001 June 21. Image (a) shows where first contact between the lunar and solar disks would occur. Image (b) shows where the thin limb of the photosphere would be just prior to second contact – and thus where Baily's beads and a diamond ring might well be seen. Image (c) is a wide-field view of the sky during totality. This would obviously help those wanting to try to spot the planets and brighter stars which should be visible. Notice the center direction indicator on the simulated horizon in the picture: the eclipse was viewed from the southern hemisphere where the Sun and Moon track through the northern part of the sky unlike in the US or UK!*

Foreign skies

These days, holidaying abroad is enormously popular and relatively cheap. While the motive of many people who journey to foreign countries is to combine rest and relaxation with assured sunshine, the principal attraction for those interested in astronomy is the chance to see constellations and other objects not visible at all, or only partly and with difficulty, from home. By going no further than the Mediterranean, for example, those of us living in the UK can see such impressive constellations as Scorpius and Sagittarius in their entirety, and within their boundaries the impressive Milky Way star clouds toward the center of our Galaxy. Further south, from Tenerife in the Canary Islands, for example, the splendid southern constellation Centaurus, containing the finest globular cluster in the sky (Omega Centauri), comes into view during spring evenings. If a holiday is taken in the opposite direction, in Scandinavia and perhaps as far as the Arctic Circle, there could well be plentiful aurorae to enjoy and photograph, as well as the midnight Sun.

The challenge of the South

Should a trip take us to Australia, New Zealand, South Africa or South America, we can enjoy the full glories of the southern sky (including our companion galaxies, the Small and Large Magellanic Clouds), which are almost overpowering at first. In addition, northerners need to accommodate to major differences of orientation. The Sun, Moon and planets track through the northern part of the sky, and not only does the Moon's face appear upside down (a case of northern chauvinism perhaps?), but also it waxes and wanes from the left to the right. The constellations need relearning too, and a star map of the southern skies is essential. At first, it is difficult to recognize or accept clearly delineated constellations (such as Orion or Leo) which appear upside down or side-on, or Gemini being lower than Orion in the sky, while Sirius is higher. Slowly, however, it all begins to make sense.

When we return home we need to readjust again, even if we have been to just another part of the northern hemisphere. For example, as seen from the Canary Islands (28°N, 16°W) in the spring, the beautiful steel-blue star Vega in the constellation Lyra clears the northeastern horizon around 23.00 local time. When I return to the south coast of England (51°N), it is easy to be puzzled briefly by the bright star very high in the northeastern sky at 23.00. Yes, it is Vega – acting as a reminder of the differences of geographical location which speedy air travel tends to make us forget.

A major attraction of foreign travel for astrophotographers is the possibility of very dark skies. Of course this is far from certain, and it is likely that if a holiday is taken in the most popular areas then the amount of light pollution will be as bad as in urban areas back home. But a location or tour chosen with some care can be rewarding. A fly–drive holiday to the southwestern United States for Europeans (or for Americans living in less astronomically favorable areas) will reveal dark skies in large areas of Arizona and New Mexico, while the blackness of the sky from Monument Valley in Utah is almost beyond belief when first seen by a city-dweller. The holiday resorts in the south of Tenerife yield very poor skies, but just a few miles inland by car, around the volcanic peak Teide, the stars are gloriously clear. Holidays in desert (and therefore thinly populated) areas generally yield dark skies, and it is easy to imagine the delights there would be, weather permitting, for keen and hardy astronomers whose work took them to the Arctic or Antarctic during the winter months.

A third attraction of foreign travel for the astrophotographer is the possibility of exotic foregrounds for unashamedly pictorial images (see Figures 16.1 and 16.2). Of course, this is not to underrate such opportunities at home, but a planetary conjunction and crescent Moon photographed with minarets or a magnificent saguaro cactus in the foreground are worth traveling many miles to secure.

What sort of tour?

The opportunities for the astrophotographer will depend greatly upon the type of holiday. With a package tour your chances of finding out much in advance about an area's suitability for astrophotography are severely limited. Most tour operators and travel agencies are selling holidays in a fiercely competitive market, and will not have the time, inclination or local knowledge to answer questions from those with special interests. (Just try asking whether you'll be able to see the setting Sun from your hotel room during your two weeks in July!) However, all is not entirely lost. At least the individual can choose a holiday date that coincides with the most suitable phases of the Moon, for example, and hopefully with other events such as planetary conjunctions.

There are other possibilities. Tour operators offer many choices of holiday location, and the astronomer or astrophotographer prepared to do a little advance research may find that the weather conditions in some of the locations offered were analysed in detail in magazines such as *Sky & Telescope* when a solar eclipse or other major astronomical event was due to be visible from there. From time to time the *Journal* of the British Astronomical Association, and similar publications in other countries, publish accounts of the experiences of members on

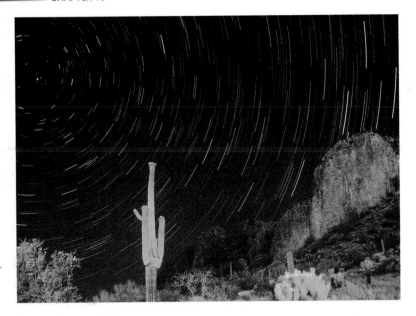

Figure 16.1 *Star trails from different parts of the world. Above left is a 30-minute exposure on ISO 200 Ektachrome Professional film using a 35–105-mm Nikkor zoom lens set to 50-mm focal length and the maximum aperture of f/3.5. The saguaro cactus and foreground rocks of the Arizona landscape are dimly lit by security lights at a nearby resort complex. Polaris, at the top left, scarcely moved during the exposure, but the stars of Cassiopeia, toward the right edge of the frame, show quite long trails. Above right is a much longer exposure of $3\frac{1}{2}$ hours shot*

trips abroad, and these too can make helpful reading. Nonetheless, while initiatives taken by the individual can yield some results, the fact must be faced that astrophotographers get nothing special out of the typical package-tour holiday. In the end, it may be a question of just taking the binoculars and enjoying new constellations.

Infinitely preferable is the specialist astronomical tour, usually organized for a specific event like a solar eclipse. While they are not usually as cheap as an ordinary package tour, their party rates normally make them cheaper than an individual would pay for a privately arranged trip, and there is the added attraction of being with fellow enthusiasts in a group probably led by knowledgeable specialists. The learning potential is therefore high. Even here, however, it is wise to take care. In my experience some astronomical tours can fall between the two stools of providing ordinary holiday-type attractions and catering for the more specialist interests. Indeed, it is not unknown for so-

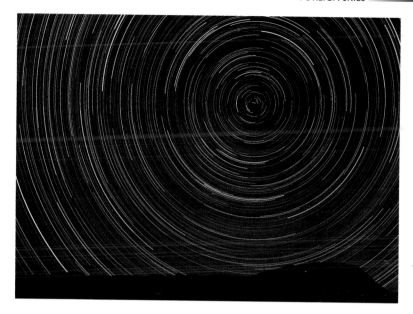

in the Cedeberg Mountains, to the north of Cape Town in South Africa. The film used was ISO 400 Ektachrome Panther loaded in a Nikon F4S. The lens was a 35-mm wide-angle stopped down to f/4 from f/1.4 to limit off-axis aberrations. This star trail is of the southern celestial pole, of course. The members of Crux – the Southern Cross – are to the top right and the two "pointers" in Centaurus across to the left. The difference in sky background is noticeable. This possibly results from a mixture of different film characteristics and also the effect of sky glow in the longer exposure.

called star trips to have been offered at a time when the Moon hampered deep sky observations and photography. It is essential that the tour operators or leaders should have familiarized themselves with the viewing and other conditions at the destinations and to be aware of any problems. A newcomer contemplating such a trip will be well advised to seek out others who have been on trips organized by the same operator, and to take their opinions into account.

There is a third possibility which, on grounds of cost, is not open to too many – the privately arranged astrophotography trip abroad. Obviously it has many advantages. The location can be chosen without any need for compromise, and even such details as a balcony facing east (or west) for convenient dawn or dusk photography can be arranged. A hire car gives maximum mobility in finding dark sites. Once found, it is likely that a suitable area will receive further visits from the serious enthusiast.

Astronomical centers

An excellent development in relatively recent years has been the appearance of small centers providing facilities for astronomers to indulge their hobby at the same time as they and their families enjoy a holiday. Telescopes, mounts and other essential equipment are usually provided or can be hired, and informed and helpful guidance is at hand. I have visited two such centers on a number of occasions, and can highly recommend them. The Star Hill Inn is situated in magnificent wooded mountain country at Sapello, not far from Albuquerque, New Mexico, and the Center for Observational Astronomy in the Algarve (COAA) has been set up by an English couple not far from Portimão in the popular tourist area of the Algarve in Portugal. Places at both can be booked for just a few nights or for longer periods, and since both areas also have many attractions for the non-astronomers in a family or group they are well worth serious consideration. Other such locations exist and a review of advertisements in astronomical magazines will usually yield details.

Whatever the type of holiday or trip, it is best to take with you all the films and most of the equipment you will need. If you plan to use color transparency or black-and-white films, these may not be available abroad and this will certainly be the case in popular resort areas where the films on sale locally will be largely amateur color negative–positive films (which most probably will not have been kept in temperature-controlled conditions). Any consideration of possible price advantages should be disregarded. It is also vital to take reserve supplies of any other expendable items such as batteries. While few of us are likely to have the skill to repair a camera, a jeweller's screwdriver set can be useful for tightening small screws that work loose, as well as opening the battery compartment cover of some cameras (though for this job a coin is frequently more suitable). In case a film becomes jammed in the camera, a light-tight changing-bag (as described in Chapter 13) is a valuable addition to the photographic kit, and in case of possible malfunctions it is as well to take the instruction booklet for the camera since it may contain a troubleshooting checklist. Of course, if you take the booklet you may even learn something new about the camera!

Sun lotions will be used extensively during a holiday in warm countries. A determined attempt should be made to keep one's hands away from the exposed surfaces of lenses, but the occasional failure of good intentions is to be expected, and lens-cleaning tissues should be packed for the trip. Better still, take a small bottle of lens-cleaning fluid. Finally, although on holiday and relaxing, we need to remember good, everyday photographic practice. If it is hot, keep the cam-

era and other equipment out of direct sunlight, and always away from such things as sand, water and drinks.

X-ray problems

The advice to take with you all the film likely to be required raises the question of current security measures at airports. This was a consideration long before the tragic events of 2001 September 11. The first categorical guidance that can be given is that on no account should unprocessed film be packed in suitcases or other luggage which is to travel in the hold of the aircraft. The X-ray equipment used for screening such items will have a serious effect on the films.

Hand baggage is generally also subject to X-ray screening. However, this equipment is now more sophisticated than when first introduced, and X-ray inspection levels are claimed to be below the level at which photographic film starts to fog. So far as the UK is concerned, tests carried out at London's Heathrow Airport in 1993 showed that X-ray screening produced no visible changes in films of speeds up to ISO 3200, even after many repeat inspections. Similar equipment is used in other developed countries such as the US, Canada, Japan and Australia. Where this is the case you can safely allow your films to be passed through the X-ray inspection. Later tests conducted on behalf of BPLC (the British Photographers' Liaison Committee) with the cooperation of the British Airports Authority and published in the 2000 February 23 issue of the *British Journal of Photography* provided generally similar, reassuring results, although it was suggested that films of a speed greater than ISO 800 could be more vulnerable to X-ray screening than was suggested by the 1993 tests. Fortunately, the vast bulk of travelers would be unlikely to be using films of this high speed. However, inveterate travelers tend to journey further and further afield and older, higher-intensity devices are still in use in some less-developed countries and elsewhere. These can damage unprocessed films by just one inspection, the fogging showing up as a general increase in fog and grain or as density streaks and "waves" on the subsequently processed film. Such streaks are more pronounced if the film slot of the cassette happened to have been facing the X-ray source during the screening.

Obviously, such undesirable effects on photographs are to be avoided whatever the subject matter. But this applies even more to the astrophotographer's images since they represent much application and patience, and frequently contain faint and minute objects that are especially vulnerable to degradation by fogging. The best policy is to place all your films (exposed and unexposed) in a clear plastic bag, and to ask for a visual examination if this is allowed (it is not at London air-

Figure 16.2 In the image above, local architecture in the Algarve provides an exotic foreground for this picture of a crescent Moon in the evening sky recorded with a Nikon F301 camera on ISO 800/1600 Ektachrome film. A 35–105-mm Nikkor zoom lens was found to be most useful for pictorial compositions of this kind. Earlier in the evening, the camera's automatic exposure system was relied upon for images of a colorful and still light sky, but as the sky darkened manual exposures based on previous experience were used. This exposure was for 1 second at f/3.5, and the camera was of course fixed on a tripod. The color cast of the white villa walls results from illumination by streetlights. Quite different is this hand-held picture, shown at right, taken through an archway during a solar eclipse trip to the northwest of India. Exiting from a visit to a palace, we were confronted by a dome brightly lit by the setting sun with storm clouds beyond acting as a backdrop to a rainbow, with a secondary bow further out. The camera was a Nikon 801S with the 35–105-mm zoom set to about mid point and the aperture at f/8. ISO 200 color negative film was used; the exposure was metered but on this occasion the shutter speed was not noted.

ports). Clearly the traveler is in the hands of the security staff, but on the whole I have encountered few difficulties with such a request in the US and elsewhere, especially if the plastic bag is packed so that it can be retrieved easily from hand luggage, and an attempt is made to pass through the security check when it is less crowded and the security staff are under less pressure. Bags that are claimed to protect films from X-ray screening can be purchased, but the results are unpredictable and depend on a number of factors (such as film and X-ray machine

variations) beyond the traveler's control. Experience indicates the clear plastic bag to be a cheaper and more reliable solution – and one, moreover, that does not attempt to defeat the whole purpose of a security check directed to the common good.

Processing films

Of course, the surest way of preventing any harmful effects from X-ray screening of exposed films on the way home is for the films to be processed before departure. While color processing is available in many resort areas, it is almost entirely limited to handling amateur negative–positive films. Even where color transparency film or black-and-white processing is available, the special nature of astronomical images and possible language problems in explaining your requirements point to the advisability of either bringing the films

Figure 16.3 *Basic processing equipment for a foreign astrophotography trip. At right rear is a daylight developing tank with a pair of rubber gloves in front. The items in the center foreground are placed on a changing bag. They are (right to left) a pair of scissors, a hook-type bottle opener for opening the 35-mm film cassette, a digital thermometer resting on a film washer tube, two film clips and a reserve dial thermometer. In front is a plastic measuring cylinder. At far left are three 600-ml color processing solution bottles with a small bottle of antistatic film wetting agent in front. On location, the bowl at the rear can be filled with hot water and used as a water jacket for maintaining the correct temperatures of the processing solutions in the developing tank. All the other processing equipment can be packed into the bowl, which is in turn packed in a suitcase. (Since the processing kit will be placed in luggage stowed in the aircraft hold – and will therefore be inaccessible during the flight – the scissors should present no problem, even allowing for the increased severity of security screening since September 2001.)*

back for processing or processing on the spot. Home processing has been covered in Chapter 13. For on-the-spot processing all the essential equipment can be packed into a small kitchen bowl (which is used as a water jacket to maintain required temperatures) that occupies a relatively small volume in a suitcase, as shown in Figure 16.3. A portable, thermostatically controlled processing jacket would be a welcome innovation from the manufacturers, but there probably would not be a high enough demand for it to be commercially viable. Anyway, the high daytime temperatures at many foreign holiday destinations make it much easier to maintain high processing temperatures than at more temperate latitudes.

It is of course for the individual to decide whether holidays abroad are to be used for total relaxation, mostly for rest with a small amount of observing, or chiefly for serious astrophotography. If you go for the last of these options, you will find that there are enthusiasts the world over, and that warm friendships are there to be made.

Postscript

Perhaps by now you have come to a decision on astronomy. Maybe it is simply a matter of the delight of roving free through the heavens without specializing, or using relatively inexpensive binoculars just to look, or maybe to search for comets or novae or to time satellite passages. If so, I wish you well. But hopefully astrophotography may have taken a firm hold on some.

Publication – and maybe a reward?

If you make the grade, your pictures may well see the light of day in the astronomy magazines. In addition, if their quality is good enough, the opportunity to earn some further money from your new skills should be borne in mind. After all, a hobby often demands a considerable outlay, and the chance to recoup some of it should not be neglected. High-quality images can attract the attention of picture editors. If there has been discussion about a new launch of the space shuttle to the International Space Station and you secure a good photo of the spacecraft flying over your home area (there is need for quick processing in cases such as this), ring up the picture desk of the local newspaper and ask if they would like to see it. Even if the photograph does not get printed on this occasion you will have made a useful contact for the future. But your photography does need to be very good. If a regional magazine is published in your home area and frequently uses color landscapes on the cover or inside, think about planning a dramatic skyscape at night or twilight with a recognizable feature in the foreground, as in Figure P.1. Make a point of studying the layout of the magazine, however: if you are attempting a cover picture, keep the area where the title and any other information is located free of any distracting detail.

Provided poetic licence is not pushed too far in the direction of the impossible, talented darkroom workers – and those familiar with digital techniques – should think of constructing composite images containing two or more elements. Commercial opportunities can arise unexpectedly. I was once approached by a manufacturer of aircraft fire-control equipment about the cover of a new brochure. Fire in aircraft is an emotive subject, and the company wished to suggest the message without a literal (and inevitably staged) treatment. I remembered having taken a sequence of pictures at dawn when aircraft vapor trails had framed the rising Sun which could be seen through light cirrus cloud. The connection was made – aircraft and fire – and the cover problem was solved (see Figure P.2).

If you are making progress with your astrophotography, then think seriously about moving onward into the new areas outlined in the later

Figure P.1 *Stonehenge makes a marvelous foreground for pictures. In this dawn image, Venus climbs above two of the trilithons with the standing stones and lintels of the sarsen circle beyond. The planet was in Gemini at the time, and Gamma Geminorum can be seen clearly below and to the right of Venus. Betelgeuse is at the extreme right. This was a 6-second exposure taken on Ektachrome ISO 400 film loaded in a tripod-mounted Hasselblad 500/CM camera fitted with an 80-mm f/2.8 Zeiss Planar lens.*

chapters of this book. Enjoyable work can be done with a fixed camera and everyday photographic equipment, but once you progress to a driven camera and the telescope, the metaphorical chains are broken and you are free to roam wherever your skill can take you.

One of the fascinating things about astronomy is the contribution that the amateur can make to new knowledge. It would be understandable to assume that all areas of the sky are studied continuously by professional astronomers working in observatories around the world. In fact such astronomers number but a few thousand. Perhaps half of them are theoreticians who rarely look at the sky, or are working with radio or other wavelengths. Most of the rest will be fighting

for very limited observing time in the pursuit of important but very restricted research projects. Hardly any will ever conduct broad, sweeping surveys of the night sky.

The amateur contribution

This is where amateur observers and astrophotographers have a role to play. For example, in the study of the Moon, planets, asteroids, meteors and variable stars, and in the search for comets and novae, it is amateurs who as a group can contribute the time and enthusiasm, and also the ever-developing skills that have come to be so highly regarded by professional astronomers. In the eyes of the general public, astronomy is regarded as a high-tech science that requires sophisticated, costly telescopes and spacecraft. It is in fact a revelation to realize how much can be achieved with a pair of binoculars, or even the naked eye. There is a corollary: do not assume that you must have the

Figure P.2 *A dawn shot on a very different morning from that in the Stonehenge image. On this occasion full details of the exposure were not recorded but ISO 400 negative film was used in a Nikon 301S with a 200-mm Nikkor lens attached. Since relatively little of the Sun was shining through the cloud, center-weighted metering was adopted. The camera was hand-held but camera shake problems were minimized by the relatively fast film used. Dawn and twilight skies display enormous differences and nuances: the appeal of this sky was the almost ghostly, veiled appearance of the Sun with the etched outlines of the vapor trails above.*

latest, fashionable piece of equipment to enjoy the hobby – or to do good work if your approach is more serious. Nothing will be achieved by throwing money at your hobby if there is little or no background understanding, knowledge or application.

In the late 1960s and early 1970s, I was much involved with the photographic programs on NASA's Apollo lunar missions. When looking in particular at the superb, high-resolution images of the Moon's surface obtained by mapping cameras flown from Apollo 15 onward, it was easy to question why anybody, anywhere back on Earth should ever again bother to photograph the Moon. Shortly afterward I took up astrophotography seriously, and the answer was provided. Nothing could rival the Apollo images, but equally there was nothing to compare with the thrill and elation of roaming over the lunar maria and mountains at the eyepiece of a telescope, and – whatever the problems with the Earth's atmosphere – of personally recording these features with growing skill on photographic film. Much more recently, digital techniques have attracted a growing following and a major British retailer has forecast that by the end of 2002 sales by value of digital cameras will have surpassed those of film cameras for the first time. Be that as it may, for some time yet both film and pixels will have their respective parts to play and in a very real sense it is the end product – the image – that matters, not how it is obtained.

The true delight of astronomy is that, even if our interest is more casual than those who devote much time, effort and skill to "patrol" activities or other programs, all can share the emotions roused by the never-ending mystery, drama and beauty of the sky. Astrophotographers have an advantage over their colleagues in virtually all other branches of photography, for in a very real sense we can begin to appreciate the true meaning of "infinity." If this book helps readers part of the way toward that appreciation, I shall be well content. May we all successfully defy Spode's law – and may I express the time honored hope to my readers that you will enjoy clear skies: as the Romans might have said *sit caelum faustum tibi*!

Appendix

Magazines

Magazines are a valuable source of up-do-date information. They carry numerous news reports on recently launched products and contain frequent, usually unbiased reviews of equipment and other items.

Sky & Telescope, Box 9111, Belmont, Massachusetts 02178 (www.skypub.com)

Astronomy, Box 1612, Waukesha, Wisconsin 53187 (www.astronomy.com)

SkyNews, P.O. Box 2050, Station LCD Malton, Mississauga, Ontario L4T 9Z9 (www.skynews.ca)

The Planetary Report 65 N, Catalina Avenue, Pasadena, California 91106 (www.planetary.org)

Stargazing Guides

The Backyard Astronomer's Guide by Terence Dickinson and Alan Dyer (Firefly Books)

Burnham's Celestial Handbook by Robert Burnham Jr. (Dover)

General Astronomy Books

Astronomy: The Cosmic Journey by William K. Hartmann and Chris Impey (Wadsworth Publishing)

Astronomy: From the Earth to the Universe by Jay M. Pasachoff (Saunders)

The Universe and Beyond by Terence Dickinson (Firefly Books)

Websites

www.nasa.gov/today/ NASA news and announcements.

Science.msfc.nasa.gov Technical stories from NASA.

Oposite.stsci.edu/pubinfo/Latest.html Photographs and news from the Hubble Space Telescope.

www.heavens-above.com Times and sky locations of all Earth satellites.

Telescope Equipment & Accessory Manufacturers

Astro-Physics, Inc. 11250 Forest Hills Road, Rockford, IL 61115, Ph. 815-282-1513 (www.astro-physics.com) Apochromatic refractors, high-precision equatorial mounts.

Celestron International. 2835 Columbia St., Torrance, CA 90503, Ph. 310-328-9560 (www.celestron.com) Full line of refractors, Newtonians, Schmidt-Cassegrains, eyepieces and telescope accessories.

Coulter Optical. 1781 Primrose Lane, W. Palm Beach, Florida 33414, Ph. 561-795-2201 (www.e-scopes.cc/Murnaghan_Instruments_Corp56469.html) Dobsonian-mounted Newtonians.

Edmund Scientific Company. 101 E. Gloucester Pike, Barrington, NJ 08007, Ph. 609-573-6250 (www.edsci.com) Astroscan telescope, eyepieces, lenses, optical components.

Lumicon. 2111 Research Dr., #5A, Livermore, CA 94550, Ph. 925-447-9570 Nebula filters and photo accessories.

Mag I Instruments. 16342 Coachlight Drive, New Berlin, WI 53151, Ph. 414-785-0926 (www.mag1instruments.com) PortaBall 8″ and 12″ Newtonians.

Meade Instruments Corporation. 6001 Oak Canyon, Irvine, CA 92620, Ph. 714-451-1450 (www.meade.com) Telescopes of all types and sizes, plus extensive array of accessories.

Obsession Telescopes. Box 804, lake Mills WI 53551, Ph. 920-648-2328 (www.globaldialog.com/~obsessiontscp/OBHP.html) Premium-quality Dobsonians.

Questar Corp. 6204 Ingham Road, New Hope, PA 18938, Ph. 215-862-5277 (www.questar-corp.com)

Sky Instruments. Box 3164, Vancouver BC V6B 3Y6, Canada, Ph. 604-270-2813 Eyepieces and introductory-level telescopes.

Starsplitter Telescopes. 3228 Rikkard Drive, Thousand Oaks, CA 91362, Ph. 805-492-0489 (www.starsplitter.com) Premium-quality Dobsonians.

Taurus Technologies. Box 14, Woodstown, NJ 08098, Ph. 609-769-4509 (www.taurus-tech.com) Astrophotography equipment.

Tectron Telescopes. 3544 Oak Grove Dr., Sarasota, FL 34243, Ph. 941-355-2423 (www.icstars.com/index.html) Premium-quality Dobsonians.

Thousand Oaks Optical. Box 4813, Thousand Oaks, CA 91359, Ph. 805-491-3642 (www.thousandoaksoptical.com) Solar filters.

University Optics, Inc. Box 1205, Ann Arbor, MI 48106, Ph. 313-665-3575 (www.universityoptics.com/) Eyepieces and accessories.

CCD Cameras

Apogee Instruments. 11760 Atwood Road, Suite 4, Auburn, CA 95603-9075 (www.ccd.com)

Finger Lakes Instrumentation. 7298 West Main Street, PO Box 19a, Lima, New York, 14485 (www.fli-cam.com)

Meade Instruments. See Telescopes for details.

Santa Barbara Instrument Group. 147-A Castilian Drive, Santa Barbara, CA 93117 (www.sbig.com)

Digital Camera Adapters

ScopeTronix Astronomy Products. 1423 SE 10th Street Unit 1A, Cape Coral FL 33990 (www.scopetronix.com)

Computer Packages

MegaStar. Willmann-Bell, PO Box 35025, Richmond, VA 23235 (www.wil-bell.com)

Sky Map Pro. SkyMap Software, The Thompson Partnership, Lion Buildings, Market Place, Uttoxeter, Staffs ST14 8HZ, UK (www.skymap.com)

Starry Night. Space.com Canada, 284 Richmond Street East, Toronto, Ontario, Canada M5A 1P4 (www.starrynight.com)

Lunar Phase. Gary Nugent, 54a Landscape Park, Churchtown, Dublin 14, Ireland (www.nightskyobserver.com)

Index